The Monarch of the Glen *Landseer in the Highlands*

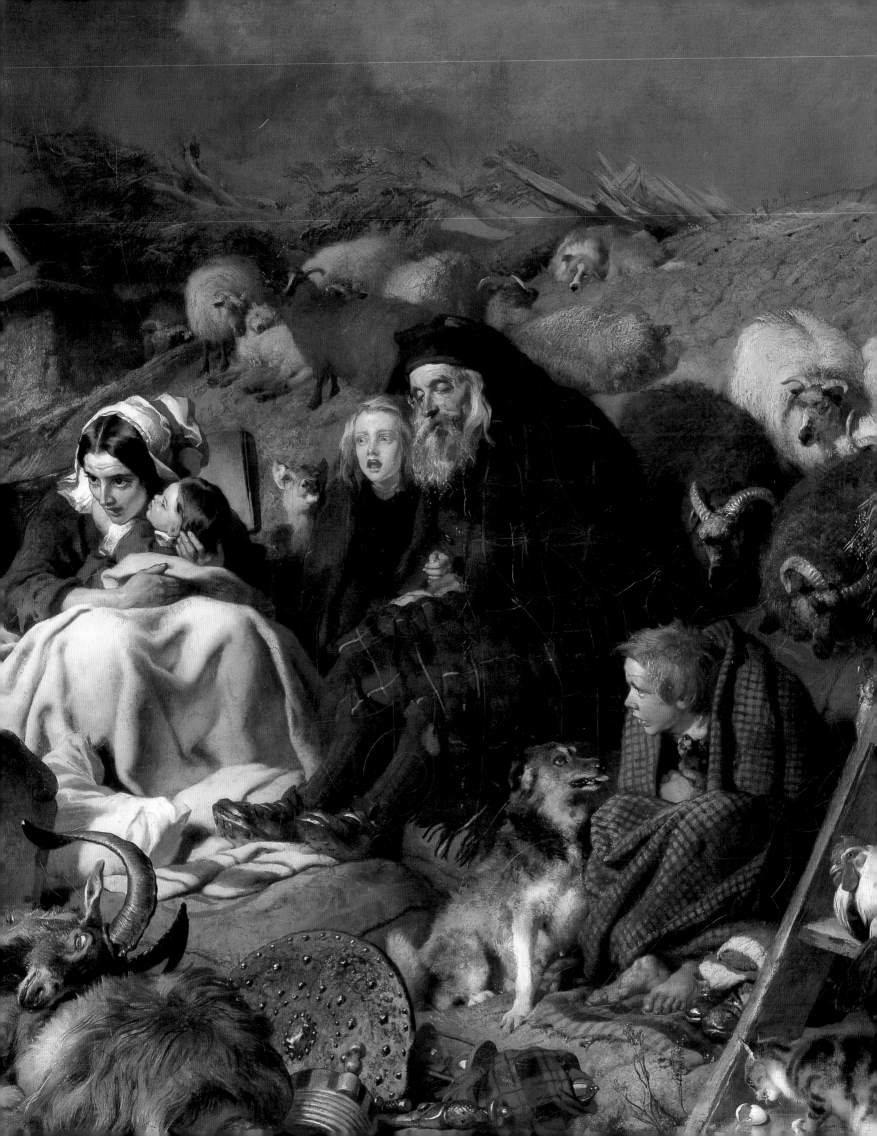

Richard Ormond

WITH AN ESSAY BY T. C. SMOUT

THE MONARCH OF THE GLEN

Landseer in the Highlands

National Galleries of Scotland

Edinburgh · 2005

Published by the Trustees of the National Galleries of
Scotland to accompany the exhibition *The Monarch of the
Glen: Landseer in the Highlands* held at the Royal Scottish
Academy Building from 14 April to 10 July 2005.

© Trustees of the National Galleries of Scotland 2005

ISBN 1 903278 57 0 [paperback]

ISBN 1 903278 70 8 [hardback]

Designed by Dalrymple
Typeset in Miller and Victoria Condensed
Printed by Perfekt, Poland

Front cover: detail from Sir Edwin Landseer *The Monarch
of the Glen*, *c*.1851 [plate 132], by kind permission of Diageo,
on loan to the National Museums of Scotland

Back cover: Sir Edwin Landseer *A Highland Breakfast*, *c*.1834
[plate 65], Victoria & Albert Museum, London

CONTENTS

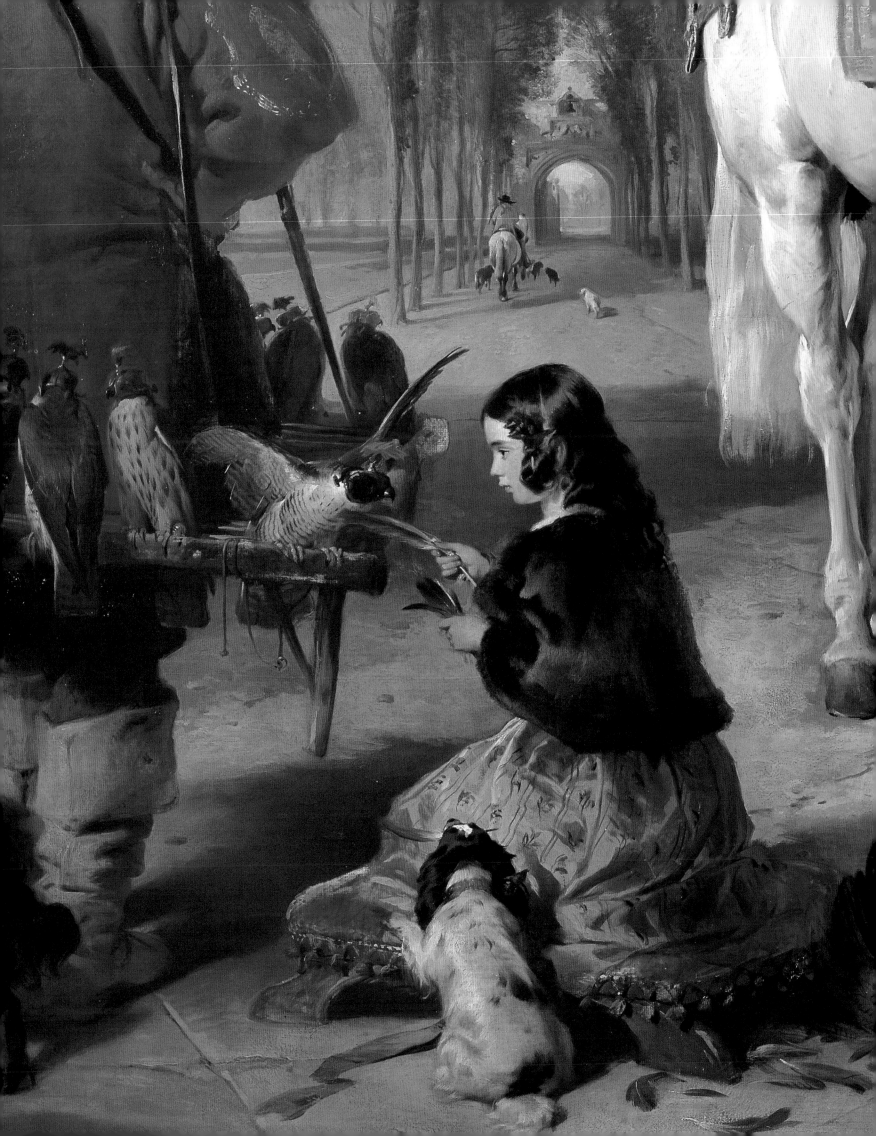

FOREWORD

In Queen Victoria's estimation, Sir Edwin Landseer was quite simply 'the cleverest artist there is'. Landseer was arguably the single most important contributor to the fashioning of the Queen's public image in Scotland and without doubt the greatest British animal painter of the nineteenth century. His intensely romantic vision of the Highlands as a place of natural wonder and sublime beauty influenced successive generations of British artists including Scotland's own Horatio McCulloch and continues to influence us today. *The Monarch of the Glen: Landseer in the Highlands* is the first exhibition in Scotland to be devoted to this extraordinary artist. His world-famous painting *The Monarch of the Glen* (by kind permission of Diageo, on loan to the National Museums of Scotland) features in reproduction on the set of Coronation Street and has lent its name to the phenomenally successful television series filmed near Ardverikie. This exhibition will provide a unique opportunity to explore the complete range of Landseer's work in Scotland from the 1820s, encompassing exquisite Highland landscapes painted for the artist's own pleasure, literary pictures inspired by the novels and poems of Sir Walter Scott, and magnificent studies of deer informed by the first-hand knowledge of a practising sportsman.

This fascinating show has been selected and researched by Richard Ormond, a former director of the National Maritime Museum and an internationally recognised scholar of Victorian painting. The National Galleries of Scotland is extremely privileged to have benefited from his unrivalled expertise on Landseer, which inspired the pioneering exhibition on the artist staged at the Tate Gallery and the Philadelphia Museum of Art in 1981–2. The present exhibition has been devised in collaboration with Helen Smailes, Senior Curator of British Art at the National Gallery of Scotland. The exhibition team has been ably assisted by many colleagues in the National Galleries of Scotland whose particular contributions have been acknowledged by Richard Ormond himself. For his illuminating essay in the book, we are also greatly indebted to Professor Christopher Smout, the Historiographer Royal for Scotland, whose advisory association with the National Galleries of Scotland dates back to the 1980s.

Above all, we are deeply conscious that such an ambitious exhibition could not have been realised without the co-operation of lenders throughout the United Kingdom, headed by Her Majesty The Queen. The public-spirited generosity of our private lenders has been truly exceptional and we hope that they will derive from the exhibition as much pleasure as their cherished loans will undoubtedly afford our visitors. The roll-call of public institutions is equally impressive and includes: Aberdeen Art Gallery; Birmingham Museum and Art Gallery; Bury Art Gallery and Museum; English Heritage; Fitzwilliam Museum, Cambridge; Laing Art Gallery, Newcastle upon Tyne; Manchester City Art Gallery; National Museums of Scotland; National Museums Liverpool; the National Trust; Perth Museum and Art Gallery; Sunderland Museum and Art Gallery; and Tate, London. A special tribute is due to Mark Jones, Director of the Victoria & Albert Museum, and to his curatorial colleagues who agreed to waive compelling prior claims to the museum's major Landseers in recognition of the importance of this exhibition.

We are delighted to have secured the financial support of a remarkable group of benefactors. For the Friends of the National Galleries of Scotland, the principal sponsor of the exhibition, this initiative marks a new departure and we hope that this may prove to be one of many mutually rewarding associations of this kind. Exhibition supporters to whom we are grateful for their generosity include Johnston Press plc and Sotheby's. The latter's commitment is especially welcome and appropriate, the intermediary role of many senior colleagues in the commercial art world having proved invaluable in the process of selecting the exhibition as a whole. Among our individual supporters, we are grateful to Alan and Ellen Reid for their contribution towards the costs of this book. Finally, we are honoured that two of our Playfair founders, Allan and Carol Murray, have agreed to assist this exhibition while continuing to lend generously from their private collection to the National Gallery of Scotland.

SIR TIMOTHY CLIFFORD
Director-General, National Galleries of Scotland

MICHAEL CLARKE
Director, National Gallery of Scotland

SPONSOR'S PREFACE

The Friends of the National Galleries of Scotland celebrate their fifth year in 2005 at a time when the membership has grown to record numbers, with Friends across Scotland and the United Kingdom.

To mark this anniversary, we are delighted to sponsor *The Monarch of the Glen: Landseer in the Highlands*, our first exhibition sponsorship, demonstrating the kind of valuable and practical support that the Friends can offer the National Galleries of Scotland.

One of the aims of the Friends is to support the wide range of activities carried out at the National Galleries of Scotland. Our sponsorship of the Landseer exhibition fulfils this aim, but our relationship with the organisation runs much deeper with benefits flowing in both directions. For example, in return for individual support, through the Friends, the National Galleries of Scotland extends free entry to paying exhibitions, which is complemented by a programme of events. These varied and vibrant activities nourish a further interest in art, whether it is old masters, modern artists or great Victorians like Sir Edwin Landseer.

If you are not already a Friend, join now and give your support to the National Galleries of Scotland, and you can enjoy and learn about the magnificent national collection in their care.

JOHN WASTLE
Chairman of the Friends of the National Galleries of Scotland

AUTHOR'S ACKNOWLEDGEMENTS

I would like to pay a special tribute to Helen Smailes, the curator at the National Gallery of Scotland charged with responsibility for the exhibition. She has been active on every front, including research, and her contribution to the final result has been enormous. Michael Clarke, Director of the National Gallery of Scotland, has been extremely supportive throughout, and we have benefited from his experience and wise advice. An exhibition is a large collaborative exercise, and many members of the National Galleries' staff have contributed skills and energy to the realisation of the exhibition, among them: Agnes Valencak-Kruger and Anne Buddle in registrars; Michael Gallagher, Donald Forbes, Keith Morrison and Lesley Stevenson in conservation; Charlotte Robertson and Sheila Scott in the curatorial department; Emma Nicholson in education; Janis Adams, Christine Thompson and David Simpson in publishing; Catrin Tilley, Frances Shepherd and Lucy Davidson in development; Patricia Convery in the press office; Martin Reynolds and Ross Perth in marketing; Sofia Bruce and Susan Colquhoun in retail; Alastair Patten, Angus Ferrans and the art handling team; and last but not least the warding staff.

I have received unstinting help and hospitality from many of the lenders to the exhibition, and I would like to extend my warmest thanks to all of them. I have benefited from the great knowledge and insight of my fellow contributor to the book, Professor Christopher Smout. The book, which accompanies the exhibition, has been designed by Robert Dalrymple and the index provided by Anne McCarthy.

My research has been aided by the expert staff at the London Library, the National Library of Scotland, the National Portrait Gallery Library and Archive, the National Art Library at the Victoria & Albert Museum, and the Witt Library. I would also like to thank the following who have helped to make the exhibition happen in all kinds of different ways: the Duke of Abercorn; Jane Anderson, archivist at Blair Castle; Claire Baxter, curator at Alnwick Castle; the Duke of Bedford; Martin Beisly, Christies; Alice Bircher, Royal Collection Trust; Dr Chris Brickley, Bonhams; Richard Burns, Bury Art Gallery and Museum; Julius Bryant, formerly English Heritage; Jessica Copcutt; Alan Cowie, Robert Holden Ltd; Simon Dickinson; Pam Goodman, Local Studies Library, Rochdale; Chris Gravett, curator at Woburn Abbey; Martyn and Penelope Gregory; Ruth Hampton, Tate; James Holloway, Scottish National Portrait Gallery; Dr Juliet Horsley, Sunderland Museum and Art Gallery; Mark Jones, Victoria & Albert Museum; Susanna Kerr, Scottish National Portrait Gallery; Briony Llewellyn; Alastair Laing, National Trust; Christopher Lloyd, The Royal Collection; Rupert Maas; Jennifer Melville, Aberdeen Art Gallery; Julie Milne, Laing Art Gallery, Newcastle upon Tyne; Jacquie Moore, Office of Public Works, Dublin; David Moore Gwyn, Sothebys; John Morton Morris, Hazlitt, Gooden & Fox; Theresa-Mary Morton, Royal Collection Trust; Hugo Nathan, Simon C. Dickinson Ltd; Karshali Patel, Birmingham Museums and Art Gallery; Dr Edgar Peters Bowron, Museum of Fine Arts, Houston; Hon. Jane Roberts, Royal Collection Trust; Anthony Spink; Lyn Steven Wall, National Museums of Scotland; Catherine Wills; and Alison Winter, Hazlitt, Gooden & Fox.

RICHARD ORMOND

[1] Localities associated with Landseer

Map © Wendy Price Cartographic Services, Scotland IV1 3XQ

Digital elevation modelling by Geo-Innovations 01492 878023

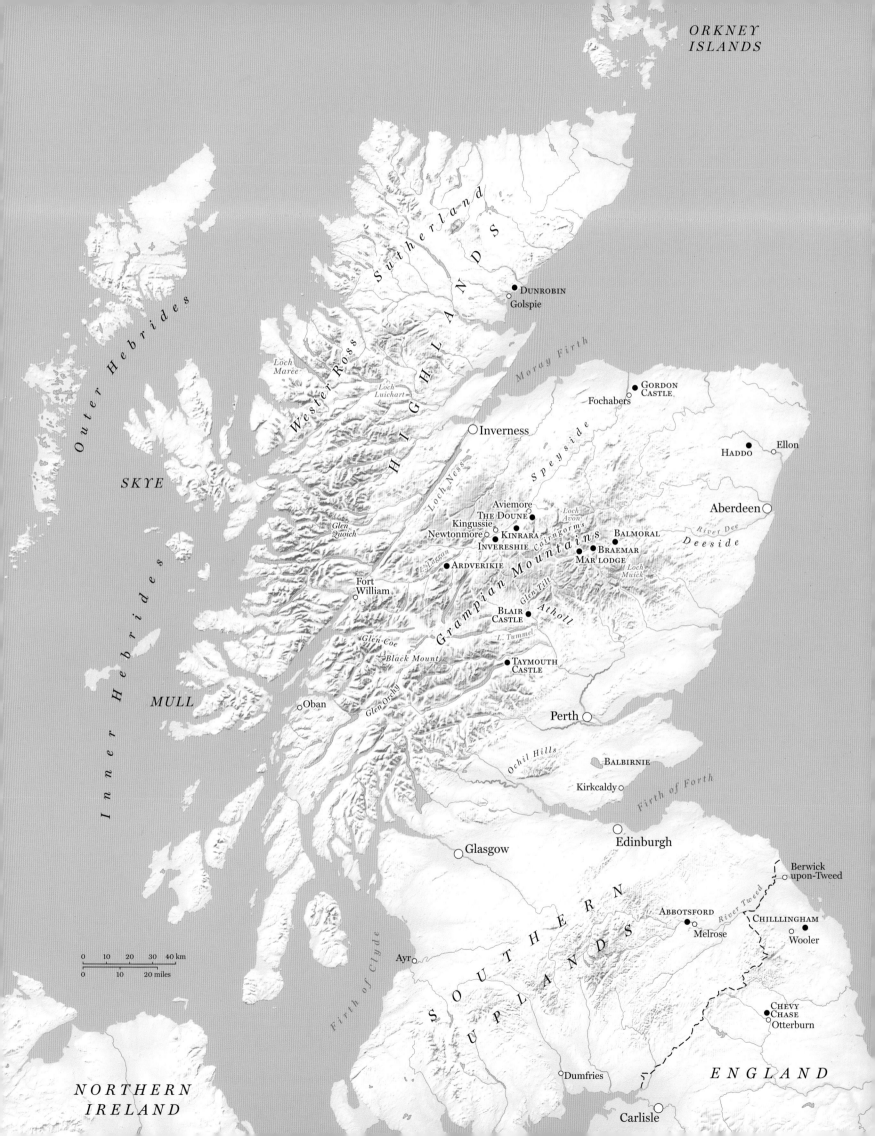

ORKNEY
ISLANDS

Outer Hebrides

Sutherland

HIGHLANDS

*Loch
Maree*

*Loch
Luichart*

Wester Ross

● DUNROBIN
Golspie

Moray Firth

● GORDON
CASTLE
Fochabers

○ Inverness

Loch Ness

Speyside

SKYE

*Glen
Quoich*

Aviemore
THE DOUNE ●
Kingussie *Loch
Avon*
Newtonmore ● KINRARA
INVERESHIE
ARDVERIKIE ●
L. Laggan *Cairngorms*

○ Aberdeen

HADDO ● ● Ellon

River Dee

Deeside

● BALMORAL
● MAR lodge ● BRAEMAR
*Loch
Muick*

Fort
William

Grampian Mountains

BLAIR
CASTLE ●
Glen Tilt
Atholl
L. Tummel

Glen Coe

Black Mount

TAYMOUTH ●
CASTLE

Inner Hebrides

MULL

○ Oban

Glen Orchy

○ Perth

Ochil Hills

BALBIRNIE ●

Kirkcaldy ○

Firth of Forth

○ Edinburgh

○ Glasgow

SOUTHERN

Berwick
upon-Tweed ○

ABBOTSFORD ●
Melrose ○

River Tweed

CHILLLINGHAM ○
Wooler ○

0 10 20 30 40 km
0 10 20 miles

Ayr ○

UPLANDS

CHEVY
● CHASE
Otterburn ○

Firth of Clyde

Dumfries ○

ENGLAND

NORTHERN
IRELAND

Carlisle ○

LANDSEER'S HIGHLANDS

T. C. SMOUT

Landseer's first Highland jaunt was in 1824: he completed his last notable Scottish paintings in the early 1860s. The dates span a period, in the Highlands, of deepening crisis. The coming of the Lowland sheep-farmer to the southern Highlands in the later eighteenth century and to the far north and west of that region in the early nineteenth century, had resulted in the clearing of thousands of poor tenants from their holdings and their concentration into very small crofts. At the same time a steep rise in human population resulted in severe rural overcrowding; then the crofters' occupations of fishing, kelping and raising black cattle collapsed early in the nineteenth century. The staple of life on the congested shores and glens became the potato, but in 1846 the same blight that brought death and devastation to Ireland in the Great Famine, destroyed the crops in the western Highlands. Because charitable and government relief was more generous, easier to distribute and more effective, mortality was never on anything like the same scale as in Ireland. Nevertheless, it was a turning point. Thereafter emigration and, in the short term, eviction, increased. The rural economy was gradually and painfully rebuilt round a smaller, less vulnerable population.

In 1851, Landseer, at the height of his reputation as a painter of the Scottish Highlands, completed his iconic masterpiece, the *Monarch of the Glen* [plate 132] for the refreshment room of the House of Lords. In the same year Sir John McNeill reported officially to Parliament on the condition of the crofting population after five years of famine, concluding that though the crofters were a people of many noble traits of character, most had no future in their own homeland. They should be encouraged to leave in large numbers, as humanely as possible. Between 1848 and 1853, Queen Victoria and the

Prince Consort first leased and then built for themselves a new holiday home in splendid baronial style at Balmoral in Deeside, marking the moment when the post-Union British monarchy first put down a root of Scottish residency. Landseer and the Queen together helped to construct a new image of the Scottish Highlands, one far removed from the realities of rural crisis and economic collapse, a fusion of bloodsports and wild romance. They did not by themselves create what has come to be called 'Balmorality', but along with Sir Walter Scott they contrived its most compelling and enduring icons, still at the heart of the popular image of Scotland. The other artist who also did much to form this image was Horatio McCulloch (1805–1867), who had much less commercial acumen than Landseer, and was less of an international star, but whose landscapes were even more empty – a sweep of ruined castles under lowering skies, wide moors and gloomy lochs with Highland cattle. He influenced many other landscape artists of the late nineteenth century, good and bad, from Peter Graham to the two Breanskis and beyond. Theirs is the image of Scotland that is perpetuated on innumerable tourist brochures and biscuit tins.

The ironies are heavy, but to consider the Highlands without its problems was not so much wilful fantasy on the part of Landseer and McCulloch as selective vision, much like today considering Africa as a destination for wildlife tours and not dwelling on its disease and poverty. Landseer could depict poverty and cruelty without flinching, though the poverty shown in his scenes of Highland life has no obvious cause in injustice, and the cruelty is of man to animal, or of animal to animal, not of man to man. These were, literally, not Landseer's business. Being a close friend of many of the owners and lessees of

< Detail from plate 26

sporting estates, and a sportsman himself obsessed by the thrills of the chase in a way few artists had ever been before, he celebrated what they and he loved, and what his clients wished to see on their walls. For this he has been criticised as the stooge of a system that used his recreational images to avoid considering the realities of injustice and exploitation.

There is something in this, but the Highlands which he knew best personally were not those where the dramatic scenes of contemporary dispossession and social collapse were most evident. He did not stray much into the far north beyond painting Dunrobin Castle at Golspie and around Brahan Castle near Dingwall. His Highlands, like those of the Queen, were mainly in the centre, on the estates of Breadalbane and Atholl in Perthshire and in Speyside and Deeside in the Cairngorms. Ardverikie on Loch Laggan was another forest where he was welcomed as a frequent guest, and where he left murals later destroyed by fire. He also visited Glenquoich, the home of the Ellice family near Invergarry, and he famously painted an exhausted stag that had found refuge on an island in Loch Maree. That was as far west as he got. He never visited Skye or the Outer Hebrides or strayed into the congested districts of Wester Ross or the Argyll islands. Breadalbane, Atholl and the Cairngorms, the districts that Landseer frequented most, were undeniably poor: the condition of the tenants on Rothiemurchus in 1846, for example, was unfavourably compared, by the married daughter of the former laird, to those on her estate in one of the less deprived districts of Ireland. These parts of the Highlands had also suffered from clearances, including many of the earliest in the eighteenth century, some being to improve the sporting opportunities in the deer forests, others to accommodate the first of the new sheep-farmers. In the nineteenth century the latter declined but the former increased. Evictions for sporting purposes were not uncommon in the Victorian period, for example at Balmoral in 1848 and at Abernethy in 1869, but they were generally on a smaller scale and sometimes with offers of restitution. It was said (though admittedly not by the crofting tenants themselves) that the inhabitants of Glen Gelder on the Balmoral estate 'gladly forsook their holdings' when the Prince Consort offered them employment on the estate 'with comfortable houses and an assured livelihood'. Frequently one of the relatively new sheep-farmers was himself the recipient of such an offer he could not refuse, in which case, in the words of the contemporary Glasgow journalist and radical critic of the deer forests, Robert Somers, 'it gives him little trouble to remove from one part of the country to another … while his few shepherds merge into the foresters with pretty much the same ease. Hence the clearance of a sheep-farm is a much quieter proceeding than the clearance of a township.'

Be that as it may, the demographic history of the Cairngorms area was in complete contrast to the better known history of the western Highlands, often taken to typify the Highlands as a whole. In the Outer Hebrides and on Mull, for example, population in the second half of the eighteenth century rose by sixty per cent, in mainland Wester Ross by almost half. Contrastingly, in the parishes of the central Grampians population fell by fourteen per cent and in Upper Deeside by about a quarter. In the first four decades of the nineteenth century, the average increase of population was nine per cent per decade in the western districts, in the central Grampians less than half that, and in upper Deeside there was no increase at all.

Similarly, the history of landownership was less tumultuous. In the west, with collapsing estate rentals and growing obligations, some seventy per cent of the territory of the islands and mainland coastal parishes in Argyll, Inverness and Ross had changed hands, by the last quarter of the nineteenth century, mainly to rich industrial or commercial commoners from England or the Lowlands. In the centre, old families also had debts and some sold at least part of their patrimony (like the Duke of Gordon) or temporarily fled abroad to escape their creditors (like Grant of Rothiemurchus), and there were some new names among the old. But more somehow stayed on, and a sense of mutual obligation of the rich to the poor and the poor to the rich, survived more easily. In the 1880s the government's Napier Commission, set up to investigate Highland discontents, found less friction, the radical Crofters' Party made less headway, extreme forms of Presbyterian dissent were less obvious, and Parliament felt it was appropriate to leave these districts out of the corpus of legislation designed to protect poor crofting tenants.

All these were signs that, in Landseer's day, population and resources in the Cairngorms were in a better balance than in the north and west. An economy had emerged over the previous century in this part of the Highlands, with its own hardships, but less prone to crisis and collapse. Potatoes had never completely replaced oatmeal as the main staple of life, although at the time of the famine there was a need for some relief and a certain response by emigration: a hundred people left Kingussie for Australia, for example, and the Central Board for relief gave £150 to the small tenants of Newtonmore. But overall the situation was more robust. Deer stalking and deer forests were less unfamiliar, and in the post-Napoleonic period quickly became a mainstay of economic and social life in these districts. They could be seen locally as providers of employment rather than as a diversion of resources from man to wild beast. More of the old landed families continued to live in their castles than was the case in the west, or, if they hired them out or let their forests, they were seen to bring in wealthy outsiders to spend summer money in the glens. The economy of the area in some other respects was rather old fashioned, with droving and illicit whisky distilling continuing at some level of activity. What Landseer painted in his social pictures of interiors and farming life, was in many ways realistic, despite its overtones of sentimentality and drama – a very poor society, traditional, but not smashed or cowed by misfortune. There is not in fact a great distance between Somers's description of the poverty of a village like Newtonmore, where 'the propertyless, the dependent, and the wretched of the parish are gathered', and Landseer's pictures of interiors almost bereft of furniture and creature comforts (apart from the inevitable dog).

What brought the artist fame and wealth, however, was not celebrating archaic peasant pursuits or the deserving poor at home, but two aspects of the modern that he had the good fortune and intelligence to put together. One was the rise of the romantic, which went back to James Macpherson's publication (1760–3) of the poems of Ossian. These he claimed to have translated from original Gaelic manuscripts that he could never produce, but many contemporaries took them to be genuine. Not only Scotland but Europe as a whole was swept off its feet by his depiction of a Homeric Highland past full of wild heroes declaiming in the mist. It quickly became allied to another fashionable cult, for the sublime landscape that by its wildness and scale uplifted the human soul, and then generalised into a vision of the Highlands as a place of inspiring beauty, simple people and a picturesque past. The romantic idea grew by feasting on impressionable travellers like Wordsworth and native bards like Byron, and matured in Scott's *Rob Roy* and *The Lady of the Lake*. By the early Victorian years tourists were coming every year in their thousands to experience the *frisson* of wild scenes and imagined history. The other factor was the transformation of the old aristocratic deer forest into the modern sporting estate, made possible by a concatenation of recent circumstances. Firstly, modern transport, by coach, by steamboat and finally by train, made the central and southern Highlands readily accessible. Next, modern rifles and cartridges had been invented, greatly improving the chance of shooting a deer or a grouse even by an inexperienced man; an incidental effect was the extraordinary increase in 'vermin' destruction, including that of eagles, kites and ospreys. Then the financial problems of an overstretched aristocracy led to a lively market in houses and sporting lets.

Renting land to a shooting tenant began around 1812, when the Duke of Gordon advertised the forest of Glenfeshie in *The Times*: the number of Scottish deer forests, in 1811 reckoned at only six where the deer were actively preserved, had reached eighteen by 1825 and forty by 1842. Somers ironically portrayed the central Highlands as a place where 'the Nimrods of England and half the world have made a desperate rally'. The gentry and aristocracy of the south, having seen their privileges falling one by one 'by the blows of public opinion', and their parks and game preserves 'invaded and ruined by the rise of towns, factories, railways and similar democratic nuisances', had retreated, he said, into the Grampians like the Picts before the Romans, wasting the earth before them:

Houses, roads, enclosures, cattle, men – every work of time and progress – the valuable creations of labour and the slow changes of centuries – are all extirpated by a word, in order that deer may enjoy the luxury of solitude, and sportsman monopolise the pleasures of the chase.

His hostility was that of an urban radical wielding the power of the pen against the landed classes, and the English invasion was only in summer, not a permanent occupation, but he correctly identified what was happening. Of course, even in the eighteenth century, shooting deer, grouse and other game had already been popular with the local gentry, and there had long existed the genre of sporting pictures where the women and children of the family came together to admire the dominant shooting male and his haul of game. David Allan's portrait of the Atholl family in Blair Castle [plate 41], for example, prefigures several such scenes by Landseer and indeed shows the same duke who appeared much later in life as the central figure in Landseer's *Death of the Stag* [plate 37]. But by the 1820s Highland sport had become a pleasure, even an obsession, for the British élite as a whole. English peers like the Duke of Bedford and the Duke of Leeds, untitled English members of parliament, fashionable parsons and successful industrialists seeking to associate with the landed classes, the royal family and Landseer himself, could join the Duke of Gordon, the Duke of Atholl, or the Marquess of Breadalbane on their native heaths, or hire or buy patches of the heath for themselves. The pleasure was not merely in the hunt, but also in the socialising and net-working between the great and the merely aspiring. After Landseer died and Victoria aged, the enthusiasm still grew. By 1895 there were 137 forests covering more than three million acres of Highland Scotland. In 1921, Lloyd George called the only cabinet meeting ever to have been held outside London, in the council chamber of Inverness, because virtually the entire cabinet was away shooting in the north.

Landseer himself was not merely brought in as a competent artist to paint all this. He participated obsessively himself, trusted to disembowel a stag properly and respected enough to provide references for a stalker anxious to move to another employer. The head stalker of the Breadalbane estate once described him as a 'nice wee mannie' who 'carried a braw rifle', but, in Hart-Davis's words, 'his artistic sense was always stronger than his blood-lust'. The future Earl of Tankerville thought he had caught a poacher when he came upon a Puck-like figure gralloching a deer on the hillside. The stranger disembowelled the deer with 'great quickness and dexterity' and 'next let the head hang down so as to display the horns', then appeared to reach for his whisky flask; Tankerville was about to pounce, when the poacher brought out his sketch-book and 'I found myself face-to-face with my friend for many years to come – Landseer'. Through his close friendship with the Duchess of Bedford, despite the whiffs of scandal, he had instant access to the highest social circles, and when he gained royal patronage his influence and success was totally assured.

From an inside position, therefore, he painted the aristocracy and their prey, with a supporting cast of Highlanders as keepers, ghillies and servants, celebrating the hunt as David Allan had done before, but now for a larger market because inclusive of more customers. Moreover, it was not, like fox-hunting art in England, merely celebrating the bucolic. Because Landseer's Highlands were romantic, his pictures were implicitly infused with an altogether nobler and more symbolic atmosphere.

Landseer took all this a step further when he began to paint animals without the hunters, seen pursuing their own fights and striking their own postures, as it were for themselves alone, the hunter only there by implication, a peeping Tom at the eyepiece of a sporting telescope. Now the romanticism of the swirling mist and towering crags was fully unleashed, as a splendid backdrop to the animals. The stags enjoy their dominance, roar out their male belligerence, aristocrats of nature, their realm the imagined wilderness. It is this last set of images, of animals in their own right, not portrayed only as game with lolling tongues under the sportsman's leg, that are particularly iconic today. Those in charge of the Scottish tourist industry can use *The Monarch of the Glen* on their websites, but would have problems with the impaled beast writhing on a spear in *The Otter Hunt* [plate 134].

That Landseer was so admired by Queen Victoria is not surprising. She thrived on the romance of the Highlands, its wildness, beauty, safety and privacy; she adored her sportsman husband, admired his skill with a gun, and she appreciated her Highland servants for a certain lack of obsequiousness combined with complete competence. Landseer captured all these things, not least the last, including those formidable head stalkers who with grim courtesy taught their employees and their guests how to behave

in the field, to avoid too frequent a fiasco.

That Landseer should capture the hearts of so many of Victoria's art-loving subjects is on the face of it more surprising, but he managed to do so through the manufacture and distribution of very large numbers of prints. While he could hardly fail in selling originals of sportsmen and game to the aristocracy and their friends, his greater success with the wider public was with images of Highlanders themselves, and above all with images of animals without the people, those prints found so often in boarding houses and hotels throughout the Highlands, speaking to their guests of the inutterably romantic sur-roundings in which they had chosen to stay.

Victorians praised Landseer for his realism in portraying people, beast and place, yet his mountains are bathed in a wonderful unreality, scenes that one might aspire to see but never will. Moderns blame him for ignoring the bitter truths of Highland life, and glamourising the wild and empty, yet his paintings of people are not so unrelated to historical context as generally supposed. His art was a response to a business opportunity, but rooted in an experienced mood and place. If we cannot altogether rid our collective minds of his images, that is his talent, not his fault.

1 · SIR WALTER SCOTT AND HISTORY

NOTE
In the captions, an asterisk *
denotes works in the
exhibition. Dimensions are
given in centimetres, height
before width.

Landseer was twenty-two when he first visited Scotland in the autumn of 1824. He was already an established animal painter, with several exhibition successes behind him and his reputation was growing.[1] What impressed Landseer's aristocratic patrons was his power of composition and his gift for narrative, as well as his ability to portray animals 'to the life'. The scope and quality of his art reminded people of the Flemish sporting artists of the seventeenth century and he was more than once described as the 'English Snyders'.[2]

Edwin Landseer had been born on 7 March 1802 at 88 Queen Anne Street East, Marylebone, London, the youngest of three sons and the fourth of seven surviving children born to John Landseer (1769–1852), an engraver and author, and his wife Jane, née Potts (1773/4–1840).[3] Small, good-looking and always passing for younger than his years, Landseer grew up in an artistic environment. His father, a frustrated engraver, a polemicist for his profession and an eccentric antiquarian, harboured ambitions for his children. The two eldest, Thomas (Tom) (1798–1880) and Charles (1800–79), both became artists, the first a prolific engraver, the second a painter, and two of his daughters, Jessica (b.1807) and Emma (1809–95), practised as miniaturists. No evidence of Edwin Landseer's schooling survives, but from his earliest years his father took him out sketching in the fields abounding the Finchley Road. His earliest drawings, dating from the age of four or five and lovingly preserved by his father,[4] are mostly of farm animals, but he also studied lions and tigers at Mr Cross's Menagerie at the Exeter 'Change in the Strand in company with his boyhood friend and neighbour, John Frederick Lewis (1895–76). Lewis was the son of another engraver, F.C. Lewis, sen. (1779–1856), and his early sporting

pictures and Highland interiors [see plate 59] follow the same track as those by Landseer. Lewis might have become a serious rival had he not switched direction in the early 1830s to take up the Spanish and oriental themes for which he is famous. His two brothers, F.C. Lewis, jun. (1813–75), and C.G. Lewis (1808–80) both became engravers, the latter producing several prints after Landseer's paintings.[5]

In 1815, at the age of eleven, Landseer won the silver palette from the Society of Arts for his drawing of a spaniel, and two years later he showed his first works at the Royal Academy of Arts as an honorary exhibitor because of his age. In the same year, he and his brother began studying with Benjamin Robert Haydon (1786–1846), the champion of high art and the author of a remarkable diary, whose struggles to establish himself as a history painter ended in suicide. Haydon not only encouraged Landseer to dissect animals and study their anatomy, but trained him in the principles of large-scale composition and stimulated his imagination. He also introduced him to his circle of literary friends, including William Hazlitt, John Keats and Leigh Hunt. In 1816 Landseer was admitted to the Royal Academy Schools to complete his artistic training, becoming a favourite of the Keeper, Johann Fuseli, a master of romantic art, who called him 'my little *dog boy*'.[6] By 1817 he was a regular contributor to the Royal Academy and other exhibitions, and his work sold well. By 1825 he was sufficiently wealthy to lease his own property, a small house at 1 (later 18) St John's Wood Road on the west side of Regent's Park. Much altered and expanded over the years, this would remain his home for the rest of his life. His success was sealed by his election as an associate of the Royal Academy in 1826 at the early age of twenty-four.

< Detail from plate 5

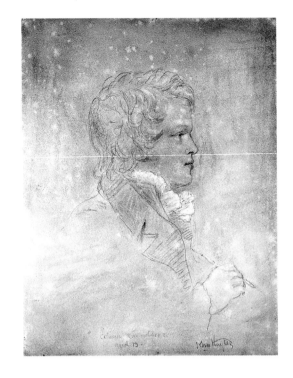

We do not know what prompted Landseer's first visit to Scotland, but he had invitations to stay with the Duke of Atholl, and with the Duke and Duchess of Bedford, who had taken Forest Lodge for the season on the Duke of Atholl's estate.

In August 1824, Landseer took ship for Edinburgh in company with his friend and fellow artist, Charles Robert Leslie (1794–1859), the American-born genre painter and close friend of John Constable. During the sea journey, Landseer suffered so acutely from sea-sickness that he was obliged to disembark at Scarborough and continue his journey by road.[7] By early September he was at Blair Atholl, staying in the picturesque castle of the Duke of Atholl (1755–1830), in order 'to obtain some studies of deer'.[8] Landseer would visit Blair Atholl again in 1825 and 1826, and it must have been in one of those years that the Duke commissioned the sporting group of himself, his grandson and keepers, *The Death of the Stag in Glen Tilt* [plate 37], on which the artist laboured for another three or four years (for a description of the picture, see pp.46–8). Landseer also spent time with the Bedfords, painting pictures of their children, including an equestrian portrait of Lord Cosmo Russell and a charming picnic scene of Russell children on the banks of the River Tilt, both dated 1824 [plates 30, 32; see pp.42–3 for descriptions]. Either then or in the following year, the Duke of Bedford commissioned *The Hunting of Chevy Chase* [plate 10], the historical companion piece to the Atholl sporting group.

Exposure to the Highlands overwhelmed Landseer. He was intoxicated by the scenery, the sport, the picturesque inhabitants and the romance and tradition of Highland culture. In 1825, he would write to the miniaturist William (later Sir William) Ross:

I have not time at present to give you my adventures, only that I have been further north this season and am a little crazy with the beauties of the Highlands – and have been working very hard at painting, Deer and Grouse Shootings &c &c have been my amusements. My career is now nearly over with the acceptance of three or four visits I have to pay – after I leave the Marquess of Huntly [later Duke of Gordon] *who I am going to revisit my movements will be south … when you write to me enclose your letter to the Duke of Atholl who is a fine old Chieftain - but very little else, and particularly kind to me - the Duchess is really quite a mother.*[9]

The Highlands were a playground for the artist, where he could enjoy himself with fellow sportsmen in hunting lodges, and a laboratory for serious study. Scenes of Highland sport and life would become the source of new subject matter and a substantial part of his artistic output.

It was apposite that Landseer's first visit to Scotland should end at Abbotsford, the antiquarian, neo-Gothic home of the novelist Sir Walter Scott (1771–1832) in the Scottish Borders. C.R. Leslie records spending a week with Landseer in Edinburgh in early October before Scott came up to whisk the painter back to Abbotsford, 'where I am sure', Leslie wrote, 'he will make himself very popular both with the master and mistress of the home, by sketching their doggies for them.'[10] No one had done more to popularise the Highlands than Scott and to create that romantic vision of ancient castles, warlike clans, stern traditions, picturesque tartans and distinctive dialect. That sense of the Highlands which we still have today of a place apart, wild, remote, sublime and exotic, was articulated by Scott in his stories and ballads. His evocation of the romantic past with its feudal ties and codes of honour brought Scottish history to life for a European audience. That Highland traditions were backward-looking and conservative and could never hope to prevail against the more developed and progressive

forms of society to the south did not make them any the less attractive.

Abbotsford was a magnet for visitors to Scotland, and for artists in particular, and Scott was in consequence much painted. To a friend he confided in October 1824:

Since that time [1803] *my block has been traced by many a brush of eminence and at this very now while I am writing to you Mr. Landseer who has drawn every dog in the House but myself is at work upon me under all the disadvantages which my employment puts him to. He has drawn old Maida in particular with much spirit indeed and it is odd that though I sincerely wish old Mai had been younger I never thought of using the same advantage for myself.*[11]

As well as drawing Scott repeatedly, Landseer also painted two oil sketches of him, which the present author believes were painted at this time. The first, in the National Portrait Gallery, London, shows him as man of letters, pausing in the act of writing, quill in hand, keen-eyed and thoughtful; it might be the portrait described by Scott in the letter quoted above. The second [plate 3] depicts him dressed for outdoors, with a maud or Lowland plaid over his shoulder, resting his right arm on the cushion of a tomb effigy of a knight in armour, seen head-on in perspective. The forward thrust of Scott's head accentuates the roundness and ruggedness of his features. Lady Shelley described his appearance in 1815 as unprepossessing: 'A club-foot, white eyelashes and a clumsy figure. He has not any expression when his face is in repose; but upon an instant, some remark will light up his whole countenance, and you discover a man of genius.'[12]

From the two oil sketches, and a preliminary sketch for the composition (collection of the Duke of Buccleuch, Bowhill), Landseer constructed his epic portrait of *Sir Walter Scott in Rhymer's Glen* [plate 4], one of the great literary images of the early nineteenth century, as a posthumous tribute to the author who had died in 1832. Rhymer's Glen had become celebrated as the place where true Thomas the minstrel had met the queen of the fairies in one of Scott's best known ballads. Scott loved to walk to the glen where, according to C.R. Leslie, he had a favourite resting place on a natural seat beside some little waterfalls. In 1824, Scott had encouraged Leslie to paint him there, which the artist declined to do, but it is likely that Landseer had heard of the suggestion and later adopted it for his own picture. His portrait of Scott captures the intellectual force of the writer in the powerful set of the head and the visionary gaze, and gives us an image of the rustic seer at one with the wild scenery he celebrates. Scott is dressed in the maud of a Lowland shepherd and accompanied by his faithful dogs – the spritely Dandie Dinmont terriers Ginger and Spice and the aged deerhound Maida stretched out between his feet. Scott's biographer and son-in-law, John Gibson Lockhart, considered the portrait 'beautiful' and 'almost as valuable as if he [Scott] had sat for it'.[13] Others were more ambivalent. When reviewing the portrait at the Royal Academy of 1833, the critic of *The Examiner* called it 'a faithful likeness' but unprepossessing: 'The forehead is very lofty: there is an expression bordering upon cunning in the eyes and of harshness not untouched with fierceness in the mouth, which is anything but agreeable.'[14]

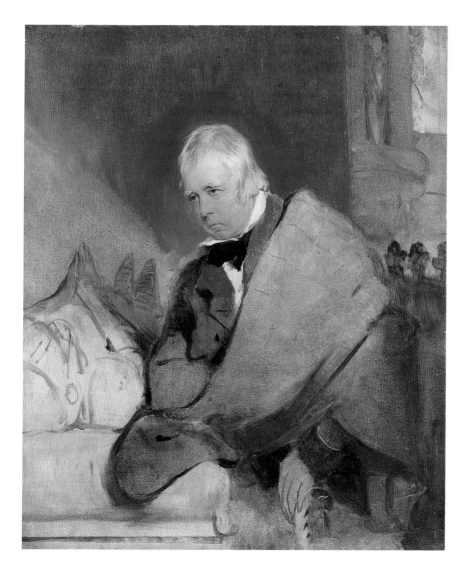

[3] *Sir Walter Scott*, *c*.1824 *

Oil on canvas, 61 × 51
National Museums Liverpool
(The Walker)

This was echoed in the *Athenaeum*, which saw Scott as 'a clouterly ploughman everywhere save the head, which is bare, and inclined forward; his eyes look as if they saw what no other eyes could see. There is great merit in the work, but it is weak where it should be strong: it wants poetry:- the Scott of the Rhymer's Glen required to have His rapt soul sitting in his eyes'.[15]

During his stay at Abbotsford, Landseer not only sketched Scott but painted pictures of his dogs, which occupied a prominent place in the household. According to C.R. Leslie, Scott never went out unless accompanied by at least two dogs, of which Maida 'a very venerable old deer-hound of gigantic size',[16] was pre-eminent. A cross between a Pyrenean sheep dog and a Scottish greyhound, Maida had been bred and given to Scott by the eccentric Highland chieftain, Macdonell of Glengarry, the prototype for the Highland chieftain, Fergus MacIvor, in Scott's novel, *Waverley*. Penning an affectionate portrait

of the dog to accompany an engraving of Landseer's picture, *A Scene at Abbotsford* [plate 5], published in *The Keepsake* for 1829, Scott wrote:

As Maida always attended his master when travelling, he was, when in a strange town, usually surrounded by a crowd of amateurs, whose curiosity he indulged with great patience until it began to be troublesome, when a single short bark gave warning that he must be urged no further ... He was as sagacious as he was high-spirited and beautiful, and had some odd habits peculiar to himself. One of the most whimsical was an aversion to artists of every description ... When Mr. Landseer saw Maida, he was in the last stage of weakness and debility, as the artist has admirably expressed in his fading eye and extenuated limbs. He died about six weeks afterwards ...[17]

Landseer's sketch of Maida from life is currently untraced, but it was etched by the artist in

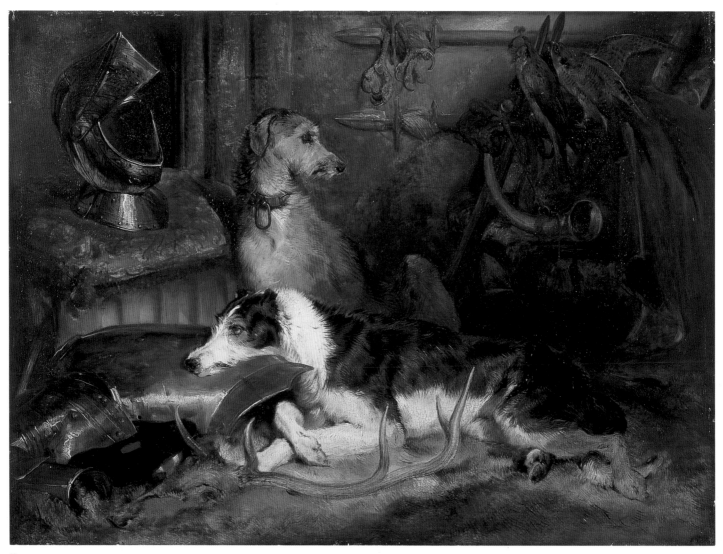

5

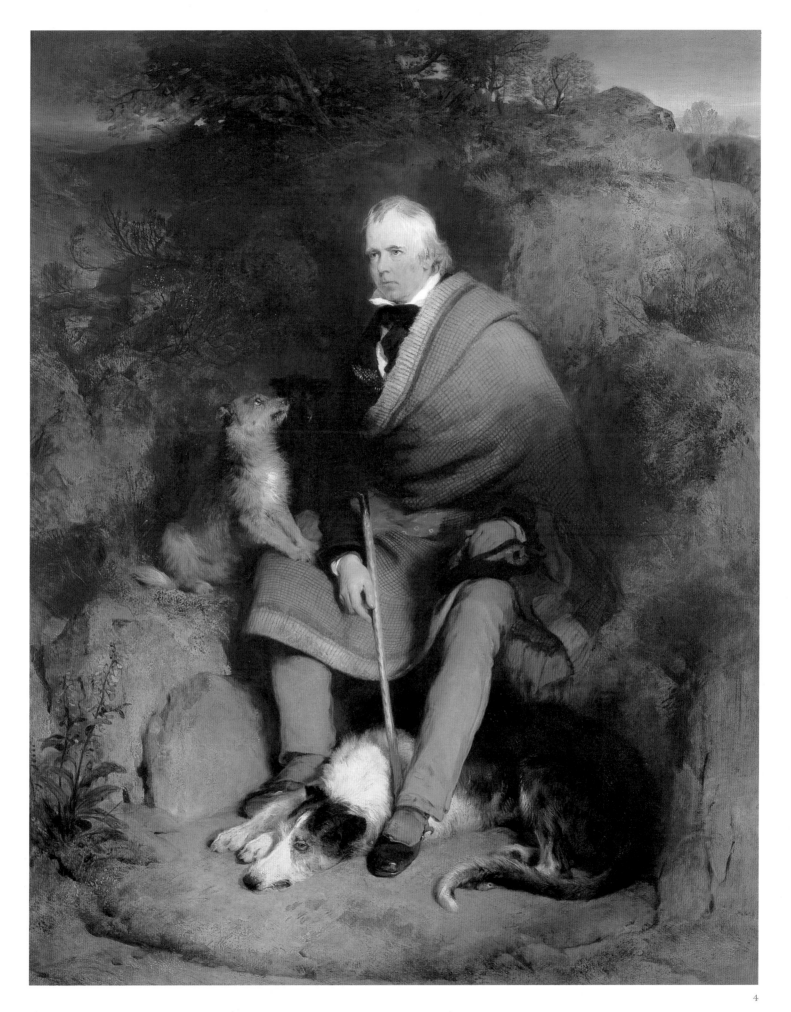

4

1824 and shows the hound forlornly prostrated beside its master's bonnet and stick, very much as shown in the Rhymer's Glen portrait. In *A Scene at Abbotsford* [plate 5], Maida is again represented in a state of lassitude lying on a deerskin rug incorporating the head and antlers of a stag and resting its head on a breastplate of Italian white armour. Scott wrote of the image that 'it would be difficult to point out a finer exemplification of age and its consequences acting upon an animal of such strength and beauty'.[18] The other dog is a deerhound given to the artist by the Duke of Atholl. The armours, spears, hawks and hunting paraphernalia evoke the chivalric atmosphere of Abbotsford, with its wealth of antiquities, but they were not, in fact, painted from objects in the house. The Duke of Bedford, who bought the picture in 1827, claimed that it had been begun in Scott's study 'some years ago, and has been finished this year … and the whole thing forms a sort of historical record as connected with so celebrated a writer'.[19] The Duke gave the picture to Scott's friend and admirer, William Adam of Blair Adam, who was Lord Chief Commissioner of the Jury Court of Scotland.

Landseer would exhibit one last reminiscence of Maida in 1858 which he called *Extract from a Journal whilst at Abbotsford* [plate 6]. In this picture Maida is made to appear even more senile and pathetic than usual, a mere bag of fur and bones with rheumy eyes and lolling tongue, enduring the attentions of a young puppy biting his tail – a play on the theme of 'Dignity and Impudence'. The torn envelope, another sign of the depredations of the puppy, is addressed to Sir Walter Scott from his publishers, Constable & Co. The picture is in close-up, and the boar spear shooting across the wall behind the dogs reminds us of the sporting traditions for which Maida had been bred.

6

Maida was not Scott's only dog to be the subject of a separate portrait. There is a delightful study of Ginger, the Dandie Dinmont that appears in the Rhymer's Glen portrait of Scott, which is still at Abbotsford. Another dog with Scott connections is the terrier in *Attachment* [plate 7], a picture inspired by a climbing accident in the Lake District. A young man, Charles Gough, had fallen off a cliff while climbing Helvellyn in 1805.[20] His body was discovered three months later still guarded by his faithful dog, and this affecting story has passed into Lake District lore. William Wordsworth and Sir Walter Scott together visited the spot where the young man had fallen, and both wrote poems about the incident. Landseer exhibited his picture in 1829 with a quotation from Scott's poem. It shows the young man recently fallen from the cliff (the body shows no signs of decomposition) with the terrier pawing at his chest as if to awaken him.

Landseer used Scottish settings for several of his portraits of dogs, like *Jocko with a Hedgehog* [plate 8]. The fox terrier waits tensely for the hedgehog to unfold so he can pounce and kill it. The vibrant white body of the dog, all muscle and action, is forcefully painted and its gleaming white fur stands out from the darkening landscape with brilliant effect. Landseer could never paint conventional sporting pictures; he needed incident and narrative to bring his animal subjects to life. Jocko belonged to Owen Williams, a Buckinghamshire landowner and member of parliament, and it is unlikely that the dog was ever in Scotland. The artist put in the Highland background to add spice to the picture.

There is no evidence that Landseer returned to Abbotsford, but he and Scott remained friends, occasionally met in Edinburgh and corresponded. Scott was an admirer of Landseer's animal pictures, writing of his visit to an exhibition at the Institution for the Encouragement of the Fine Arts in Edinburgh in February 1826 that 'Landseer's dogs were the most magnificent things I ever saw – leaping, and bounding, and grinning on the canvas'.[21] A year later he described the artist as 'one of the most striking masters of the modern school. His expression both in man and animals is capital. He showed us many sketches of smugglers, etc taken in the Highlands, all capital.'[22] When Scott was planning the Waverley edition of his novels,

7

8

which he called his Magnum Opus, he selected Landseer as one of the artists to illustrate it. The artist proved elusive, but he told an intermediary that he would do whatever Scott requested, so great was his reverence for the author, and, notoriously unpunctual as he was, he did deliver.[23]

Landseer's contribution to the edition consists of two frontispieces and vignette designs for five of the title-pages which were published between 1829 and 1832. The subjects were executed as oil sketches and engraved by a number of different artists. What latitude Landseer had in his choice of illustrations is unknown, but unsurprisingly they are almost all of scenes with animals and often dramatic in character: the wolf hound saving the infant Roland Graeme, the hero of the story, from drowning in *The Abbot*; the false herald being savaged by dogs in *The Antiquary*; and Ravenswood shooting dead a wild bull as it charges Lucy Ashton and her father, Sir William Ashton, in *The Bride of Lammermoor* [plate 9]. In this last novel, Ravenswood falls in love with Lucy, the daughter of the man who has dispossessed him of his property, with fatal consequences for them both. The bull in Landseer's illustration is one of the ancient breed of white Chillingham cattle, and the predecessor of another bull shot to save a life, commemorated in *The Death of the Wild Bull* [plate 42; for a description, see p.49].

There are oil sketches for two Scott subjects by Landseer, which may have been intended for the Waverley edition, but neither of which appears as an illustration. The first is a dark and dramatic picture of the hound wounded by an arrow which comes from *The Talisman* (private collection). The second shows the *Death of Elspeth Mucklebackit* in the arms of Edie Ochiltree (himself the subject of a title page by Landseer for the Waverley novels), watched by the antiquary, who gives his name to the novel, and by his nephew (private collection). The involved plot revolves around the love affair between Isabella Wardour and Lovel, who, unknown to everyone except Elspeth, is the son and heir of Lord Glenallan. There is one further Scott subject, a print of *Catherine Seyton* from *The Abbot*, which was engraved by C.G. Lewis in 1833 for a series of Scott's heroines published by Chapman and Hall.[24]

No verbal or written record of Landseer's response to Scott's writings has yet been discovered, but the imagery of his early work bears the stamp of Scott's influence. Like the writer, Landseer saw the Highlanders as products of their environment and history, and he draws them as sharply and indelibly as the writer does to characterize a society and a way of life forged in harsh and primitive conditions. *The Hunting of Chevy Chase* [plate 10] was Landseer's first historical work inspired by Scott, and it was set in the Borders, not the Highlands. Although the particular ballad on which it was based was first published by Thomas Percy in 1765 in his *Reliques of Ancient English Poetry*, it was Scott who had popularised the ballad form and given it a universal currency. The ballad tells the story of a hunting expedition in medieval times led by the English Earl Percy, who deliberately hunted across the lands of his Scottish rival, Earl Douglas. The result of this challenge was a battle in which both leaders and most of their men were killed. The picture was commissioned by the sixth Duke of Bedford, who was gathering together a group of contemporary history paintings for the gallery at Woburn Abbey. An advocate of history painting, the Duke was constantly urging Landseer to work on subjects of an elevated character. He followed the progress of this commission with unusual interest and made

known his views on the subject. In a letter of July 1825, he urged the artist not to mix the breeds of deer, but to have only red deer in preference to the fallow deer of the ballad because they were much 'finer subjects' for a picture: 'We must therefore have all the deer in your picture, of the red species, but we must give it some other name than "Chevy Chase". Persuaded as I am that this stag hunt will be one of the finest pictures in my collection I naturally feel a more than common anxiety about it and for your credit and fame wish it could be ready for Somerset House [location of the Royal Academy exhibition] next year, but that is now quite out of the question.'[25] Landseer put in the red deer, refused to change the title and, contrary to expectations, finished the picture in time for the 1826 Royal Academy.

In choosing to paint the violence of the hunt in preference to that of the battle, although the one prefigures the other, Landseer demonstrated the real focus of his interests. He was first and foremost an animal painter and the picture lives through the superbly realized groups of hunting dogs and dying deer that populate the foreground of his picture. Earl Percy on horseback in the centre prepares to deliver the *coup de grâce* to a stag brought down by the pack of hounds, two of which lie pinned beneath its head and antlers. The composition looks back to the great hunting pictures by Sir Peter Paul Rubens and Frans Snyders, and so does the technique of transparent glazes and vibrant colour. Landseer made a copy of the *Wolf and Fox Hunt* by Rubens probably around this date [plate 11], when it was in the collection of the banker, Alexander Baring, later first Baron Ashburton, whose son Landseer would later paint (private collection). The artist modelled his equestrian figures and retainers on the work of his famous predecessor, as well as the relationship of men to animals, and the dynamic of movement and drama. Landseer captured the spirit of the original Rubens in his preliminary oil sketch [plate 14], especially the figure of Earl Percy which became wooden in the finished painting. The mounted figure on the left of Landseer's large picture looks like a portrait of Rubens himself. From *The Staghunt* by Frans Snyders (Musées Royaux des Beaux-Arts, Brussells), a version of which he must have known, came the pose of both the foreground stag and the leaping hind in the middle distance. A more recent

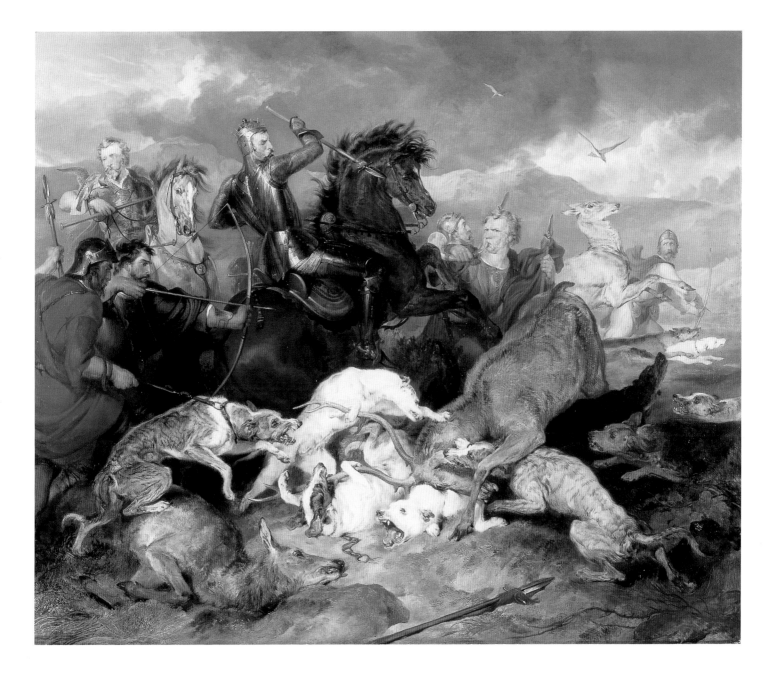

[10] *The Hunting of Chevy Chase*, 1825–6 *

Oil on canvas, 143 × 170.8
Birmingham Museums and Art Gallery

source of inspiration could have been Benjamin West's *Alexander III of Scotland Saved from the Fury of a Stag by the Intrepidity of Colin Fitzgerald* [plate 12], then owned by Lady Mary Stewart Mackenzie of Brahan Castle, daughter of Lord Seaforth who had originally commissioned it. Landseer was a regular visitor to Brahan Castle, and later painted *Rent Day in the Wilderness* [plate 26], commemorating the steadfastness of the Seaforth factor, Donald Murchison, after the 1715 Jacobite uprising. C.R. Leslie, with whom Landseer travelled to Scotland in 1824, had made a copy of West's picture in 1814 (Philadelphia Athenaeum), which Landseer may well have seen and admired. Benjamin West (1738–1820) had been an influential pioneer of history painting from the 1760s onwards, a past

president of the Royal Academy and an artist noted for his huge romantic 'machines', many of them painted for King George III. In an early oil sketch for *The Hunting of Chevy Chase* [plate 13], in which he worked out the central motif of stag and hounds, Landseer borrowed the figure of the huntsman almost verbatim from 'Colin Fitzgerald', as well as the atmosphere of high drama in West's painting [plate 12].

The Hunting of Chevy Chase was well received when it appeared in the 1826 Royal Academy exhibition [plate 10]. Calling it 'the most perfect picture, of its class, that has yet been seen in this country', the critic of *The Examiner* wrote of the artist that it required 'no prophet's vision to see the altitude to which he will soon attain'.[26] Yet in spite of such praise, and the urgings of his patron,

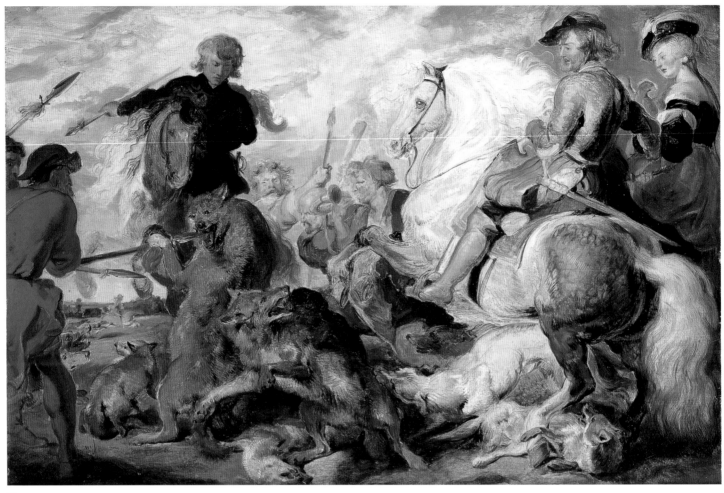

11

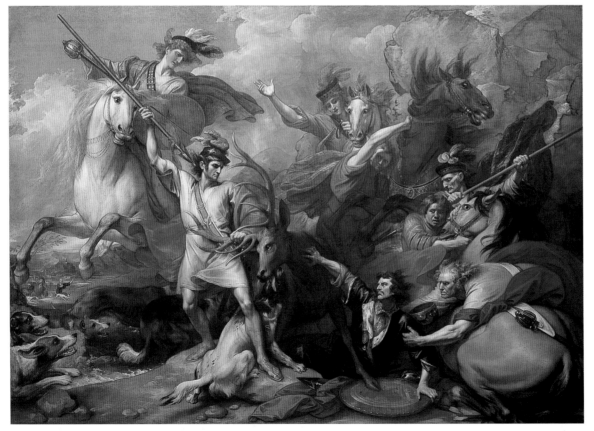

12

[11] *The Wolf and Fox Hunt, after Sir Peter Paul Rubens*, c.1825
Oil on board, 40.7 × 61
Private Collection

[12] *Alexander III of Scotland Saved from the Fury of a Stag, by the Intrepidity of Colin Fitzgerald* (also called *The Death of the Stag*) by Sir Benjamin West, 1786
Oil on canvas, 366 × 521
National Gallery of Scotland, Edinburgh

[13] *A Hunting Scene*, study for *The Hunting of Chevy Chase*, c.1825
Oil on canvas, 54.6 × 71.7
National Museums Liverpool (Sudley House)

[14] *Study for The Hunting of Chevy Chase*, c.1825 *
Oil on panel, 45.8 × 61
Private Collection

13

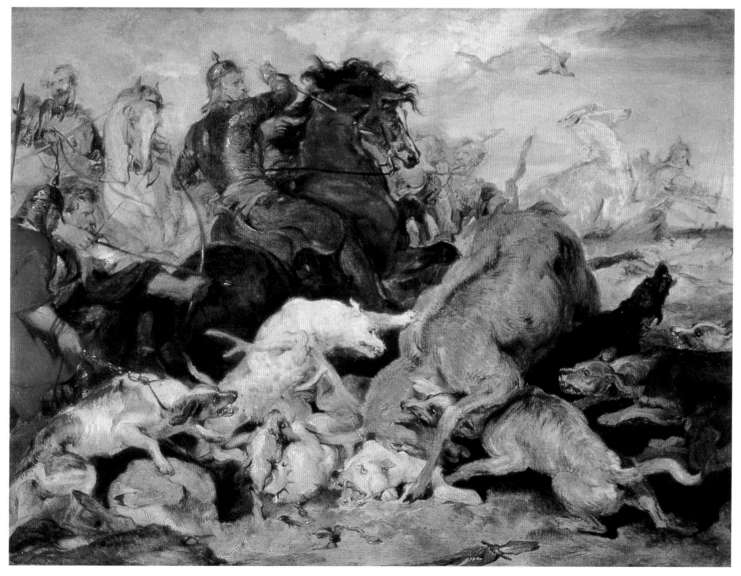

14

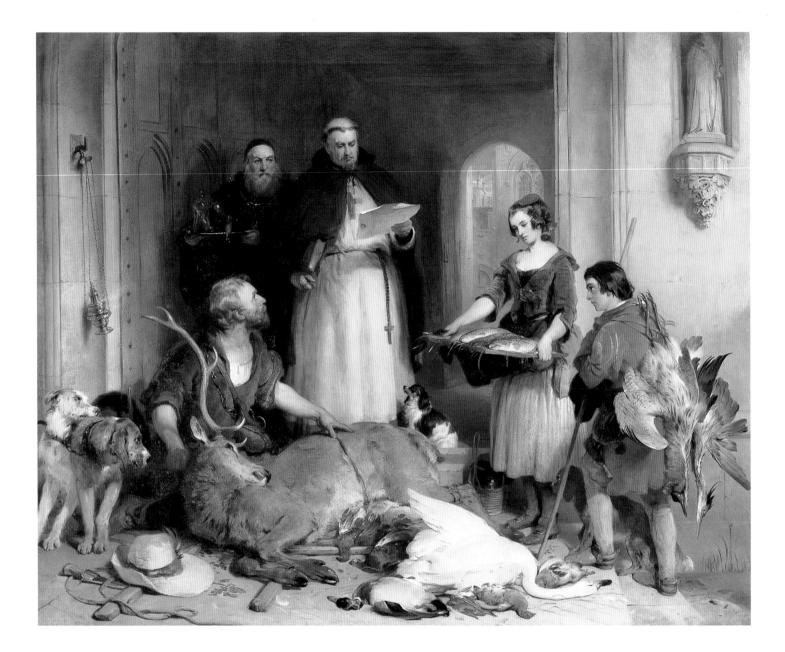

[15] *Bolton Abbey in the Olden Time, c.*1834
Oil on canvas, 155 × 193
The Devonshire Collection, Chatsworth

the Duke of Bedford, Landseer did not follow up the success of the picture with others of a similar character. There is an oil sketch showing the scene of carnage following the battle of Chevy Chase (*c.*1825–6, Sheffield City Art Galleries), but the artist took the composition no further.[27] However strongly the claims of history painting were pushed by the art establishment, the truth was that such art rarely paid. Not until the commissioning of murals for the rebuilt Houses of Parliament in the 1840s would any significant public investment be made in works of patriotic history. The lack of success enjoyed by Landseer's high-minded contemporaries like B.R. Haydon and William Hilton (1786–1839) was scarcely an inducement for him to follow in their tracks. But it was not just commercial considerations that held him back. The truth was

that he did not possess a strong historical imagination and he was not at ease with large-scale figure composition. In contrast to the wonderful vitality of his animals, the human figures in *The Hunting of Chevy Chase* fail to carry the same conviction. The figure of Earl Percy, in armour of mixed periods, is stagey and contrived, while his followers look like characters borrowed from Flemish painting and not real people painted from the life.

It would be a decade before Landseer attempted another such ambitious history painting and this time it was an English subject, *Bolton Abbey in the Olden Time* [plate 15]. Significantly, it was once again a commission, not a picture painted for sale. Landseer's patron was the sixth Duke of Devonshire (the 'bachelor Duke'), a hugely wealthy and highly cultivated aristocrat with a

passion for the arts.[28] The artist used the commission to create a vision of medieval monastic life and not, as requested, a portrait of the old abbey lying beside the banks of the Wharfe on the Duke's estate in the West Riding of Yorkshire. There is a play between the refined and secluded world of the abbey and the rustic simplicity of the foresters who have brought in the game as a form of tribute. There is a hint of satire in Landseer's characterization of the Augustinian abbot as a portly and worldly personage, accompanied by a pet spaniel and seemingly ticking off items on an inventory, but the scene is less about confrontation between opposing classes and more about a settled social order in which people understand and accept their place in the world. The Gothic Revival owed part of its popularity to the nostalgia that was felt for an age of faith and a unified social hierarchy. The concept of 'Merry old England' provided people with a comforting

and utopian ideal of a simpler and happier society in the past.

A picture of similar date, *Interior of a Castle Courtyard* [plate 16], shows a group of figures in Tudor costume, and it might be construed as the secular equivalent to the monasticism of Bolton Abbey. The imagery of the picture anticipates the lithographs of Tudor castles and mansions published by Joseph Nash (1808–78), such as his *Architecture of the Middle Ages* (1838) and *The Mansions of England in Olden Time* (1839–49), which did much to popularise the Gothic Revival. Surprisingly in view of its size and importance, Landseer's picture was never exhibited, and he may not have regarded it as a finished work, despite the existence of a preliminary oil sketch.[29] A young page boy kneels before a group of three figures offering a ceremonial knife on a velvet cushion to the lady of the castle. She is flanked by an older woman in ruff and

[16] *Interior of a Castle Courtyard* (also called *Bolton Court in Olden Time*), *c.*1834 *
Oil on canvas, 101.6 × 127
Sunderland Museum and Art Gallery

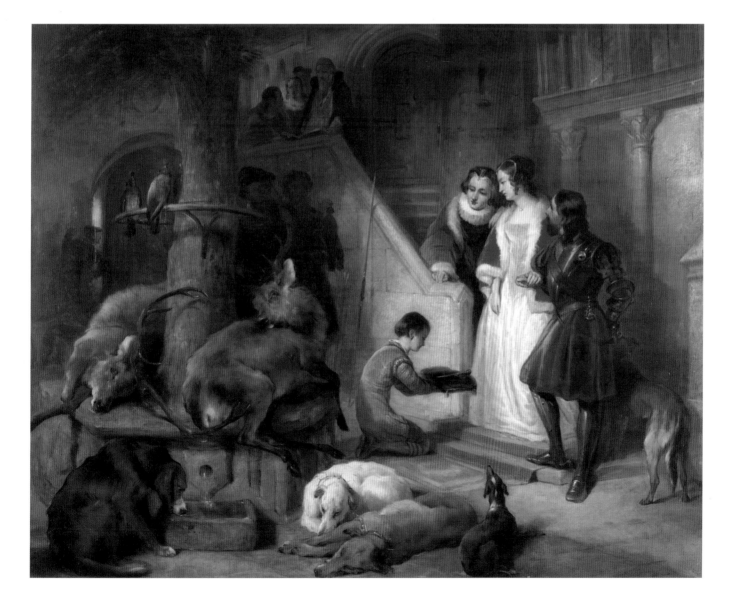

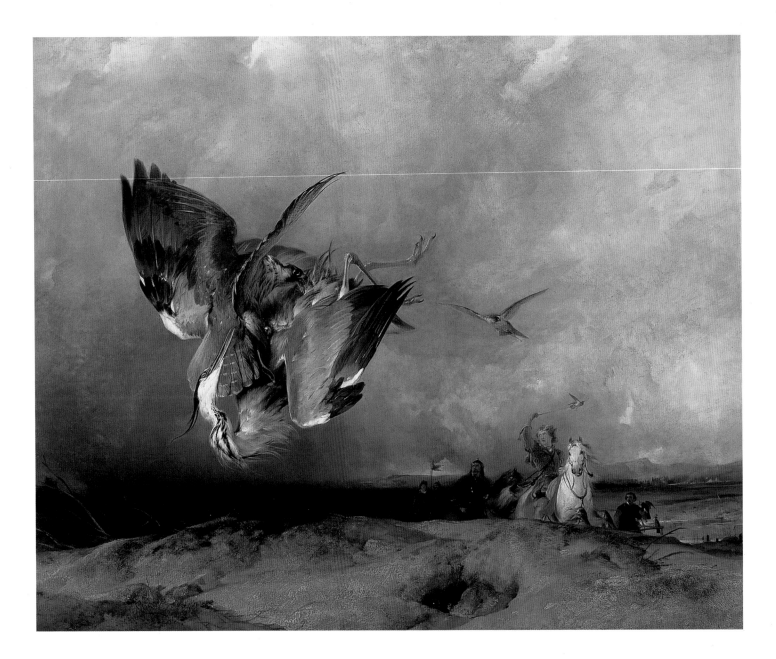

[17] *Hawking* (also called *Hawking in the Olden Time*), *c*.1832 *

Oil on canvas, 152.5 × 183
English Heritage (The Iveagh Bequest, Kenwood)

fur-lined cloak and by a knight dressed in armour, whose deferential manner suggests that he is her retainer rather than her husband; she is certainly the focus of the group. The two keepers who have brought in the stags wait at a respectful distance, as do the figures at the top of the outer staircase, one of whom may be a cleric and the others stewards or servants. The picture, evoking the martial spirit of the Highlands and the Borders, illustrates the feudal nature of its society, while the dead stags, frame of hawks and the hunting dogs remind us of the wilds lying outside the castle walls.

The romantic atmosphere of the picture and its colourful antiquarian detail take us back into the world of Scott's novels, where detailed description of castles abound, and it would not be a surprise to discover that the characters come

from a scene in *Ivanhoe* or *Kenilworth*. Though a narrative is implied in Landseer's picture, he was always wary of precise literary references, and it could be argued that the figures and setting are ancillary to the display of dogs and dead game. Landseer was unusual in turning his back on literary texts, for the walls of the Royal Academy were crammed with pictures illustrating subjects from Scott. Only Byron ran him a close second as a contemporary source and both were overshadowed by Shakespeare. This was the great age of literary painting, and Scott's writings provided a rich source for popular and anecdotal pictures.[30]

Hawking [plate 17], like *Bolton Abbey in the Olden Time*, is another combined history painting and sporting scene of the early 1830s, but very different in character to the pictures so far discussed.[31] A picture dated 1795 of *A Hawk*

upon a Buzzard by the sporting artist, Philip Reinagle (1740–1833), may have given Landseer his first idea for *Hawking*.[32] In the foreground of the latter painting a peregrine hawk is seen bringing down a heron, its talons gripping the body of its prey while it tears at the tail feathers. One contemporary reviewer of the picture doubted that a hawk would ever strike with its head towards the tail of its victim, but the soaring wings of the one superimposed on the plunging wings and trailing legs of the other, in a tight interlocking design of curves and counter-curves, is exciting and highly effective pictorially. Shock at the destruction of one beautiful animal by another is intensified by the close-up view of anatomical detail and delicate plumage. As in *Highlanders Returning from Deerstalking* [plate 44], the stormy and desolate landscape underscores the theme of mortality and nature 'red in tooth and claw'. Only the reviewer of *The*

Examiner felt any qualms about the violence on view by posing the question, 'whether it be justifiable to inflict pain and death upon any sentient creature, for the purpose of amusement?'[33] The voice of the anti-blood sports lobby was muted but it was there.

The painting is three-quarters sky, with a low horizon line, and the hawking party cresting the slope are extras in a scene of aerial combat. The lack of prominence given to the figures was a criticism at the time, but the picture was praised for both being 'nature itself' and 'a wonderful piece of painting'.[34] The leading figure on a white horse, dressed in sixteenth-century costume, is the ancestor of those gilded young aristocrats with whom Landseer hunted. The knight has just released a second hawk and is whirling a live pigeon round his head to bring the first hawk off the prey. Beside the young nobleman walks a falconer with his field cadge suspended from his shoulders, and behind him rides an older man in armour, a woman in red velvet riding side saddle and a second attendant with lance and pennant. Visible in the background is a castle with tents alongside it and a large concourse of people, suggesting a tournament or festive event of some kind. In 1839, the Earl of Eglinton was to stage a famous tournament at his castle in Scotland in emulation of medieval chivalry. Extravagant suits of armour were hired and fitted out by each contestant and a full-scale tournament was re-enacted before huge crowds, though the event was marred by heavy rainfall.[35] Landseer painted a portrait of *The Duke of Beaufort on Horseback* [plate 18] in the armour he was to wear at the tournament, although in the event he was unable to participate.

The sport of hawking was associated with the chivalric world of the middle ages and Tudor England, and it enjoyed a revival in the early nineteenth century among aristocratic sportsmen. Descriptions of hawks and hawking are scattered across Scott's writings, and one of Landseer's illustrations to the Waverley edition of his works is a scene of hawking from *The Betrothed* [plate 19]. Scott uses the imagery of hawking for period effect, and Landseer does the same in history paintings like *Bolton Abbey in the Olden Time* and *Interior of a Castle Courtyard*. His sketch, *A Visit to the Falconer's* [plate 20], might have been taken from a Scott novel so in tune is it with the author's rich descriptive detail

[18] *The Duke of Beaufort on Horseback*, *c*.1839–42 *
Oil on canvas, 89 × 68.6
Property of the Somerset Trust

[19] *The Hawking Party* (also called *Hawking in the Olden Time*), *c*.1832
Oil on board, 28 × 40.6
Untraced. An illustration to Sir Walter Scott's novel, *The Betrothed*. Engraved for the Waverley edition of Scott's works.

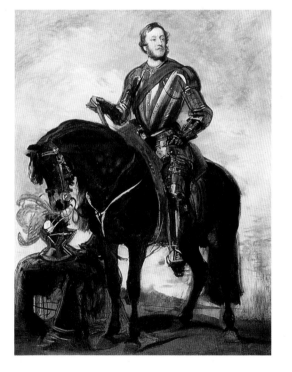

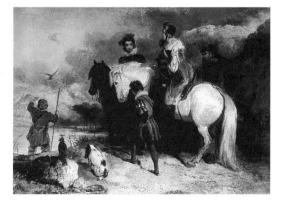

and romantic characterization. Two young ladies of the castle, itself visible through the doorway, are visiting the falcon house and intently watching a young falconer training a bird; an older man peers over his shoulder. Two rows of falcons are perched facing one another; a dead heron, a game bird, a greyhound and a stove occupy the foreground; and shields and other paraphernalia line the walls of the simple wooden barn. Through these suggestive details and the sixteenth-century costumes we are transported back to a period that appears more heroic and more exciting than our own.

It was the connection between hawking and the chivalric past that led Landseer to include references to hawking in his contemporary sporting portraits such as the *Lord Richard Cavendish and his Dog, Spot* (*c*.1827, collection of the Duke of Devonshire, Chatsworth), with a hawk at the sitter's wrist, and the group of Lord Francis Egerton (1800–57) and his family, *Return from Hawking* [plate 21]. In the latter picture Egerton, dressed as a cavalier, is pictured as a nobleman from an earlier, more courtly age. The falconer with his field cadge is not a subservient figure but a major focus of the composition, holding aloft a bird in a gesture of triumph. He might have stepped straight out of a Dutch genre scene of the seventeenth century. In fact the picture abounds in references to Dutch art; the group of Egerton and his family is strongly reminiscent of equestrian hunting pictures by Aelbert Cuyp, and the distant, tree-lined avenue is lifted directly from *The Avenue at Middelharnis* by Meindert Hobbema [plate 22], a picture now in the National Gallery, London, but then recently acquired by Sir Robert Peel, a friend and future patron of the artist.

These references to Dutch art are not there by accident, for Lord Francis Egerton had inherited one of the greatest collections of old master paintings ever assembled from his uncle the third and last Duke of Bridgewater, much of it now on loan to the National Gallery of Scotland. Egerton was an active member of parliament and an early advocate of free trade, serving briefly as secretary of war in 1830. His real interests, however, were intellectual. He published over twenty books, including poems, works of biography, history and archaeology, travel reminiscences and translations from the French and German. He was the first president of the

[20] *A Visit to the Falconer's,*
c.1830 *
Oil on board, 33 × 42
Private Collection

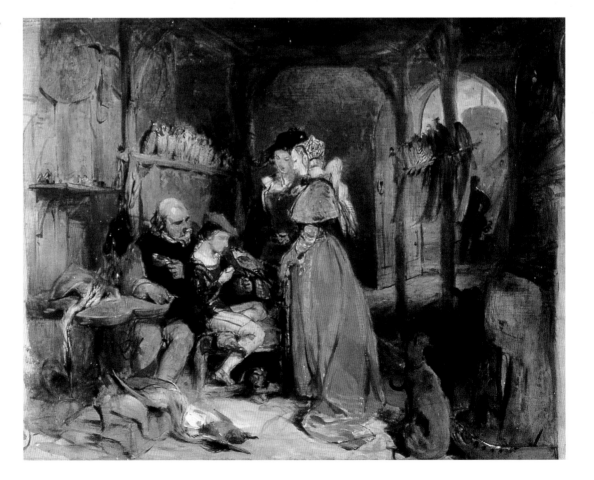

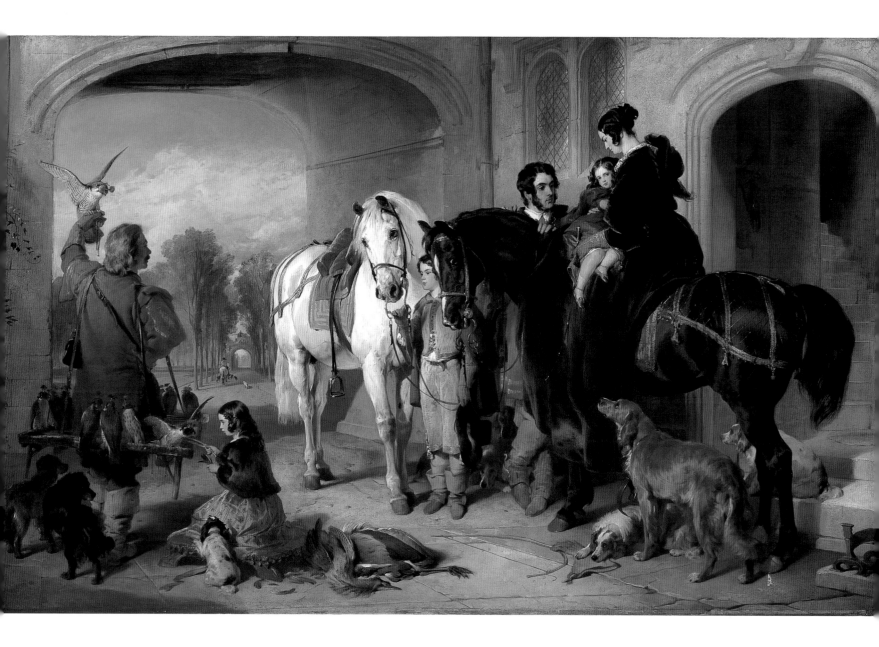

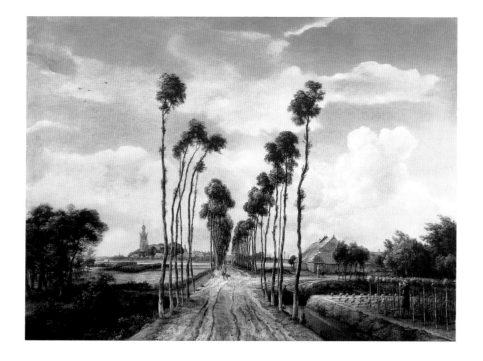

[21] *Return from Hawking
(Lord Francis Egerton and
Family), c.1835–7* *
Oil on canvas, 148.6 × 238.8
Private Collection

[22] *The Avenue at Middleharnis*
by Meindert Hobbema, 1689
Oil on canvas, 103.5 × 141
National Gallery, London

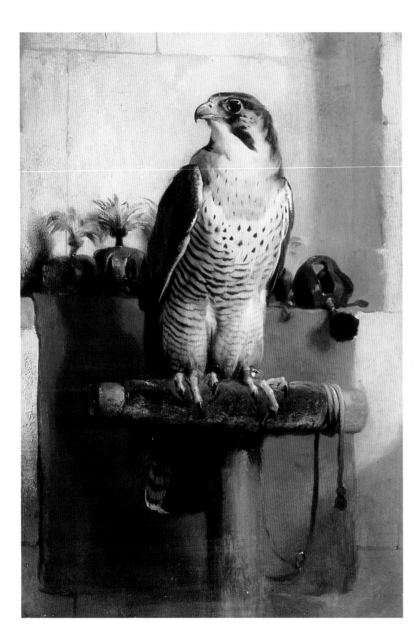

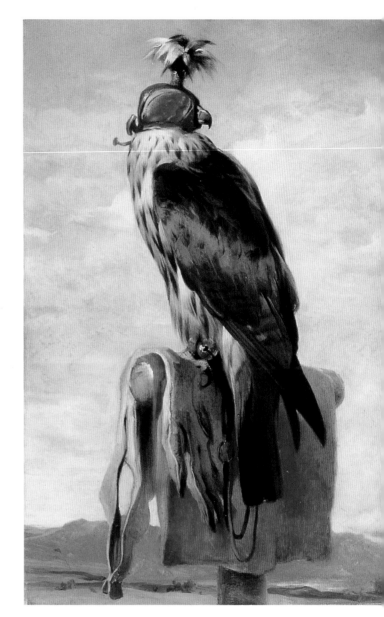

[23] *Falcon*, c.1837
Oil on board, 50.8 × 36.8
Private Collection

[24] *Hooded Falcon*, c.1837
Oil on board, 50.8 × 36.8
Private Collection

Camden Society, and also served as president of the British Association and other learned societies. He married Harriet Greville, only child of Charles and Charlotte Greville, by whom he had five sons and two daughters. In 1846 he was raised to the peerage as Viscount Brackley and Earl of Ellesmere, and in 1855 he was appointed a knight of the garter. The circumstances behind the commission are not known, but artist and patron moved in the same circles and would have been well known to each other. Lord Francis Egerton wrote to Landseer on 11 December 1835 to say that his little girls were in 'painting condition',[36] and enclosing a cheque for three hundred pounds in part payment for the picture; Landseer acknowledged a cheque for a further four hundred pounds in a letter to Egerton of 9 September 1837.[37]

Return from Hawking is similar in theme to *Interior of a Castle Courtyard*, using the references to an idealized past to counterpoint the sporting activities of a modern-day nobleman. Egerton and his wife have just entered the courtyard after a day's hawking to be greeted by their young daughters. A booted page holds the black and grey horses by the head while Egerton, who has dismounted, stands close to his wife who has Blanche, their youngest daughter, in her arms. The elder daughter Alice is shown to the left tickling one of the falcons on the field cadge with a feather, with dead game beside her. There are no fewer than eight dogs, both hounds and domestic pets, and they work as a sub-text to the main narrative, exhibiting a range of different behaviours. Through the door way on the right we see a spiral staircase leading to the apart-

ments above, and to the left the castle gateway frames a distant avenue with a solitary horseman, presumably a departing falconer for he has a hawk on his arm and dogs at his heel.

Landseer exhibited companion pictures of a pair of falcons [plates 23, 24] at the same Royal Academy exhibition (1837) to which he sent *Return from Hawking*. They show contrasting views of possibly the same bird, front view at rest in one, hooded and in the hunting field in the other. The unhooded falcon is presented in an interior as a virtuoso ornithological specimen, painted with absolute precision. The T-shaped block on which the bird perches and the background grid of wall, ledge, row of hoods and red blanket are combined in a carefully crafted and decorative ensemble. The hooded falcon is painted more freely and placed up high against blue sky, its natural habitat, with a sliver of Highland landscape far below. The two pictures were acquired by William Wells of Redleaf, who already owned the finest group of Landseer's studies of dead or dying game birds, including *Ptarmigan* and *Grouse* [plates 51, 52], and a number of other works [see pp.55–6 and n.20].

The knowledge of hawks and hawking, which the artist reveals in his pictures, strongly suggests that he was a follower of the sport. Certainly several of his friends were, including the Duke of Gordon and William Russell, great grandson of the fourth Duke of Bedford, whom he painted hawk in hand in a portrait sketch of

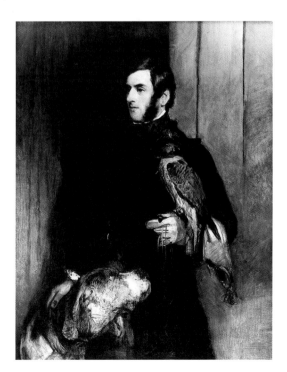

[25] *The Falconer* (said to be a portrait of William Russell), *c.*1835
Oil on canvas, 138.5 × 110.5
Private Collection

the 1830s [plate 25]. A rare reference to Landseer's picture of *Hawking* [plate 17] occurs in the recollections of Maria Edgeworth published in 1834. She records a conversation between two sportsmen, one of whom asks the other 'if he had been at Lord Berner's when Landseer was studying the subject of his famous hawking scene. "Have you seen it, Lady Cecilia?" continued he, "it is beautiful; the birds seem to be absolutely coming out of the picture"; and he was going on with some of his connoisseurship, and telling his mortification in having missed the purchase of the picture.'[38] The picture had in fact been bought by Samuel Cartwright, a successful dentist and a considerable patron of contemporary art.

Landseer had abandoned history painting by the mid-1830s, but there is an exception from the end of his career, which comes closer to the spirit of Scott than any other, *Rent Day in the Wilderness* [plate 26]. The text given for the picture in the Royal Academy catalogue for 1868 is Robert Chambers, *Domestic Annals of Scotland*; volume three of this work, *From the Revolution to the Rebellion*, was published in Edinburgh and London in 1861, though there are other sources for the subject. After the defeat of the Jacobite army at Sheriffmuir in 1715, the exiled Earl of Seaforth, chieftain of the clan Mackenzie, confided his confiscated estates in Rosshire to his faithful agent, Colonel Donald Murchison, who successfully defended them from the military for ten years, and continued to collect and remit rents to his exiled master. The Colonel is said to have been badly treated by the Earl when the latter regained his estates and to have died of a broken heart.

Like the novels by Scott set in Jacobite times, Landseer's picture captures the underlying conflict between the solid, progressive society of Hanoverian Britain and the unyielding adherence of the Highland clans to the old order. Heroic as they were in fighting for their traditions, Scott understood that the Highlanders could never turn back the clock and that their cause was doomed. The hero of *Waverley*, after whom the book is named, faces this dilemma, reluctantly fighting for the Young Pretender out of a sense of misplaced idealism, and realizing as he comes south with the Jacobite army what a crazy venture it is; the English will never accept the return of the Stuarts and all the old thinking

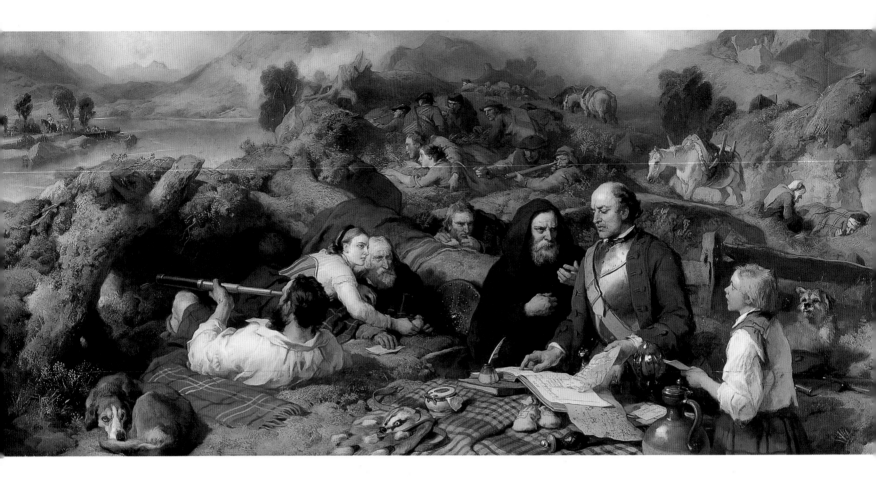

[26] *Rent Day in the Wilderness*, 1855–68 *

Oil on canvas, 122 × 265.5
National Gallery of Scotland,
Edinburgh. Bequest of Sir
Roderick Murchiston

that goes with them. Waverley is pardoned, marries the rich landowner's daughter and becomes a pillar of the establishment. Murchison's defence of his master's property is magnificent, but as Landseer well knew, it was an isolated protest in the subjugation of a once proud race.

Rent Day in the Wilderness may be intended as a representation of the incident when Murchison ambushed a party of redcoats in 1721 close to Loch Affric with a force of Mackenzies, because the account book in front of him is dated 1721 and inscribed 'The Earl of Seaforth, Kintail'. The redcoats can be seen in the distance disembarking from a ferry and advancing along a track, while Colonel Murchison calmly continues with his rent collection, unfazed by the approaching danger. He is dressed in a brown coat with a breastplate and a leather sword belt and a Highland broad sword, with account books, money bags, pen and ink, badger's head sporran, dirk, snuffbox and stoneware jug laid out on a blanket before him; the butts of two muskets are visible behind him. The snuffbox, said to have been given to Murchison by the Old Pretender, descended in the Murchison family and is now in the National War Museum of

Scotland [plate 27]. Murchison holds a document in his right hand inscribed 'Private/Colonal Donald Murchison/Kintail' which has apparently been given to him by the mysterious hooded figure to his right, and a boy approaches him from his left-hand side with another piece of paper. Contemporary reviewers complained that the three foreground figures appeared to have no legs. Behind them various groups of Highlanders can be seen crouching behind defence works constructed out of tree stumps and turf, tensely awaiting the arrival of the troops.

The panoramic composition is carefully layered along a sequence of bisecting diagonal lines that lead the eye deep into the picture space. The hillock behind which the figures crouch forms a shallow pyramid, which is echoed within by a subset of triangular shapes. The colour scheme of soft greens, lavender greys and blues, with vivid accents of red, is typical of Landseer's late style. The picture had been commissioned in 1855 by the eminent geologist, Sir Roderick Impey Murchison (1792–1871), to celebrate the exploits of his forbear. 'The wish of my heart', he wrote to the artist, 'is to be possessed of a painting by yourself of a Highland scene which was marked by the devotion of my

ancestor, Donald Murchison. Of this I spoke to you more than once & I inferred that the subject was one that pleased you.'[39] Murchison supplied Landseer with drawings of the places where his ancestor had carried out his exploits and other details. In 1860 Landseer apologized to his patron for the delay in completing the work, citing ill-heath and the pressure of other commissions as an excuse.[40] Seven years later an exasperated Murchison wrote to him enclosing his ancestor's snuffbox: 'May your real Highland genius inspire you to complete the work everlastingly here or elsewhere receive the grateful blessings of yours sincerely.'[41] A year later the picture finally appeared at the Royal Academy, to mixed reviews. The critic of *The Saturday Review* commented perceptively: 'We may observe, further, that all Sir Edwin's best compositions have been simple compositions, that any scattering of groups has always been fatal to the arrangement of his pictures, and that whatever tends to display, in too obvious a degree, the dexterities of his style detracts from his serious consideration.'[42]

Landseer was brought up at a time when the literary reputation of Sir Walter Scott was at its zenith. Critics compared the writer to Shakespeare, and he was lauded across Europe as one of the literary giants of all time. He had first made his name as a poet and balladist, and he did not begin writing novels until he was in his forties. That the young and impressionable Landseer should fall under his spell was almost inevitable, coinciding as it did with the artist's discovery of Scotland. Landseer's early history works and sporting pictures breathe the same spirit of a chivalric past to be found in Scott's poems and novels. While he did contribute to the illustrated edition of the Waverley novels, he otherwise avoided the trap of tying himself to specific literary texts, preferring narratives that allowed him the freedom to evoke the romance of the past and the glory of the hunt in suggestive and allusive ways. *The Hunting of Chevy Chase* and *Rent Day in the Wilderness* are exceptions, and Scott is the source of neither, but his influence pervades them both. Landseer's sporting groups are the complement to the historical scenes, presenting us with modern day chieftains who are the inheritors and guardians of Highland tradition. Landseer's pictures provide a visual analogue to Scott's descriptions of Scottish life set in a picturesque and heroic past.

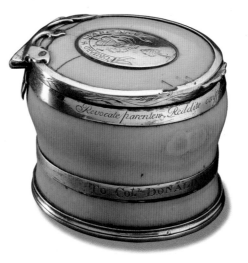

[27] *Snuffbox, c.1700*
This had belonged to Donald Murchison and appears in *Rent Day in the Wilderness* (plate 26).
National War Museum of Scotland, Edinburgh Castle

2 · SPORTING PICTURES

Landseer responded to Sir Walter Scott's ballads and novels both in his evocation of a romantic Scottish past, and also in his depiction of contemporary noblemen as heirs of traditional Highland chieftains. The Celtic Society (later the Royal Celtic Society) was founded in 1820 by Scott, the Marquess of Huntly (later fifth Duke of Gordon), Macdonnell of Glengarry and their friends, to promote the general use of ancient Highland dress, and the preservation of the 'characteristics' of the Highlanders. The revival of the culture and traditions of individual clans became the object of these antiquarian enthusiasts. Yet the clan as a composite military, social and economic unit had long since disintegrated. Those noblemen, who most enthusiastically embraced the manners and codes of a colourful past, were those same landowners who set about modernizing their estates. The discrepancy between the idea of the Highlands as a traditional community of interconnected clans and the reality of social and economic change, often accompanied by great hardship, exists to this day. The Highlands in its historical form became the focus of Scottish nationalism while remaining economically backward and politically marginalized.

Landseer's portraits of Highland aristocrats depict them as patrician chiefs engaged with their retainers in the noblest of sports – stag hunting – and invariably dressed in tartan. They exhibit attributes of hardiness, courage, pride, authority and independence traditionally associated with the Highland ruling class. They are men of action, inspiring loyalty and devotion in their followers. Their terrain is the wild moor and the high hills, and they seem to be at one with the bleak grandeur of the Highland landscape.

The patrons of Landseer's two large sporting groups of the 1820s were powerful aristocrats,

the fifth Duke of Gordon (1770–1836) and the fourth Duke of Atholl (1755–1830). The commission for the first, *Scene in the Highlands, with Portraits of the Duchess of Bedford, the Duke of Gordon and Lord Alexander Russell* [plate 35], came about through Landseer's friendship with the Bedford family. The Duke of Gordon's sister was Georgiana, Duchess of Bedford (1781–1853), and she appears in the group with her brother and her young son, Lord Alexander Russell. Landseer is said to have entered the circle of the Bedfords in 1820, but his first recorded visit to Woburn Abbey, the Bedford family seat, was in 1823, and he soon became a favourite with the family. The Duke of Bedford (1766–1839) became his patron, friend, supporter and admirer, bombarding him with letters of advice, while the Duchess is said to have been his mistress by whom he fathered the youngest of the Bedford children, Lady Rachel Russell [plates 28, 29].[1] She was born in June 1826, so conception would have to have taken place in the autumn of 1825 when both the Duchess and Landseer were in Scotland. There is, however, no certainty that they were lovers, although in some circles it was assumed so. The indignant Haydon, jealous of his former pupil's success, wrote disparagingly about him in 1829: '… but I never gave in to the vices of Fashion, or degraded myself or disgraced my Patrons by becoming the pander to the appetites of their wives … I never seduced the Wife of my Patron and accepted money from the Husband while I was corrupting his Wife & disgracing his family.'[2] In 1833, a scandal sheet called *The Satirist* carried a short piece about the Duchess's illness in Ireland: 'Strong draughts were resorted to which relieved the patient. Edwin Landseer is Her Grace's Draughtsman.'[3]

The impulsive, warm-hearted, exuberant Georgiana, Duchess of Bedford was much

< Detail from plate 35

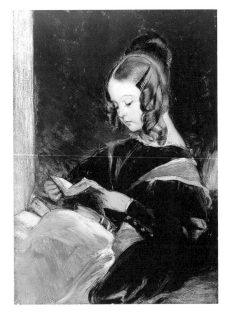

[28] *The Duchess of Bedford*,
c.1830
Oil on board, 44.5 × 26.7
Private Collection

[29] *Lady Rachel Russell*,
c.1835
Oil on board, 34.3 × 24.2
Private Collection

younger than her husband, whom she had married as his second wife. Her devotion to her husband never wavered, nor his to her, although both enjoyed close friendships with people of the opposite sex without in any way imperilling their marriage. The sparkling and attractive young artist quickly won the Duchess's heart. In November 1827, Sir Walter Scott reported Landseer in the Duchess's train when he met her in Edinburgh: 'They are from a shooting-place in the Highlands, called Invereshie, in Badenoch, which the Duke has taken to gratify the Duchess's passion for the heather.'[4] The Duchess had been brought up at Gordon Castle near Fochabers in the Highlands and she was proud

of her Scottish ancestry. Nevertheless, like her husband and children, she had become a summer visitor, looking on the Highlands as a place for sport and relaxation. She invented a role for herself as a Highland châtelaine, and never more self-consciously so than in the cluster of huts she built in the remote valley of Glenfeshie in the Cairngorms, where she pretended to live the life of a simple Highlander with groups of family and friends [see pp.81–4].

Landseer was happy to indulge her in her play-acting. One of his earliest Scottish pictures was a spirited equestrian portrait of her second son, *Lord Cosmo Russell* [plate 30]. The boy is dressed as a Highlander, with tartan stockings, plaid and Glengarry cap, and he rides his bounding pony with the poise of a young prince. Critics at the time were not slow to point out the parallels with the famous equestrian portrait of *Prince Baltasar Carlos* by Velázquez [plate 31]. The heir to the Spanish throne and the young British aristocrat, are cast in the same spirited mould, as young men born to command. The difference is, of course, that Lord Cosmo is not riding across lands to which he is heir like Prince Baltasar. He is a temporary visitor from the south, living in rented accommodation with his parents and dressed up to look the part of a Highland chief.

A picture, dating from 1824, has descended in the Russell family, and was almost certainly the work exhibited at the British Institution in London under the following title: *Scene on the River Tilt, in the Grounds of His Grace the Duke of Bedford* [plate 32]. The River Tilt runs through the Perthshire estate of the Duke of Atholl and the Bedfords had rented one of his properties for the season, Forest Lodge; in 1826 the Duchess of Bedford did an etching after Landseer of the gateway to Forest Lodge, one of six Highland subjects by Landseer, which she etched.[5] Judging by their ages, the children in *Scene on the River Tilt* are likely to have been Lord Francis Russell (born 1808) on the left with a fishing rod, Lady Louisa Russell (born 1812) to his right, Lord Alexander Russell (born 1821) and Lady Georgiana Russell (born 1810) kneeling on the right. The children have come up the river on a fishing expedition and they are grouped around an open fire with a pot on the boil. The freshly caught trout are laid out on a basket in the foreground with vegetables and other necessaries for the preparation of a meal. The old woman seated

[31] *Prince Baltasar Carlos on Horseback* by Diego Velázquez,
1634–5
Oil on canvas, 209 × 172.8
Museo Nacional del Prado, Madrid

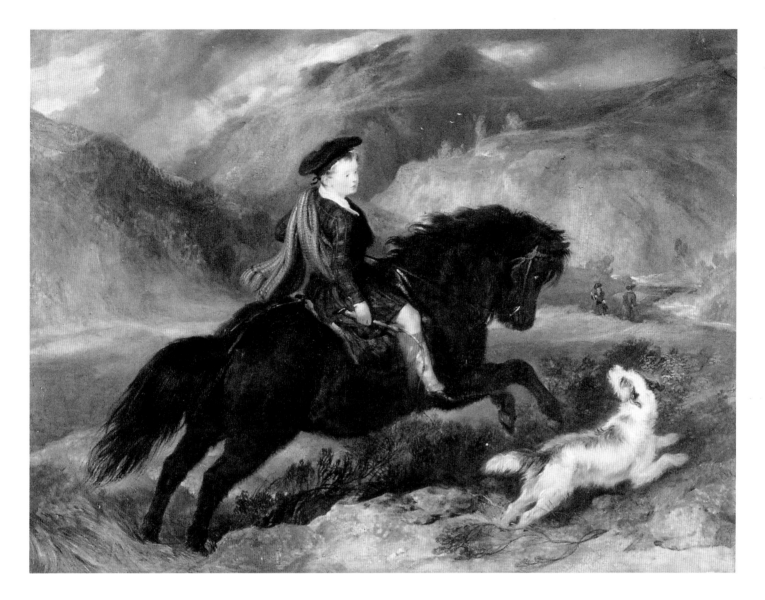

[30] *Portrait of Lord Cosmo Russell*, 1824
Oil on panel, 44.5 × 59.7
Private Collection

on the left is in the act of cutting up vegetables. She is both cook and guardian for the children, and we sense her strength of character in her forceful pose, one hand on her hip. Beside her and the shaggy pony, the children appear effete, and Landseer deliberately plays up the contrast between age and youth, rough old countrywoman and refined aristocrats.

Another picture of this time depicts Lord Alexander Russell in velvet dress and tartan stockings seated in a Highland landscape [plate 33]. A large black retriever stands beside him with a model sailing boat in its mouth, which it has just rescued from the stream running in front. A trowel, a basket of flowers, and a large straw hat held by the little boy point to a mother nearby. The picture, sometimes called *Friends* or *Hours of Innocence*, plays on the relationship between boy and dog, and between dog as faithful guardian and the wider family. In Landseer's pictures there is always a story and no detail or

accessory is there by chance. The Russells feature in a succession of later works set in the Highlands, including *The First Leap* of *c*.1829, Lord Alexander Russell on his pony Emerald (Guildhall Art Gallery, London); *Cottage Industry* of *c*.1831, Lady Louisa Russell as a Highland lassie knitting (private collection); and *Pets* of *c*.1832, Lady Rachel Russell feeding her pet fawn Harty (private collection). A charming portrait of Lady Louisa, by then the wife of the Marquess (later Duke of) Abercorn, with her eldest daughter [plate 34], may also have been painted in Scotland. She and her husband often entertained the artist at their hunting lodge, Ardverikie, on Loch Laggan.

Landseer's group of the Duchess of Bedford and her son with her brother the Duke of Gordon was exhibited at the Royal Academy in London in 1828 under the title, *Scene in the Highlands, with Portraits of the Duchess of Bedford, the Duke of Gordon and Lord Alexander Russell*

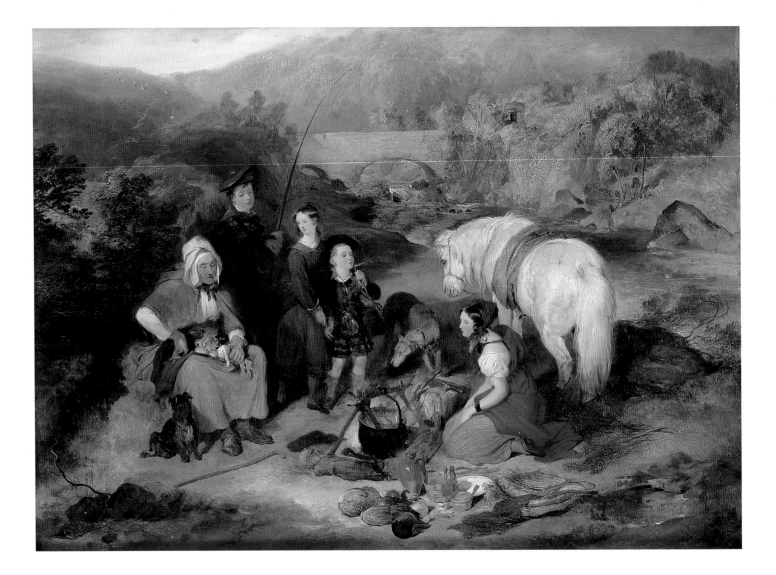

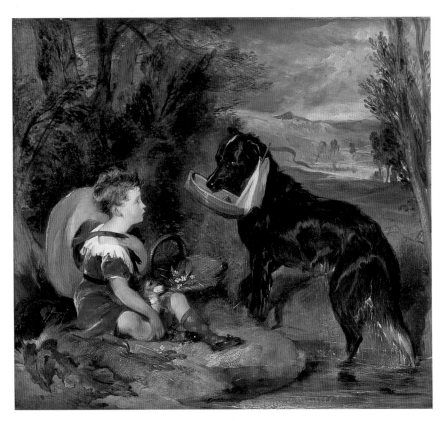

[plate 35].[6] Born in 1770, the Duke of Gordon had joined the army before being wounded on active service in Holland in 1799. Elected as a Tory member of parliament, he held a court appointment as keeper of the Great Seal. Commonly known as the 'Cock o' the North', the Duke had served as president of the Celtic Society and later as president of the Highland Agricultural Society. In 1813, he had married Elizabeth Brodie, daughter of the wealthy Brodie of Brodie, who was twenty-four years his junior. They had no children and on the Duke's death in 1836, the title became extinct.

[32] *Scene on the River Tilt, in the Grounds of His Grace the Duke of Bedford* (also called *The Fishing Party in the Highlands* or *The Highland Picnic*), 1824 *
Oil on panel, 47 × 61 · Private Collection

[33] *Hours of Innocence, Lord Alexander Russell and his Dog Nevill*, c.1825
Oil on panel, 40.7 × 45.8 · Private Collection

[34] *The Marchioness of Abercorn and her Eldest Child,* c.1833 *

Oil on copper, 53 × 42
Tate, London, presented by Edwin L. Mackenzie, 1914

[35] *Scene in the Highlands, with Portraits of the Duchess of Bedford, the Duke of Gordon and Lord Alexander Russell* (also called *Sport in the Highlands*), c.1825–8 *

Oil on canvas, 130.5 × 166
Private Collection, on loan to the National Gallery of Scotland, Edinburgh

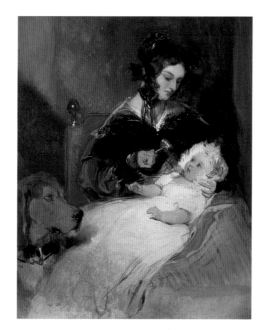

A contemporary expressed surprise at his marriage (he was then Marquess of Huntly): 'Lord Huntly, now in the decline of his rackety life, overwhelmed with debts, sated with pleasure, tired of fashion, the last male heir of the Gordon line – married.'[7]

It is not known when Landseer began painting the picture, possibly in 1825 when he did a beautiful sketch of the Duke's favourite shooting pony [plate 36]. He is known to have stayed with his patron in the autumn of that year. Lord Alexander Russell looks little older in this group than in the 1824 fishing picture, which also lends support to an early dating. By the time the picture was exhibited in 1828, the Duke had succeeded to the title, and was living at Gordon Castle. That he chose to be painted with his sister

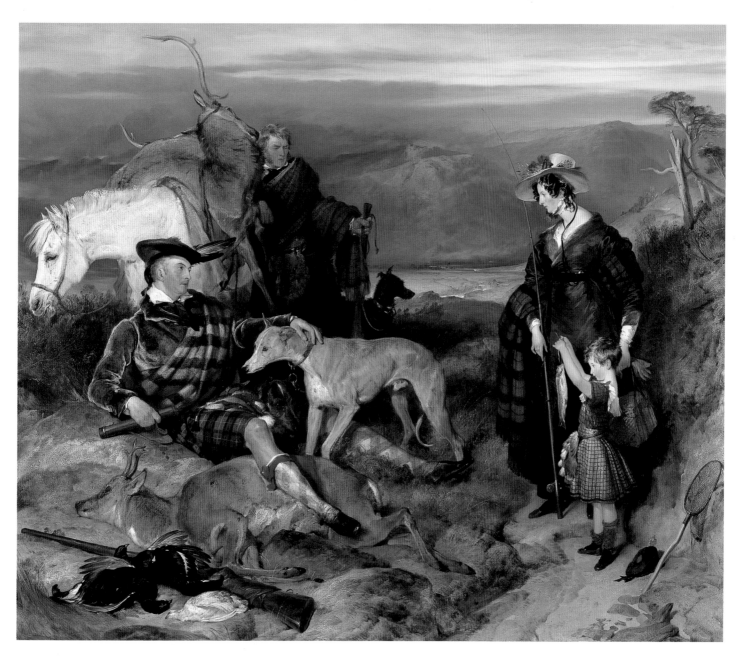

[36] *A Favourite Shooting Pony*, 1825
Oil on board, 31.8 × 38.7
Private Collection

sprigs of heather and a folded plaid wrapped round her arm, and she holds the fishing rod and basket for her young son. He, in tartan skirt and matching top and sporran, proudly holds up a trout for his uncle's inspection. One sock is round his ankles, and his bonnet and fishing net have been thrown aside, but his eager expression tells its own story. Between the groups of figures, a stream can be seen winding its way from a line of misty hills, probably the Cairngorms, across a stretch of moorland.

In composition the picture is strangely like *An Illicit Whisky Still in the Highlands* [plate 57], which Landseer was painting at this same period. The pose of the Duke with his dog is almost identical to that of the surly Highlander with his leg cocked over the body of a dead stag, and the space between the figures of the Duke and his sister is very much like that dividing the Highlander from the young girl on the right, possibly his daughter. Both Duke and Highlander are exercising power, though in a very different context, the one as refined aristocrat, the other as lawless brigand and poacher. What is instructive is that Landseer brings to the sporting group the same theatrical construction, psychological edge and symbolic accessories that he deploys in his genre scene. The underlying theme of both works is man's relationship to the natural world, for all the differences in class, place and morality.

Landseer's second great sporting picture of the 1820s, *The Death of the Stag in Glen Tilt* [plate 37], depicts the fourth Duke of Atholl in the hunting field, with his grandson and keepers. It is conceived in more monumental terms than the picture of the Duke of Gordon and the Duchess of Bedford. The tall and stately Duke of Atholl (1755–1830), one of the most powerful Highland chieftains with his own private militia, dominates Landseer's picture. The castle at Blair Atholl is one of the most picturesque sights in the Highlands, much painted and much visited by tourists then, as now, on the Highland trail, and it lies at the centre of a vast estate. Already in his seventies, and described by one contemporary as the 'greatest deer killer in Scotland', the Duke of Atholl had an insatiable passion for hunting, and he was noted for his stature, physical courage and stamina. His young grandson, the Hon. George Murray, later sixth Duke of Atholl (1814–64), flanks him on one side,

and nephew rather than his wife is probably due to the artist's intimate friendship with the Duchess of Bedford. The bold exchange of looks between brother and sister would lead most spectators to assume that they are husband and wife. Only the degree of space between them suggests that there could be a different reading of their relationship.

The Duke of Gordon is shown resting after the rigours of the hunt, and the trophies of his expedition are piled up around him like a veritable buffet of dead game – grouse and blackcock beside his rifle, a young stag on which his leg rests, and above him and his deerhound an old pony bearing the carcase of yet another stag with arching antlers. Apart from his green velvet hunting jacket, the Duke is dressed entirely in tartan (stockings, belt and plaid) with a magnificent badger sporran, and he holds his telescope like the baton of a commander symbolizing his authority. This is endorsed by the submissive attitude of his keeper, standing deferentially behind his master. The Duke is shown as an archetypal Highland nobleman and sportsman back from a day's successful shooting in the high hills.

Representing gentler values and feminine grace, the Duchess and her young son are depicted on their return from a fishing expedition. The Duchess is dressed in a plain, high-waisted black costume, a straw bonnet decorated with

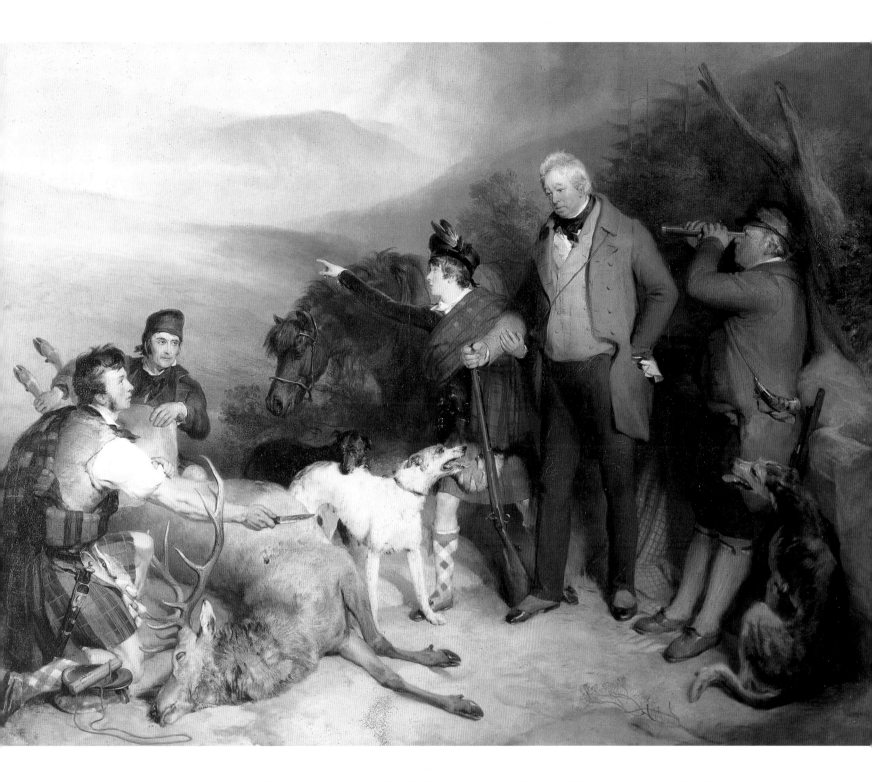

excitedly pointing out some deer he has seen on the hills above. He is dressed in a tartan kilt with a sporran, a red plaid and a blue bonnet with eagles' feathers. On the other side of the Duke is the head forester, John Crerar, a legendary sportsman and fiddler about whom many stories are told, who follows the deer with his spyglass.[8] Like the Duke, he is dressed in conventional hunting costume with a deerstalking cap, a powder horn slung round his body and a rifle and deerhound beside him.

The Duke, at the apex of the composition, does not follow the progress of the deer, but looks across at the two keepers squatting on the ground beside him. The deference paid to him underlines the hierarchical nature of Highland society. Charles Crerar, son of the head forester, holds out his knife ceremonially to the Duke before beginning the gralloching (disembowelling) of the stag, while his companion, Donald McIntyre, holds down the haunches of the beast. The picture was painted in the lower reaches of Glen Tilt, the long and beautiful valley that runs from the castle deep into the Grampian hills.

[38] *Study for The Death of the Stag in Glen Tilt* (also called *Taking the Deer: The Duke of Atholl with Foresters*), *c.*1824–5 *
Oil on board, 48.2 × 63.4
National Museums Liverpool
(The Walker)

Charles Crerar, wrestles with a stag he is trying to lasso. A baying deerhound and a wounded hound occupy the foreground, and in the background is a frisky black pony. The interlinked group of men and animals is more like an emblematic tableau than a real hunting scene, and it is designed to show off the valour and physical prowess of the participants.

Figures in action were never to be Landseer's forte, and the challenge of working up the sketch into a finished composition may simply have proved too difficult and problematic. The existence of other oil sketches, including studies of the Duke of Atholl and John Crerar [plate 39], another of John Crerar standing beside a shooting pony [plate 40] and two of the keeper Donald McIntyre (both private collections), prove that Landseer had taken his action group to an advanced stage. This may explain his lack of progress with the commission which originated in 1824.[9] The views of his elderly and conservative patron could also have influenced him. The Duke may have felt that his dignity would be compromised if he appeared as a dishevelled sportsman in the midst of such violent activity. The presence of his grandson and heir in the finished group, but not in the sketch, hints at other reasons for the Duke preferring a more conventional composition. Landseer had already painted for him a smaller picture of his younger grandson, the Hon. James Murray playing with a fawn and watched by a keeper, which the artist sent to the Royal

The background is sombre and romantic in mood, with rain scudding in from the right, and faint streaks of sunlight glimpsed through veils of mist to the left.

Landseer's first conception of the group had been very different. A preliminary oil sketch [plate 38] shows a hunting scene that is all action and drama, a modern equivalent to *The Hunting of Chevy Chase* [plate 10]. In the sketch, the Duke of Atholl is shown on the right, gun in hand ready to shoot, while John Crerar stoops in front to grasp the antlers of a dead stag. To his left Donald McIntyre holds down a hound, while another keeper above, presumably

[39] *Study of the Duke of Atholl and John Crerar for The Death of the Stag in Glen Tilt*, *c.*1824–5
Oil on board, 52 × 48.2
Private Collection

[40] *John Crerar* (also called *The Keeper John Crerar with his Pony*), 1824 *
Oil on board, 58.5 × 44.5
Perth Museum and Art Gallery,
Perth and Kinross Council

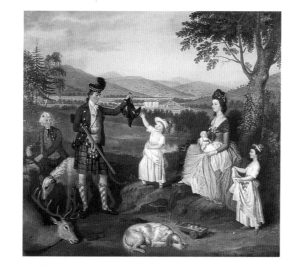

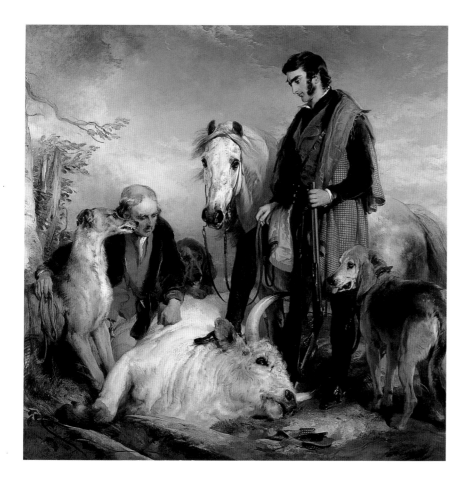

Academy in 1827 (the Blair Charitable Trust). The inclusion of the elder brother in the large picture represents dynastic continuity, something the Duke would have appreciated. Nearly fifty years earlier, the Scottish painter David Allan had painted a sporting scene of the same Duke of Atholl with his family [plate 41], which represents a lost world of Augustan elegance and innocence when compared to the weighty romanticism of Landseer's image.

The Atholl group was exhibited at the Royal Academy in 1830, the year of the Duke of

Atholl's death, to mixed reviews. The critic of the *Morning Post* complained of the want of 'energy and action about the group': 'The dogs are executed with great spirit, as is also the carcase of the antlered prey. We cannot, however, say that we are so well pleased with the other parts of the composition, of which the design as the execution are rather heavy.'[10] The critics of the *Athenaeum* and the *Morning Chronicle* were ruder, the first describing the figures of the Duke and his keepers as being in the 'worst possible taste', and the latter saying that the humans 'utterly spoil the picture'; take the figures away and 'you leave a delightful picture'.[11]

There was no sequel to *The Death of the Stag in Glen Tilt*. Its assertion of ancient bonds and clan loyalty stands in contrast to the make-believe world of *Study for Royal Sports on Hill and Loch* [plate 137]. In this later picture from the 1850s, the pageantry of Highland sport is used to idealize Queen Victoria's domestic happiness and the well-being of her realm. Landseer's two major sporting groups of the 1830s are not strictly Highland scenes at all. The first, *Return from Hawking* [plate 21], a picture of Lord Francis Egerton and his family, has already been described in the chapter, 'Sir Walter Scott and History' [see pp.34–7]. The second, *The Death of the Wild Bull* [plate 42] commemorates an event at Chillingham Castle in Northumberland, seat of the earls of Tankerville, when a plan to shoot one of the famous breed of wild white Chillingham cattle went disastrously wrong. A keeper, who was waiting in ambush, got tossed by the bull and was only saved by the prompt action of a hound, which kept the bull at bay until it could be dispatched. In the painting, the handsome Lord Ossulston (1810–99), the Tankerville heir and a great friend of the artist, stands triumphantly with one foot on the neck of the dead bull, while the head keeper, Coles, kneels in an attitude of supplication holding the faithful hound who had saved the day. The figures and animals are larger in relation to the picture space than those of the Duke of Atholl and his companions, the composition is bolder and the treatment more painterly and colourful.[12]

More in keeping with the spirit of the Atholl group is a picture called *Return from the Staghunt* [plate 43], exhibited at the Royal Academy in 1837. A Highland chief with his

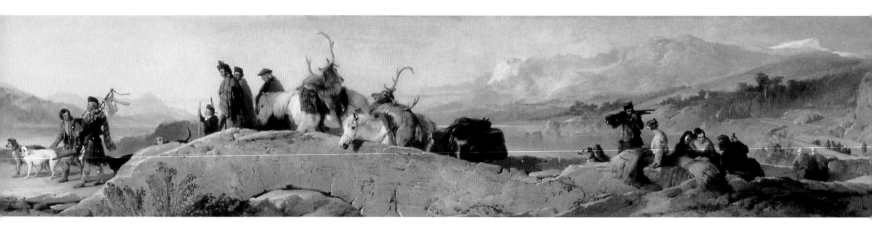

[43] *Return from the Staghunt, c.1837*

Oil on canvas, 33.5 × 160

Private Collection

keepers is crossing a bridge at the end of Loch Laggan with the day's sport strapped to the backs of two Highland ponies. Ahead is a piper ceremonially piping them home, and behind is a panorama of Highland life: two keepers with guns chatting up a pair of Highland lassies carrying the day's gleanings and watched by a duenna; two elderly women with their backs turned to us gazing out over the lake; and in the distance a procession of figures making their way along a zig-zag road. The chieftain is not named, but he is very probably the Marquess (later the Duke) of Abercorn, the Duchess of Bedford's son-in-law, who owned a hunting lodge on Loch Laggan, Ardverikie, where Landseer often stayed, and the walls of which he decorated with charcoal sketches. The evening light casts a golden glow over the peaceful scene, persuading us of the harmony between man and landscape, and the settled nature of the social order. The unusual format of the picture was dictated by the narrow space the picture was designed to fit.[13]

Landseer's paintings of deer hunting were not confined to sporting groups of his aristocratic friends. In the late 1820s and early 1830s he exhibited a wide range of deer pictures in London, which promoted an image and ethos of the Highlands strongly appealing to an audience south of the border. *Highlanders Returning from Deerstalking* [plate 44] was a popular work exhibited at the Royal Academy of 1827, and purchased there by the fourth Duke of Northumberland (1792–1865). Landseer's contemporary letter, enquiring where he should send the picture which the Duke 'did me the honour to express a wish to have' makes clear that it was a purchase, not a commission.[14] The Duke was a cultured and energetic collector, acquiring old master paintings and those by living artists,

including Landseer's impressive picture, *Coming Events Cast their Shadow before Them*, also called *The Challenge* [plate 128]. He remodelled Northumberland House in London, built the Great Conservatory at Syon House, which still survives, and created an Antiquities Museum at Alnwick Castle, his ancestral seat. Landseer was absorbed in all aspects of deerstalking and he was deeply impressed by the character and resourcefulness of the keepers and ghillies with whom he hunted. They were an essential part of the whole process of stag hunting, knowing where to find the deer, how to stalk them unobserved, helping to drive or turn them, gralloching the dead deer and carrying them home. They feature in many of Landseer's sketches at this early period. In *Highlanders Returning from Deerstalking*, the two ghillies are well contrasted types of Highlanders: an old, grey-faced man with wispy hair, dressed in tartan trousers and a plaid, and his young, ruddy-faced companion in a kilt. Also contrasted is the dark, vigorous young colt and the weary grey pony carefully feeling its way downhill. But it is the image of the stags, another pair, that gives the picture its deeper meaning, pathetically strapped down, their arching antlers silhouetted against a storm-laden sky. We are back to the theme of mortality, an elegiac discourse on the theme of death, which is further emphasized by the sheep's skull on the right, sniffed at by a pair of yoked deerhounds. The picture is painted in clear, transparent tones, with rich textural effects, careful finish and a dramatic contrast of light and dark.

Dead Deer and Deerhound [plate 45], exhibited in London in the same year as *Highlanders Returning from Deerstalking* is the first of Landseer's studies of dead deer shot in the wild without the presence of human figures. A note on

the reverse of the picture reveals that it was the record of an incident the artist had actually witnessed and painted on the spot. During a day's hunting at Blair Atholl in September 1825, two hounds had been let loose to turn an exhausted stag at bay. The stag rallied and set off across the moor with the two hounds in full pursuit, only one of which returned in the evening. After a day of fruitless searching, a shepherd brought word that he had seen a deerhound in another part of the forest 'toiling after a jaded and almost lifeless stag'. The next day Landseer armed himself with palette and brushes and, after a trek of six hours, came upon 'the subject of my picture, which I painted partly on the spot, just as I found it'. In the painting, the head of the stag is propped up against a rock, its antlers curving up above the distant skyline in

mute testimony of death. The black hound rests its head on the belly of the stag and looks up warily at an approaching eagle poised to pounce on the prey. Deer and dog are vignetted at the centre of a composition defined by the rocks behind and the burn in front, with a shower of rain scudding across the darkening landscape.

The picture was almost certainly the work exhibited at the British Institution in London in 1827 under the title *Dead Deer and Deerhound*. In a review of the exhibition, the critic of *The Examiner* described both this picture and *A Scene at Abbotsford* [plate 5]: 'They are painted to the life and death; and with their capitally adjusted colour, light and shade, their unsurpassable beauty of shape and character, and the final and most free touches of hand over them, have a peculiar charm of qualified distinct-

[44] *Highlanders Returning from Deerstalking, c.*1827 *
Oil on panel, 60.3 × 73
Collection of the Duke of Northumberland, Alnwick Castle

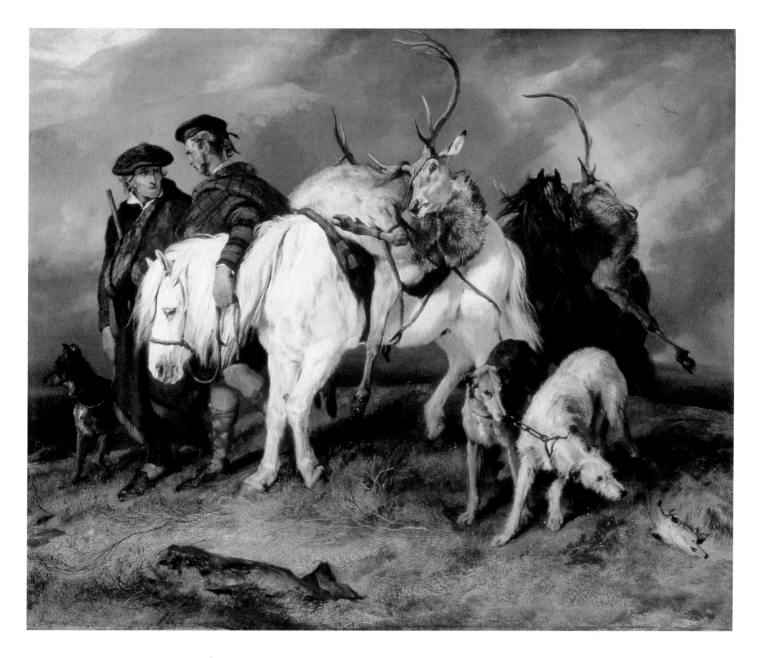

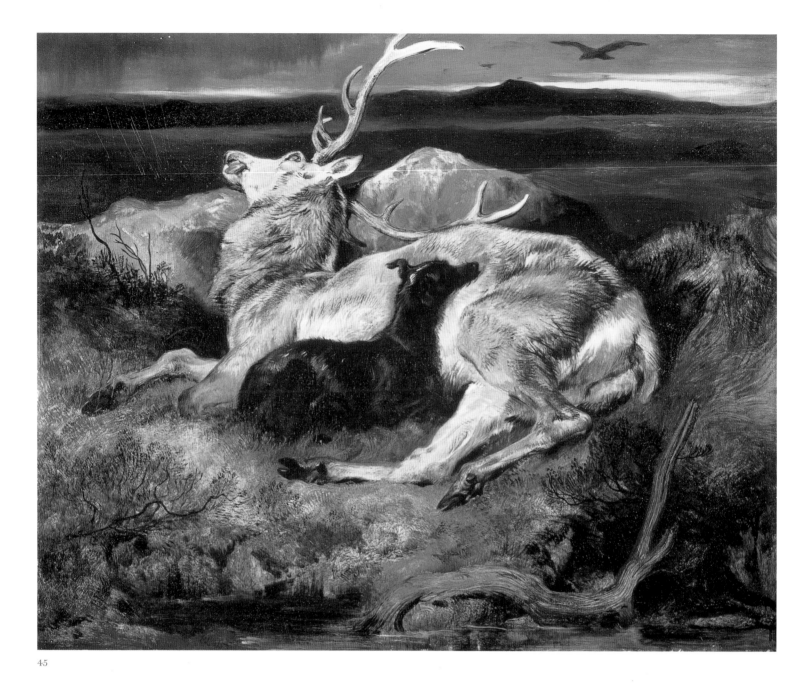

45

46

47

ness of effect which will delight the sportsman to gaze upon in the seasons of sporting cessation, as they will those who pursue the more refined pleasures of taste.'[15] The picture was purchased the following year (1828) by the London banker W. Ellis Gosling, to whom Landseer wrote at the time: 'The enclosed [the memorandum already quoted above] you may if you please paste to the back of the picture. I have not done as thinking you might possibly object to so long a History. I should like if you will give me leave to see where you place it as the picture would be assisted if the light fell on it in the proper direction.'[16]

Landseer followed up *Dead Deer and Deerhound* with two more works in a similar vein, *Deer Fallen from a Precipice* and *Deer Just Shot* [plates 46, 47], exhibited at the British Institution in London in successive years, 1828 and 1829, and sold as a pair to the sportsman and landowner, Samuel Unwin Heathcote. In these two paintings, the bodies of the animals stand out in bold relief from dark and gloomy backgrounds, and we are spared none of the graphic detail of their death agonies. The glowing colour and sensuous textures of fur, distinctively painted almost hair by hair, makes these beautiful creatures all the more pitiable. This is what deerstalking is all about – killing – and we are

faced by the reality of what is involved. Landseer deliberately dramatises the sport he loved so much, and he means to shock us and draw out our sympathy. His deer are wild animals living in extreme conditions. Like his Highlanders they have a savage and unfamiliar character to them, and it was this as much as the cruelty on display which excited the contemporary audience. Hunting is a way of life, and death its inevitable consequence, but the fate of the victims is felt to be tragic in the artist's dark romantic vision of Highland sport.

Deer Fallen from a Precipice [plate 46] may seem an improbable scenario with a dead stag wedged between rocks, having fallen from a cliff above, but such incidents of deer being driven over the edge were not unknown. Landseer's later precipice disaster, *'The Life's in the Old Dog Yet'* [plate 48], was based on a real-life event that had taken place at Black Mount, when stag and hounds had gone over a cliff in the excitement of the chase. The ghillie Peter Robertson was lowered down by rope to find one of the hounds still living. In *Deer Fallen from a Precipice*, the steeply slanted body of the stag and the plunging cliffs evoke the momentum of the animal's fall. That this has recently occurred is confirmed by the arrival of two predatory eagles

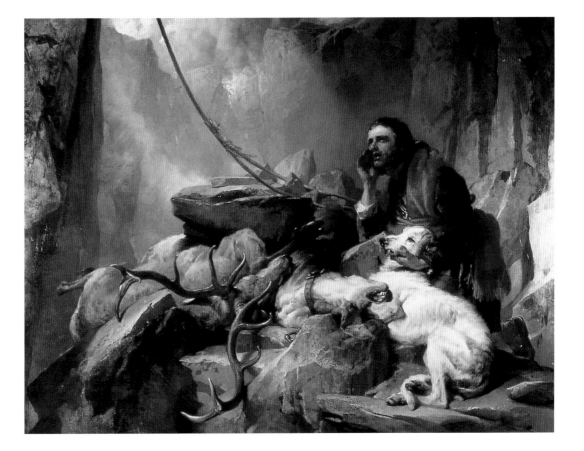

and the untouched condition of the body. The critic of *The Examiner* wrote that the artist had added 'a truly pathetic character' to 'his well-known and fine knowledge of animal form, pencilling and colour'.[17] The stag in the *Deer Just Shot* [plate 47] appears to be still quivering, tongue lolling, one foreleg and hind legs drawn up close to the body. A small wound above the shoulder indicates where the bullet has entered. Unusually the marksman here makes an appearance in the guise of an ordinary Highlander, probably a keeper but just possibly a poacher, who shields his eyes from the mist and rain as he gazes after the retreating herd.

Another unfinished oil sketch of this period, *Dead Deer with Ghillie and Hounds* [plate 49], shows a dead stag draped over a rock with its head hanging down. The unfinished state of the picture provides clues to Landseer's working methods at this early period. The figure of the resting ghillie with his back to us and those of his two hounds are sketched in quickly in monochrome, demonstrating the confidence with which the artist established the main lines of the composition. The sides of the rocks have been partially worked up, but only the body of the stag has been taken to a high degree of finish, with tiny strokes differentiating every hair of the pelt in a display of painterly virtuosity.

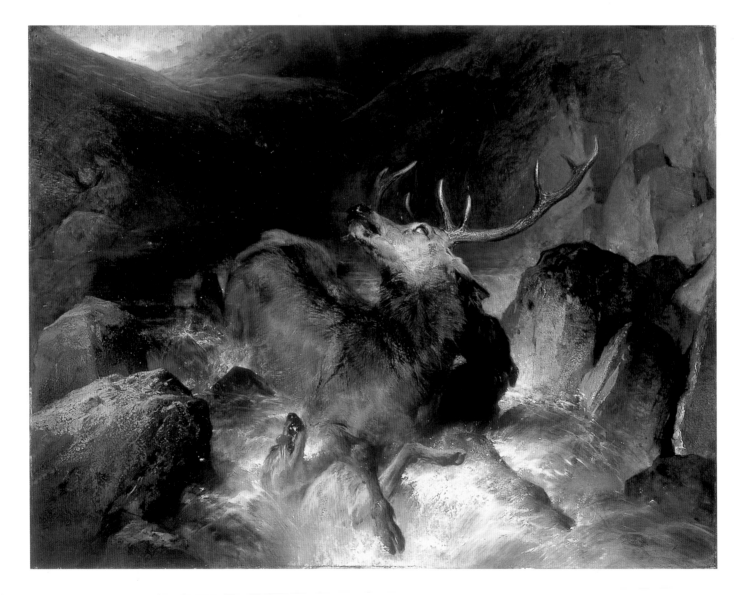

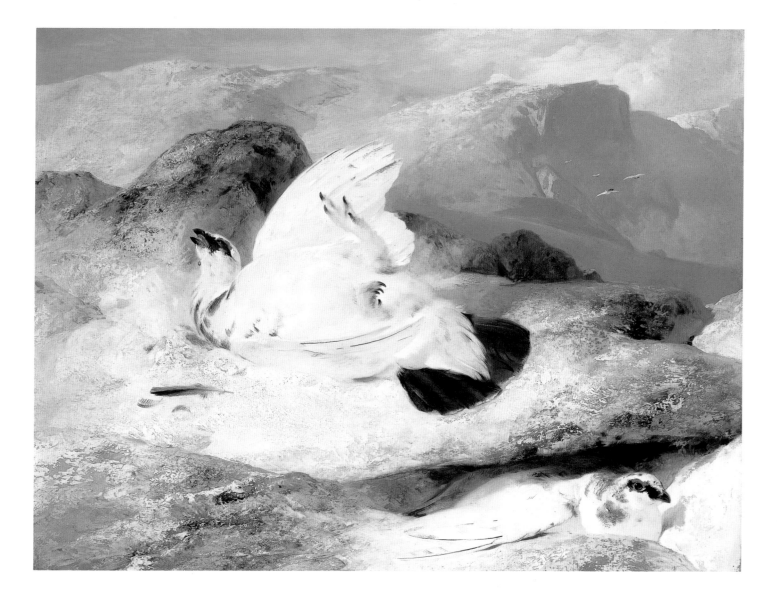

[51] *Ptarmigan, c.1833*
Oil on panel, 50.2 × 66
Philadelphia Museum of Art

The largest and most dramatic of Landseer's early deer subjects is *Deer and Deerhounds in a Mountain Torrent* [plate 50], also known as *The Hunted Stag*. Here an exhausted stag plunges towards a waterfall leading out of a mountain loch pursued by two hounds, one of whom still clings to its ear, while the other is all but submerged in the water. The upturned head and fainting eye of the stag are as pathetic as any Christian martyr, and we can only pity the death of such a sublime creature. Whether death is to come at the hands of the waterfall or the bullet remains unclear. William Scrope, a friend and fellow sportsman of the artist, describes a similar scene in his well-known book, *The Art of Deer Stalking*. A stag had been turned at bay by the edge of a waterfall:

Just at the edge of the precipice, and as it seemed on the very brink of eternity, the dogs were baying him furiously; one rush of the stag would have sent them down into the chasm, and in their fury

they seemed wholly unconscious of their danger. All drew in their breath, and shuddered at the fatal chance that seemed momentarily to take place.[18]

The setting of Landseer's picture is a dark loch ringed by an amphitheatre of hills and lit at the top by a burst of sunlight. A second *coup de soleil* dramatically lights up the foreground, accentuating the harsh surface of the rocks, the sensuous textures of animal fur and the milky translucency of the water. This last is a marvellously subtle passage of painting, with thin glazes of white and grey laid one over another. The critic of the *Athenaeum* praised the work for its 'truth exalted by feeling and skill'.[19] It was purchased by Robert Vernon, whose distinguished collection of modern masters, including one of the finest groups of Landseer's pictures, was given to the nation in 1847 [see chapter five, p.100].

Landseer's activity as a sporting artist extended to other animals besides deer. In the early

[52] *Grouse*, c.1833 *
Oil on panel, 50.2 × 59.3
Private Collection

1830s he painted a sequence of pictures of dead or dying game birds which are both intensely physical and charged with emotion. Nine of them belonged to the artist's devoted patron, friend and fellow sportsman, William Wells of Redleaf.[20]

Of the nine, one was exhibited at the British Institution in 1830 and four in 1833.[21] In these pictures the birds are generally displayed lying on the ground, viewed from above in close-up, as if they have just been shot and fallen to earth. By this means the artist introduces a note of drama into what are otherwise conventional studies of dead game. The birds are either shown dead or quivering in their death agony, sometimes on their backs, legs in the air, wings outspread. Five of the pictures show pairs of birds, with one bird either dead or wounded, which adds a further element of pathos on the human theme of grief, loss and separation.

Ptarmigan [plate 51], a brilliant study of white on white, shows a pair of white grouse in a snowy landscape set on the mountain tops of the Cairngorms. Tell-tale drops of blood reveal that the second bird has also been shot and is doomed like its mate. The picture inspired a protest from the art critic of *The Examiner*, when the picture was exhibited at the British Institution in 1833: 'The suffering of the innocent creature, its beauty and the purity of its colour, unite in producing a feeling of pity in the spectator, and forcibly suggests the question, "Is it justifiable to put a sentient being to pain merely for our amusement?" A hardened sportsman even, we should think, would find it difficult to answer in the affirmative; and a kind-hearted one, (for such there certainly are,) after gazing upon this touching performance, would, as a friend observed, be disposed to go and break the fowling-piece.'[22] *Grouse* [plate 52] is a picture in the same style: a dead cock with wings spread out lies in a hollow among the heather watched over by its faithful hen which is also guarding two chicks. The mountains in the background are almost certainly the Cairngorms. *Roe's Head and Ptarmigan* [plate 53] is a still-life of dead game in the style of the Dutch and Flemish masters. The setting itself is indeterminate and the dead animals have been deliberately grouped for picturesque effect. *Young Roebuck and Rough Hounds* [plate 54] is a play on the same theme, a decorative composition with the body of a dead deer draped over a rock flanked by four hounds.

[53] *Roe's Head and Ptarmigan* (also called *Ptarmigan and Roebuck*), c.1833
Oil on panel, 22.9 × 30.5
The Art Institute of Chicago

[54] *Young Roebuck and Rough Hounds*, c.1840 *
Oil on panel, 53.3 × 43.2
Victoria & Albert Museum, London

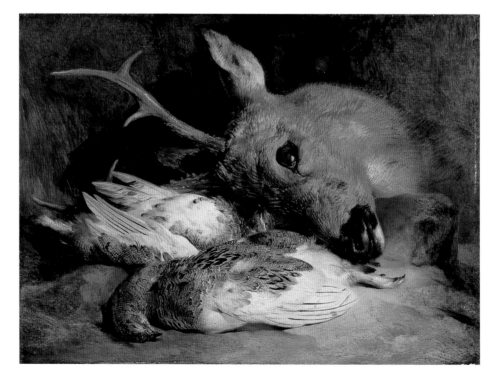

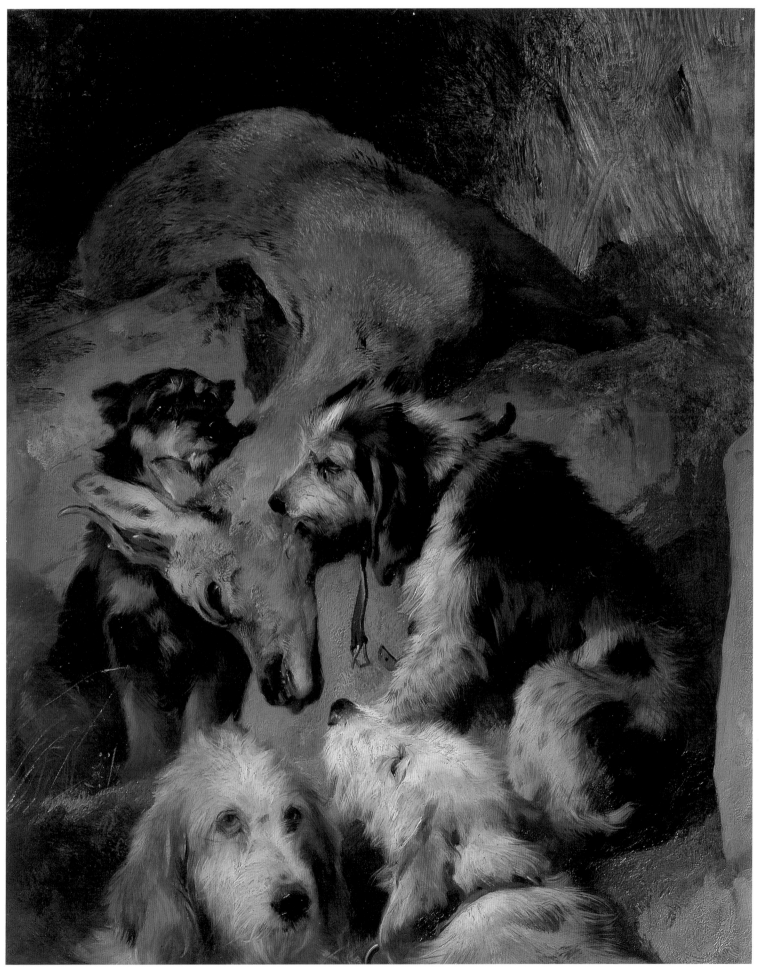

54

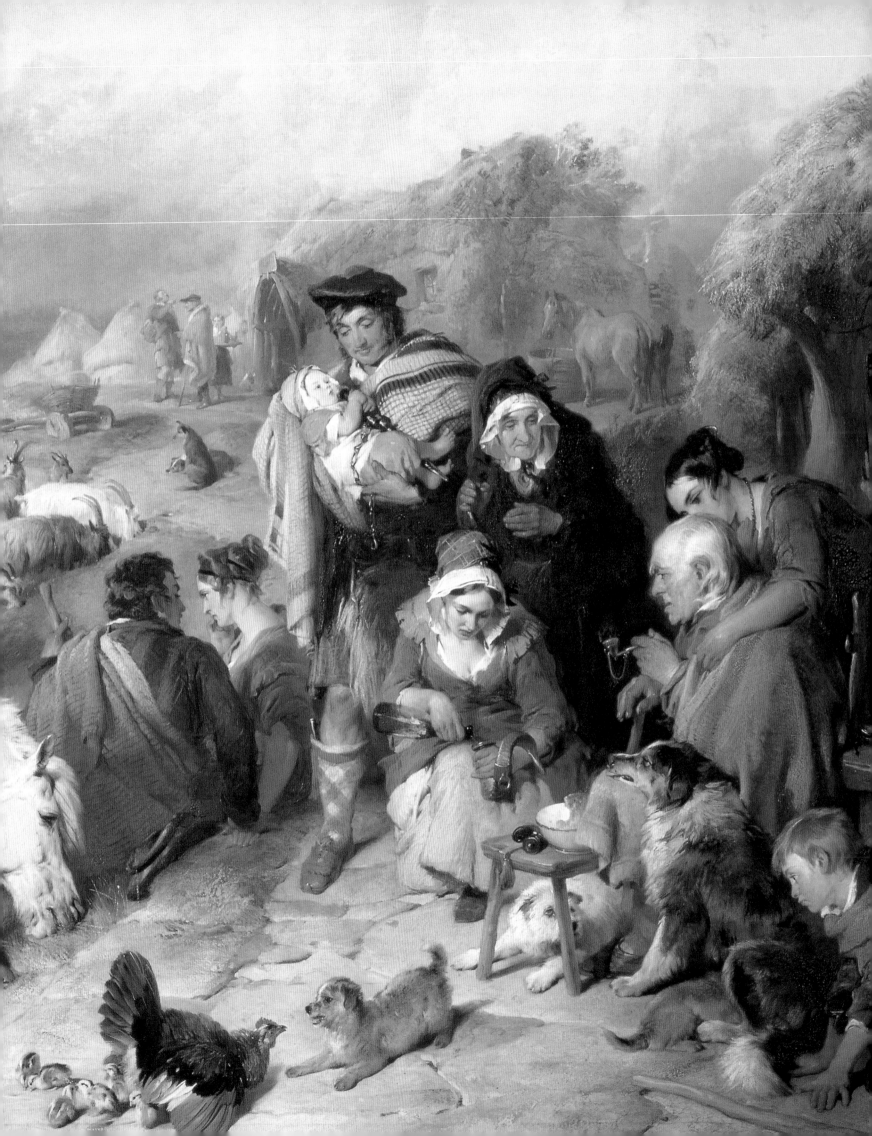

3 · HIGHLANDERS

Like his history paintings and his sporting groups, Landseer's pictures of Highlanders reflect the influence of Sir Walter Scott. The artist's vision of a primitive people leading simple lives in close communion with the natural and animal world stirred the imagination of his audience. His Highlanders are presented as a race apart with their own particular culture and mores, tougher, more resourceful and unyielding in their struggle for existence than the rest of us. Like the characters in Scott's novels, the people in Landseer's pictures come across as bold, colourful, picturesque and larger than life. In his survey of Highland types, the artist contributed to that vision of Highland society as one untainted by the corrupting influence of modern industrialisation and materialism, living the good and simple life in the wild. It reinforced the idea that Highland rather than Lowland traditions were the defining character of the Scots, at the very time that the glens were emptying and Highland society changing out of all recognition.

Landseer's scenes of Highland life do not have a literary source, unlike so many of the popular genre pictures of this period. Yet his presentation is often quite theatrical with the main participants carefully staged in atmospheric surroundings. Landseer was keenly interested in the processes of the stage, organizing amateur theatricals and tableaux-vivants at Woburn Abbey and other stately homes.[1] He was a theatre-goer himself and he numbered several actors among his friends, among them the comedian Charles James Mathews, Arthur Young whom he painted as King John (Garrick Club, London) and William Charles Macready in whose diaries he often features. Landseer's figures often seem like characters from the stage, and the construction of the picture space and the dramatic manipulation of light and dark suggest the illusionism of the theatre. Macready had created a famous role as a tartan clad Macbeth, and there were theatre productions based on Scott's novels, like the musical drama of *Rob Roy* written by Isaac Pocock in 1818. David Wilkie's picture *The Rent Day* (private collection) inspired a pictorial and domestic melodrama of the same title by Douglas Jerrold, first performed at Drury Lane in 1832.[2]

The theatrical analogue can be pressed too far. Unlike plays in the theatre which are seen at a distance, Landseer's subjects are viewed at close range. Their veracity depends on the highly polished realism with which the artist invests every detail of the scene. Like David Wilkie, Landseer is a master of the accessory, filling his pictures with carefully selected artefacts which elucidate the lives and occupations of his characters. Nothing is there by chance, and we have to learn to read his pictures through the clues presented by the humble objects of everyday existence. In Landseer's pictures we experience the reality of beaten earth floors, battered beams and planked walls, cooking pots and hearths open to the sky, simple benches, alcove beds, wooden buckets and items of personal use. The costumes of his figures are just as sharply observed, an inventory of kilts and plaids, gartered stockings, Scotch bonnets, rough shoes and boots. And the animals in these pictures are painted with a fidelity to nature and a characterfulness for which the artist was famous.

Landseer's vivid transcription of reality and his virtuosity as a painter were never ends in themselves, as the famous art critic John Ruskin recognized in his critique of *The Old Shepherd's Chief Mourner* [plate 66]. What distinguished this picture from hundreds of others of equal artistic merit was the quality of thought and emotion which the artist displayed, 'by which it

< Detail from plate 75

[55] *Old Peasant Caresses a Kitchen Maid* by David Teniers the younger, *c.*1650
Oil on oak, 43.2 × 64.9
National Gallery, London

[56] *The Highland Whisky Still* by Sir David Wilkie, 1819
Oil on panel, 64.8 × 95.9
Private Collection

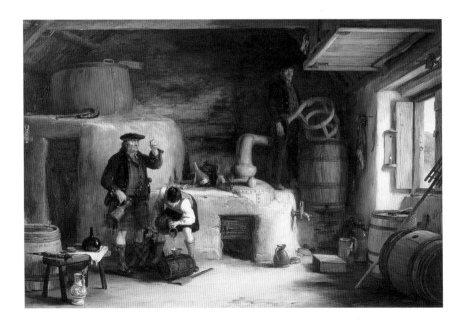

ranks as a work of the highest art, and stamps its author, not as the neat imitator of the texture of a skin, or the fold of a drapery, but as the Man of Mind'.³ Landseer is a moralist intent on uncovering the deeper workings of the human and the animal world. It was the emotional appeal of his works quite as much as their realism which made his work so popular across the whole spectrum of society. His Highlanders and their dogs stand for loyalty, sturdy self-reliance, physical hardiness, courage and a simple Christian faith. In their savage habitat, they exhibit a humanity and self-respect that would have put most of their southern neighbours to shame. The old crone cooking for her absent husband [plate 62], the shepherd playing his bagpipes for the benefit of his dogs [plate 61], the stiff-legged old man breaking stones by the roadside [plate 73], or the High-

land mother suckling her baby [plate 65] are affecting characters who arouse our feelings and sympathies. We can imagine what they are like, why they behave as they do and how they survive. Landseer also exhibits the other side of the coin, the poachers and whisky distillers, wild-eyed desperadoes for whom Landseer has a sneaking regard. In a remote, poverty-stricken society, resistant to authority, poaching and distilling were looked on with indulgence by much of the population.

Startlingly realistic scenes of everyday life had been pioneered by the Scottish artist, David Wilkie (1785–1841), in the first years of the nineteenth century.⁴ Wilkie drew on the superbly crafted scenes of low life painted by the Netherlandish artists of the seventeenth century, who were then enjoying a resurgence of popularity. David Teniers the younger (1610–90) became famous for his pictures of rustic life in Flanders, and he was an inspiration to Wilkie as he was to Landseer [see plate 55]. The realism with which Teniers invested every detail of his scenes, especially his interiors with their wealth of accessories, and the characterfulness of his figures, touched two chords of contemporary taste – a love of the natural and an appetite for story-telling.

Wilkie absorbed the lesson and took it a stage further. He studied the peculiarities of human physiognomy and gesture to create figures, who are physically and emotionally true to life. His pictures document the reality of the Scottish rural scene and bring its characters to life in compositions rich in incident revealing of human behaviour and psychological nuance. The early pictures he showed at the Royal Academy, like *Village Politicians* (1806, collection of the Earl of Mansfield), *The Blind Fiddler* (1806, Tate, London), *The Rent Day* (1809, private collection) and *Blind Man's Buff* (1812, Royal Collection), struck an entirely new note in the art of the time and made Wilkie a national celebrity, almost overnight. Where he led, others soon followed, and there grew up a whole school of painters of the everyday world. Among its early champions was Landseer's friend, William Mulready (1786–1863), whose highly finished narrative scenes, often involving boys fighting or at play, are subtle and complex.⁵

Without Wilkie there would have been no Highland scenes by Landseer, but Wilkie was

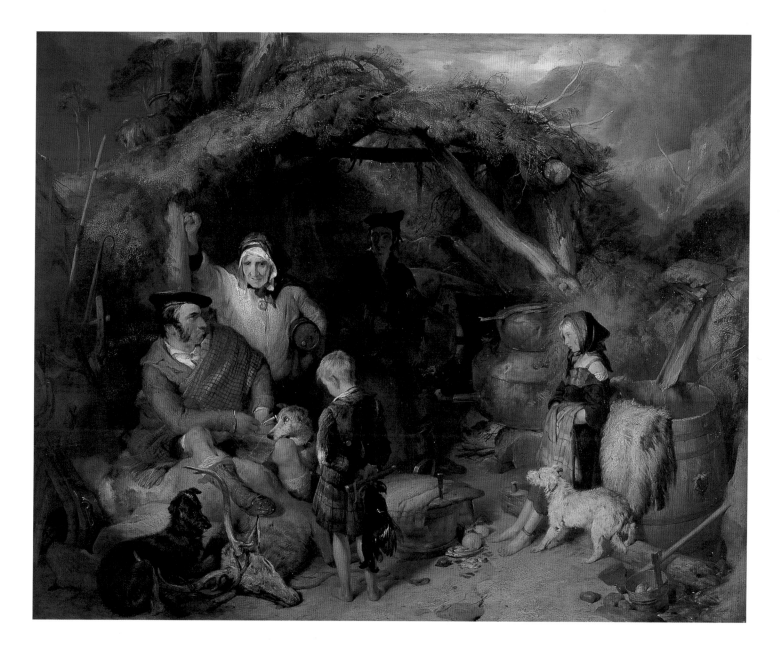

[57] *An Illicit Whisky Still in the Highlands*, 1826–9 *
Oil on panel, 80 × 100.3
English Heritage (Apsley House, London)

painting his more than twenty years earlier and he had abandoned the tight realism of his early style by the time that Landseer took up the theme. Judging by the tone of the few surviving letters between them, the two artists were well disposed towards each another.[6] Landseer comes closest to Wilkie in pictures like the *Illict Whisky Still* [plate 57], where there is a psychological edge and a moral undertone. Wilkie's *A Highland Whisky Still at Lochgilphead* [plate 56], painted ten years before Landseer's picture, sets up a similar dialogue between foreground and background figures, but it is a more restrained exercise in anecdotal genre painting. Landseer's figures are larger in relation to the picture space and more assertive, and his romantic treatment of bothie and mountainous terrain contrasts with Wilkie's cool, precise touch. The main

protagonists in each picture, however, are alike in their character as tough and resourceful Highlanders, and accessories play a similar supporting role. The majority of Landseer's Highland scenes present one or two figures, not the cast of characters Wilkie preferred, and they cannot be read as complicated narratives in the same way. A more famous picture of illegal distilling by Wilkie was exhibited in 1840, *The Irish Whiskey Still* (National Galleries of Scotland, Edinburgh), but, painted in the artist's broad, late style, it is different in character from Landseer's work.

Highlanders were in vogue in the 1820s and 1830s, and others besides Landseer followed Wilkie's lead. The latter's follower, Alexander Fraser the elder (1786–1865), painted several Highland scenes, among them *A Highland*

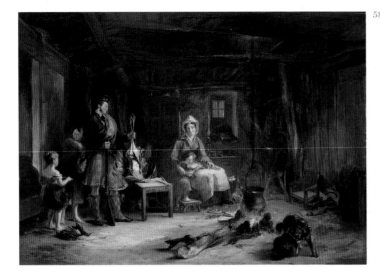

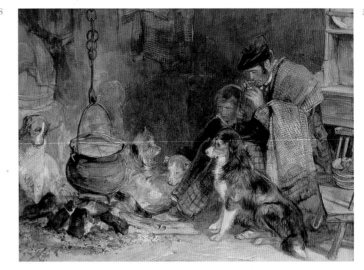

[58] *A Highland Sportsman*
by Alexander Fraser, 1832
Oil on panel, 78.1 × 109.3
National Gallery of Scotland,
Edinburgh

[59] *Watching the Pot –
Scene in a Highland Cottage*
by John Frederick Lewis, *c.*1832
Watercolour, 25.6 × 35.3 · Private
Collection courtesy of Agnew's, London

[60] *Young Girl
Carding Wool,*
*c.*1830 *
Oil on board, 33 × 22.8
Private Collection

Sportsman [plate 58], which reflect the influence of his master. Fraser's picture lacks the sophisticated imagery and technical finesse of Landseer's art, but his work proved popular and several of his subjects were engraved. Other artists contributing to the Highland vogue include Jacob Thompson (1806–79) and Landseer's old boyhood companion, J.F. Lewis (1805–76). The latter spent a season in Scotland in 1832, producing a sequence of Highland interiors [see plate 59], many in watercolour, which rival those by Landseer. Later artists contributing to the genre include J.F. Herring (1795–1865) and Richard Ansdell (1815–85).

Landseer's pictures of Highlanders fall into two distinct categories: firstly, interiors with figures engaged in simple domestic occupations, and, secondly, outdoor scenes involving deer-stalking, wood-gathering, stonebreaking, shepherding, harvesting and droving. Other types of labour are under-represented, especially those involving agriculture and crofting. There are no references to the distress and evictions suffered by many Highlanders, which have left a lasting memory of bitterness and betrayal. Sheep and deer replaced the small holdings of tenants in many parts of the Highlands during the early decades of the nineteenth century, as landowners struggled to make their estates profitable. In Landseer's pictures of the late 1820s and early 1830s, we are shown a settled and traditional society, not one in flux. As a summer visitor, it is doubtful how much he knew about the clearances or appreciated their significance. As Christopher Smout demonstrates [see pp.14–15], the impact of the clearances varied widely from one area to another, they took place over a long time-span

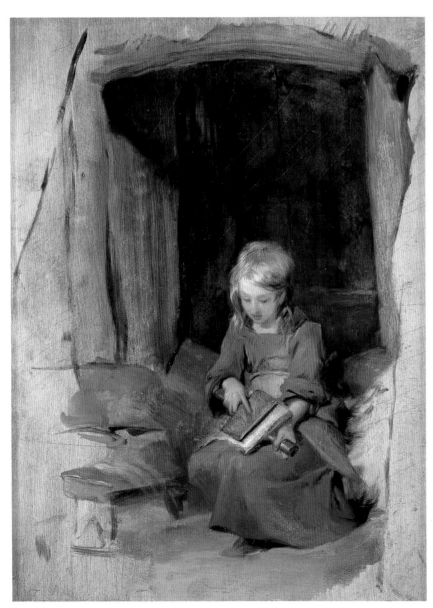

60

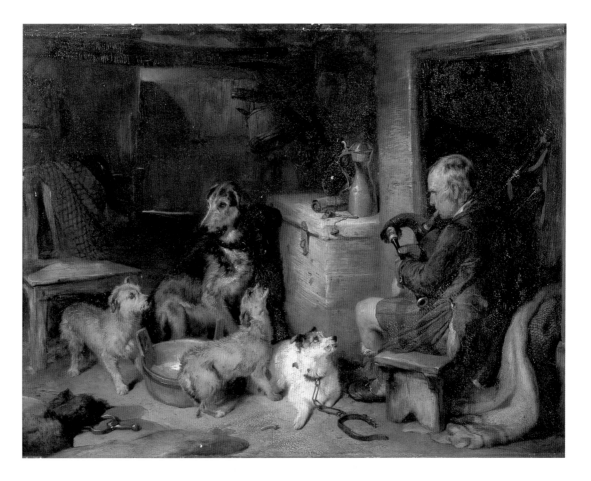

and resistance and violence were sporadic. Landseer's Highlanders are drawn from the ranks of ghillies, shepherds, drovers and labourers, and though often poor they are not destitute. Even the stonebreaker, at his remorseless and repetitive task, is well turned-out and the young girl bringing him his dinner is blooming [plate 73]. Landseer's characters are the deserving poor, who are well above the breadline.

No records survive to document how Landseer conceived and carried through his figure subjects. Several rough oil sketches of Highland interiors are known, some related to finished pictures, and for the *Highland Whisky Still* there is a significant group of surviving

studies in oil and pencil. Some, like the delicious study *Young Girl Carding Wool* [plate 60], are clearly from life. It is unlikely in view of his social and sporting obligations that Landseer would have had the time to finish his compositions while staying in the houses and castles of his Scottish friends. What seems probable is that he generated ideas for pictures set in the Highlands which he then brought to completion in his London studio; this would have been normal practice at the time. However, according to its first owner, Robert Vernon, his picture of *Highland Music* [plate 61] was 'painted from nature, Glenfeshie, 1830'.[7] The Highlanders Landseer painted were probably tenants or retainers of the noblemen with whom he stayed, and thus enjoyed a relatively privileged position in society. Landseer may also have employed Scottish models in London, surrounding them with appropriate accessories gathered on his travels. What is clear is the painstaking process involved in the creation of these meticulous and finely detailed genre scenes.

The earliest example is the *Interior of a Highland Cottage* [plate 62], which was shown at the British Institution in 1826, along with the *Scene on the River Tilt, in the Grounds of His*

Grace the Duke of Bedford [plate 32], which has already been described [see pp.42–3]. The old woman who appears in the latter picture super-intending the cooking may well be the same model that the artist used in the *Interior of a Highland Cottage*, and perhaps a retainer well known to him. In the latter picture she appears as a formidable figure squatting on a bench, with a walking stick beside her, and dressed in layers of clothing. The spotlight from above falls on her upturned face, framed by swathes of white bon-net and lining, peering out with an expression of lively intelligence and some anxiety, lips parted, as if something outside has caught her attention. The cat mimics her look, and the attitude of the dog, with ears pricked, is similarly expectant. Force of character, canniness and fortitude are written across her features and strong, knarled hands.

The woman is tending a single cooking pot suspended over the fire from an iron hook at-tached to a wooden frame. The presence of a man is indicated by the pair of stockings on the chest and the bonnet on the far right. A pair of potatoes on the chest and three dried herrings strung up above emphasize their Spartan diet. Lighting from the hole in the roof is cunningly controlled to highlight the details Landseer wants us to note: the rough-hewn timbers and beams; the square cistern and rocks above the fireplace; the sloping roof and the corner of a bed in a shadowy alcove; the wooden bowl and flagon on the chest; the key attached to a ram's horn (indicating valuables); the plaid, the basket and brush; the bucket on the right and the net on the upright post; the sprigs of heather scattered on the floor. Through this inventory of forms and objects, treated as a series of still-life motifs, Landseer unfolds the story of this poor but decent Highland woman. The harshness of her environment has taught her to be fierce and self-reliant, yet she is shown to be attached to her home, her animals and her husband and to be leading a good but simple life. The expectant attitude of herself and her animals introduces a note of drama into an otherwise peaceful scene, and the heavily contrasted lights and shadows add to the atmosphere of suspense. Though a modest work, the picture was singled out by reviewers of the British Institution exhibition and widely praised, while the artist's smaller sporting pictures were ignored. The features of

the old woman riveted the attention of one reviewer who felt she would have been a worthy model for Sir Walter Scott. She pleased another critic more than any other female in the gallery except a picture of Mary Stuart:

We were so [i.e. pleased], *on account of her more nature-bred character, so devoid of all assump-tions, but replete with the opposite character, so much praised but little expected by Critics – simplicity. This picture has great intensity of tone, effected by positive blue and dark grey strongly contrasting with white, and the warmth of Vandyke brown, the fire and flesh tints. This cold contrast has a sort of moral gravity in it, assorting with and aiding the grave character of an old female, with her admirably broad simplic-ity of dress, the humble character of her cabin, the bin, dried fish, hearth fire, &c.*[8]

The success of the picture may have surprised Landseer but he did not follow it up with another interior until *Highland Music* [plate 61] four years later. Instead he turned in another direc-tion. *Highlanders Returning from Deerstalking* [plate 44; for description, see p.50] and *The Bogwood Gatherers* [plate 63] were outdoor scenes exhibited in successive years, 1827 and 1828. They are both works of exceptional quality, painted in transparent glazes and luminous colour, with crisp detail and a lovely painterly facture. The shaggy old grey pony that appears in both pictures may well be one and the same animal. In *The Bogwood Gatherers*, the pony waits patiently with its load of wood and gorse, while in the middle distance its owner, in the attitude of an antique sculpture, hews a stump of wood gathered from the bog. His daughter peeps out shyly from behind the pony's fringe, with a bowl of berries beside her; she clasps the ear of the animal and proffers a sprig of heather. The Highlander's dog sits opposite beside another stump soon to be chopped up and transported. The landscape behind sweeps away across a sunlit stretch of heath to a loch with glinting water and to a line of distant hills. The High-lander is wisely laying in fuel before the onset of winter. This picture, together with a second version of *Highlanders Returning from Deerstaking* (private collection), may have been the first work by Landseer which his patron, William Wells of Redleaf, acquired from him [see chapter five, p.100 for more on Wells].

The most significant of Landseer's early

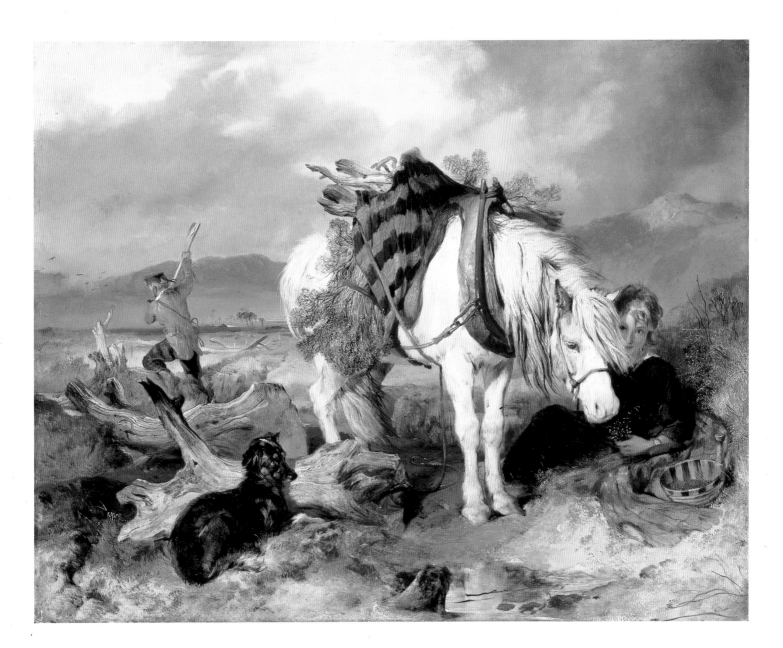

[63] *The Bogwood Gatherers* (also called *The Wood Cutter*), c.1828 *

Oil on panel, 31.8 × 61
Private Collection, courtesy of Robert Holden Ltd

Highland scenes was *An Illicit Whisky Still in the Highlands* [plate 57], exhibited a year after *The Bogwood Gatherers*, in 1829. The origins of the picture go back to 1826 when the first Duke of Wellington commissioned the work on the advice of Sir Walter Scott. The Duke had acquired a famous group of old master paintings during his campaigns in Spain, but he was not well-known as a patron of contemporary art. He had commissioned a celebrated work from Sir David Wilkie, *Chelsea Pensioners* (Apsley House, London), and he must have looked to Landseer to produce another work of similarly anecdotal character, human interest and fine detail. He was not the first nor the last of Landseer's patrons to experience delays in the delivery of his picture, and the artist had to write to the Duke in 1829 to remind him of the commission and the agreed subject.[9] There were no recriminations and the

Duke later commissioned a second work from the artist, *Van Amburgh with his Lions* (c.1848, Yale Center for British Art, New Haven).

An Illicit Whisky Still might be thought an odd subject for a military hero, but it belongs to a class of subject of brigands, poachers and smugglers popular at the time. The high cost of excise duties imposed on whisky at the end of the eighteenth century led to illegal distilling on a large scale. Unable to suppress or police the trade, the authorities in 1823 replaced the high tariffs with a flat licence fee and low rates of tax. This paved the way for an organized distilling industry, with growing numbers of distillers operating within the system. Landseer's picture, therefore, records an illicit trade that was fast disappearing, and like many of his images can be construed as a nostalgic, backward look at the good old days or, in this case, the bad old days.

The picture represents a simple wood and turf shelter partly built into the roots of a tree. Two stills are visible within the shelter, both heated by fires, together with a square waterbut served by a wooden pipe. The fire casts a lurid light over the face of a young man who is shown tending the stills with a funnel in his hand. The main action is staged outside. A haggard old woman leans against one of the posts of the shelter with a keg under her arm, looking intently at the truculent Highlander, who has just emptied his glass, to test his reaction to the brew. Sporting a bonnet, kilt and tartan plaid, the Highlander sits astride the carcase of a stag with his hounds by his side. In front of him is a nervous-looking boy with head hung down, barefoot and in tattered clothes, holding a blackcock and a telescope behind his back. Some critics have assumed that the children belong to the distiller, but it is more likely that the boy has been assisting his huntsman father who is almost certainly a poacher. The girl at whom he looks with no very pleasant expression is leaning against a water butt, her hands clasped and hidden under her apron. She, too, has a timid, disconsolate expression on her face, perhaps in response to a reprimand from the huntsman who may be her father. The psychological tension evident in the attitude and behaviour of the four main protagonists suggests a moral play on the theme of corrupting adults and innocent children. There is, however, no explicit story and there have been various readings of the ambiguous relationships between the figures.[10]

The prominent accessories chart the lives of these wild Highland characters: the shepherd's crook and horse collar on the left; the tub in the centre with board and knife on top, a pair of swedes and the remains of a bird below; a sheep's fleece hung over the water butt; the axe and pail in the right hand corner; and a goat chewing leaves on top of the shelter. In the background a wild Highland landscape mirrors the lawless behaviour in front. According to a later account, the picture was painted 'on the spot itself in a hidden glen, and alike far from excisemen and teetotallers', but fails to identify the spot.[11] An oil sketch of a Highlander looking out from his distillery may have been the starting point of Landseer's picture (private collection). The composition, developed in subsequent oil studies, clearly went through a long process of refinement and it was taken to a high level of finish.

The picture was recognized at once as an important work of art when it was first exhibited at the Royal Academy of 1829, and it received extensive coverage in the journals and newspapers of the day. The critic of *The Examiner* called it 'a capital performance, picturesque, nationally characteristic, well coloured and as wild as the Highlands in which the scene is placed'.[12] Another critique from an unidentified source described the work as 'full of interest and spirit; the wildness of the sport, the grouping of the figures, the skilful distribution of chiaroscuro all take a strong hold on the fancy – nothing better imagined than the lawless distiller, old and apathetic crone, dejected and alarmed girl, which have the moral force of a Hogarth.'[13]

It is no coincidence that the majority of Landseer's Highland scenes were painted in the years immediately following *An Illicit Whisky Still*. The artist had struck a rich vein of original subject matter that was highly marketable. The *Stonebreaker* and *Highland Music* were exhibited in 1830; three more interiors followed in 1831 together with three poaching scenes; the *Auld Guid Wife* and *Lassie Herding Sheep* appeared in 1832; the impressive *Harvest in the Highlands*, a joint work with his friend, Augustus (Later Sir Augustus) Wall Callcott, in 1833; *A Highland Breakfast* a year later; *A Scene in the Grampians – the Drovers' Departure* in 1835; and the sequence closed in 1837 with *The Old Shepherd's Chief Mourner* [plate 66], a run of just over ten years. In the early 1830s, Landseer was spending a lot of time in the remote valley of Glenfeshie with the Duchess of Bedford, and it is probable that some of his ideas for paintings were developed there. He was also painting a series of vivid outdoor landscape sketches in the same part of Scotland [see pp.85–8].

In his genre scenes Landseer presents us with a cast of colourful and heroic Highland characters defined in terms of their houses, their animals and the domestic detail of their lives. We can deduce what manner of men and women they are from the wealth of material evidence which Landseer puts before us. The artist taps into emotion at every turn, making us aware of the humanity that exists in even the bleakest of lives. It was the expression of feeling and sympathy which raised Landseer's subjects out of the

ordinary and captured the hearts of his contemporaries. Landseer domesticated the primitive and alien Highlanders and made them come to life for an English audience.

In his sequence of Highland interiors, Landseer depicts the local people living in close community with their animals and in communion with nature. Their primitive bothies consist of a single space with a rough hearth open to the sky, a chest, a chair or two, a bed, a range of simple pots and pans, pails and utensils. Lighting is generally from the side, as if from an unseen window, although our presence leaves open the side nearest to the front of the picture space. The figures are carefully arranged parallel to the picture plane in set-piece compositions as if conscious on being on show, not caught off guard in private moments. It is difficult in most cases to guess their means of livelihood or to draw social distinctions between them. The bothie in the *Interior of a Highlander's House* [plate 64] is larger and more comfortable than most, and the Highlander seemingly more prosperous than his neighbours. The dead game lying at his feet suggest that he is a keeper legitimately bringing home the spoils of the chase and not a lawless poacher. The atmosphere of the home is peaceful and benign, the day's sporting action recollected in the quiet of the evening. The man's good wife is bent over the cooking pot, his pretty daughter brings him a bowl of food, and the man himself, quietly smokes a pipe and holds a biscuit aloft for his eager begging terrier.

The space in *Highland Music* [plate 61] is more cramped; there is no sign of a wife or family; the solitary old Highlander has only his dogs for company; yet the bond between man and beast is eloquently expressed through their shared enjoyment of the music. One art critic called the Highlander a 'Scotch Orpheus, charming with his pipe a number of dogs, who are listening to the music with all the delight and attention of veteran amateurs'.[14] The artist contrasts the lively attitudes and expressions of the dogs, which have just been fed, with the dour and stolid form of their master. He is seated to the side looking inwards, his head in profile, while his dogs occupy the spotlight centre stage. A brightly lit bin occupies the middle of the composition and the interior shades away into darkness. The character of each dog is carefully distinguished from the yelping, ecstatic Dandie Dinmont to the dignified old hound, and they are made to seem almost human in their spirited

[64] *Interior of a Highlander's House* (also called *Highland Interior*), c.1831 *

Oil on panel, 69.8 × 85

Private Collection, Scotland

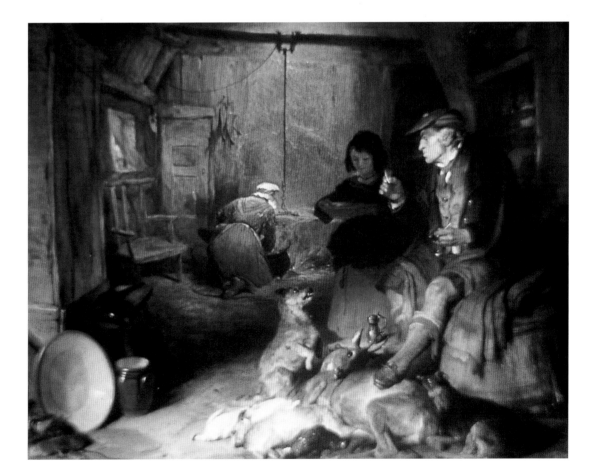

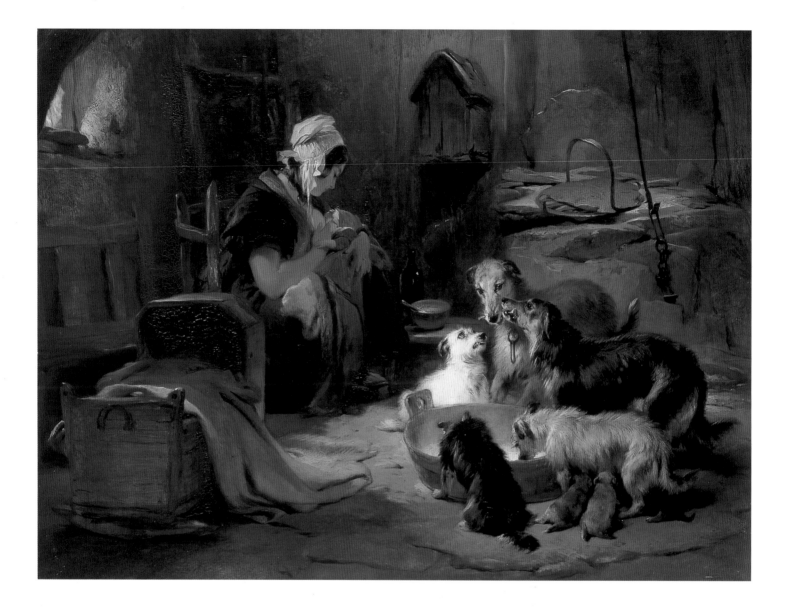

[65] *A Highland Breakfast, c.1834* *
Oil on panel, 50.8 × 66
Victoria & Albert Museum,
London

response to the skirl of the bagpipes. The picture tells us both about the bleak outward circumstances of the Highlander's life and the inner workings of his heart.

Too Hot (private collection) and *A Highland Breakfast* [plate 65] are works in the same vein. In the first, a young boy is shown feeding a cluster of dogs with a spoon from a large round tub; he restrains one over-eager dog as he goes round the group in turn. The cast of dogs, terrier, Dandie Dinmont and collie, is similar to that of *Highland Music* but they are not identical. *A Highland Breakfast* shows a young Highland mother tenderly suckling her baby while her dogs feed from a tub nearby. One of the terriers is suckling its young to underline the natural functions that link the human and the canine worlds. Shared intimacy and mutual interdependence is the sub-text here. The delicacy of feeling is underscored by the subtle treatment of

the interior, one of Landseer's best. A shaft of light from the small window on the left glances off the bonnets of mother and child and the edge of the blanket covering the cradle to fall full on the group of dogs, who are pictured like characters in a play. The white terrier and the deerhound look longingly at the bone, which the collie has been fortunate enough to secure. Such byplay with its anthropomorphic suggestion of human motives and jealousies was something which Landseer's contemporaries relished. He was already famous for humanizing his dogs in works like *Low Life* and *High Life* (*c*.1829, Tate, London), and *A Jack in Office* (*c*.1833, Victoria & Albert Museum, London), and he was to do the same in his Highland scenes.

The most famous of these was *The Old Shepherd's Chief Mourner* [plate 66]. Here, in a transposed image of human grief, a Highland collie rests its head on the simply draped coffin

of its master. It was the critic John Ruskin, with his keen eye for detail, who saw that the 'exquisite execution' of the accessories was a language in which Landseer could express the deepest emotions of the subject: the 'close pressure of the dog's breast against the wood'; the 'convulsive clinging of the paws, which has dragged the blanket off the trestle'; the 'total powerlessness of the head' laid upon its folds; the 'utter hopelessness' of the down-turned eye; 'the rigidity of repose which marks that there has been no motion nor change in the trance of agony'; 'the quietness and gloom of the chamber'; 'the spectacles marking the place where the Bible was last closed, indicating how lonely has been the life – how unwatched the departure of him who is now laid solitary in his sleep'. In Ruskin's view, these things singled Landseer out as 'the Man of Mind', and separated his picture from 'hundreds of equal merit, as far as mere painting goes'.[15]

Landseer was not above parodying his own work. *Comical Dogs* [plate 67] is a skit on Highland types and the artist's depiction of them. A terrier in a Scotch bonnet gives us a wry, appraising look, while his mate in a cap several sizes too large, adopts a begging posture. They might be any Highland Darby and Joan, characterized in terms of human attributes. The critic of the *Athenaeum* was perplexed 'whether more to admire the fun of the *party* (to speak as the diplomats do) in the grandmother's cap, with the stump of a pipe in his mouth, or the drier humour of him in the shepherd's bonnet, with the mull *at his paws*. The picture is sure to attract many gazers – who will forget the slightness of its execution in the quaintness of its design.'[16]

Not all of Landseer's interiors present us with a comforting vision of Highland life. The figure in *The Poacher's Bothie* [plate 68] is a wild-eyed, villainous looking individual, crouching with a dead stag under a low beam and looking fearfully towards the window at the approach of someone

[66] *The Old Shepherd's Chief Mourner, c.*1837 *
Oil on panel, 45.8 × 66
Victoria & Albert Museum,
London

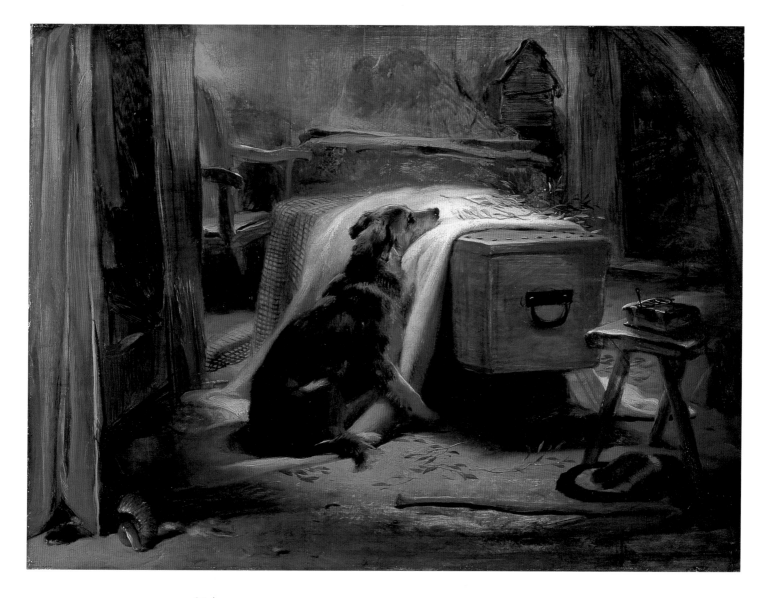

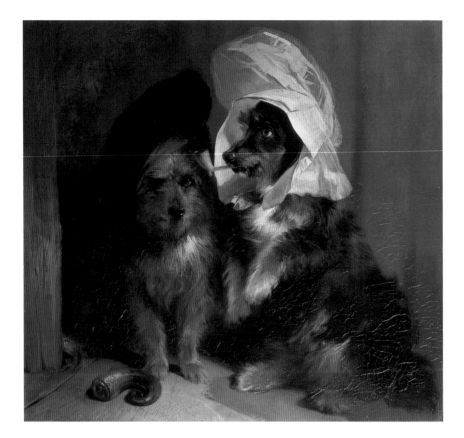

[67] *Comical Dogs, c.*1836 *
Oil on panel, 69.8 × 76.2
Victoria & Albert Museum,
London

outside. His leg is over his dog, which is also crouched tensely and looking upward, in order to restrain it from moving or barking. The poacher holds a knife with which he is preparing to slit the throat of the deer and drain its blood into a bowl. The empty whisky bottle emphasizes his dissolute way of life.

In the battle between forest owners and poachers the wild deer did not appear as private property in quite the same way as other possessions. It was not to be expected that men living on the edge of civilization and used to ranging the hills would be prevented from killing wild game when opportunity occurred. In spite of special game laws, aimed especially at discouraging armed poachers acting in concert, poaching was endemic in Highland society and sometimes

[68] *The Poacher's Bothie,*
*c.*1831
Oil on panel, 45.2 × 61
Hamburger Kunsthalle

resulted in violent confrontations. In the see-saw contest between the forces of law and order and the free-booting customs of the Highlands, some poachers acquired notoriety for their skill and daring as stalkers and marksmen. Two well-known such characters, Charles Mackintosh and Malcolm Clarke, together with a third unidentified man, figure in Landseer's beautiful picture of *Poachers Deerstalking* [plate 69]. It is not at first sight obvious that they are poachers, for they are well turned out and the leading figure might pass for a gentlemanly sportsman attended by his keepers; a variant version of the design does indeed show the artist's great friend, the sportsman and photographer Horatio Ross of Rossie, with a keeper (private collection). On closer inspection, the long hair, rough coat and plaid of the foremost figure marks him out as a local Highlander. Behind him, crouching tensely with the dogs, is his younger companion. Rifles in those days were rarely accurate enough to kill a stag with a single shot and it was necessary to hunt down the wounded animal with dogs. The line of crouching figures is a graphic illustration of the art of deerstalking which necessitates crawling over rough terrain, and staying down wind of the deer, to get within range for a shot. The air of tension and suspense which they give off is due both to the excitement of the hunt and the fear of discovery. From being hunters they could in turn become the hunted.

In *Poachers Deerstalking* there is no sense of moral judgment, as there had been with *The Poacher's Bothie*, rather admiration for their skill, resourcefulness and physical endurance. The composition is classic and well-ordered in comparison to the fragmented design of another poaching scene, *How to Get the Deer Home* [plate 70]. The poacher here has just shot a stag and is peering through the mist apprehensively, in fear of discovery. The man grips the antlers of the stag and forces its head back at an acute angle to reveal the wound in the neck, while straining to see the source of danger, his plaid streaming out behind him in a storm-tossed landscape. Although the man is a depicted as a ruffian, it is difficult not to feel some sympathy for the predicament in which he finds himself.

Landseer's poaching scenes represent his darker vision of Highland society. The majority of his outdoor scenes are very different in character, peaceful images of shepherding, harvesting

[69] *Poachers Deerstalking*
(also called *Getting a Shot*),
*c.*1831 *
Oil on panel, 50.8 × 61
Private Collection

[70] *How to Get the Deer
Home, c.*1831
Oil on panel, 50.8 × 66
Untraced

and cattle droving that are pastoral in mood. The artist's vision is inherently nostalgic, for modern estate management and developing markets were sweeping away the old economic order that he celebrates. *Harvest in the Highlands* [plate 71] describes a way of life that was rapidly passing away. Corn crops had ceased to be profit-

able as more and more land was given over to sheep and deer, those twin pillars of economic profit. The picture was a collaborative effort, with Landseer providing the figures and animals in a romantic landscape painted by Augustus Wall Callcott. The size of the field being harvested must mean that the harvesters are tenants working on behalf of a landowner and not small-holders on their own land. A group of sportsmen with dead stags on ponies can be seen in the middle distance, while the foreground is occupied by children and animals, for the picture is as much about youth and innocence as it is about peace and plenty. A grey mare with its foal waits patiently in the trasces of a cart loaded with corn. A comely Highland lassie turns her back to us to look at two young children standing beside the cart; this group was the subject of two spirited oil sketches in which Landseer worked out the composition [see plate 72]. Significantly, the

[71] *Harvest in the Highlands* by Sir Augustus Wall Callcott and Sir Edwin Landseer, *c.*1833 *
Oil on canvas, 85.8 × 148
Private Collection, courtesy of Alexander Meddowes

working lassie of the oil sketch, with a corn stook on her head, becomes the passive icon of the finished work. The imagery of the picture is reminiscent of Gainsborough's rustic scenes with carts and peasants coming and going to market, a poetic vision of the rural poor in romantic surroundings.

It would be wrong, however, to suggest that Landseer was impervious to the realities of

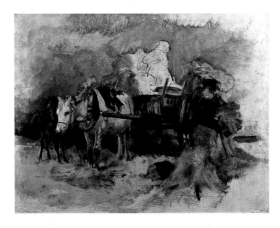

[72] *Study for Harvest in the Highlands*, *c.*1833 *
Oil on panel, 40.6 × 58.4
From the Loyd Collection

Highland labour. *The Stonebreaker* [plate 73] is one of the most remarkable pictures of its time, for it documents the back-breaking work involved in maintaining and developing the network of Highland roads that was opening up the country. The gaunt, stiff-legged, grizzled old stonebreaker is one of Landseer's most moving characterizations. He is worn down by age and infirmity and years of hard physical labour, yet there is something indomitable about him as he sits with his terrier beside him cocooned in his plaid, looking up unsmilingly at the pretty girl who has brought him his dinner. She has a little more character than most of the artist's Highland lassies, who conform to a stereotype of rustic beauty, holding one hand on her hip in a spritely, independent attitude. In the foreground are the tools of the stonebreaker's trade, heavy hammer, sieve, shovel and the lumps of rocks he must reduce to small stones. The cluster of cottages in the distance with smoke rising

[73] *The Stonebreaker*, c.1830 *

Oil on panel, 45.8 × 54.4
Victoria & Albert Museum, London

[74] *The Stonebreaker*
by Henry Wallis, 1857

Oil on canvas, 65.4 × 78.7
Birmingham Museums and Art Gallery

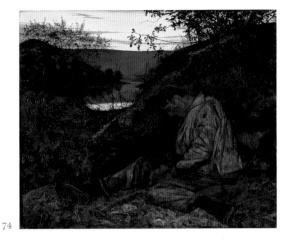

74

from their chimneys show him to be part of a settled community.

Stonebreaking as the symbol of modern labour was to be the subject of three remarkable realist works of the 1850s, Gustave Courbet's

Stonebreaker of 1851 (formerly Gemäldegalerie, Dresden, destroyed 1945), Henry Wallis's *Stonebreaker* of 1858 [plate 74] and John Brett's *Stonebreaker* of 1857–8 (Walker Art Gallery, Liverpool). The first two, in particular, provide a bleak commentary on the soulless and dehumanising effects of repetitive labour in grim conditions. Courbet's picture spares us none of the reality of what stonebreaking involves in the form of two monumental figures in dust-grimed clothes, one with a hammer poised to strike, the other holding a sieve. Henry Wallis's picture is more overtly polemical for the stonebreaker lying against the rocks is not asleep but dead, exhausted by a life of unremitting toil; the sunset above can be read as an epiphany for the labouring poor. Landseer's picture lacks the reforming agenda

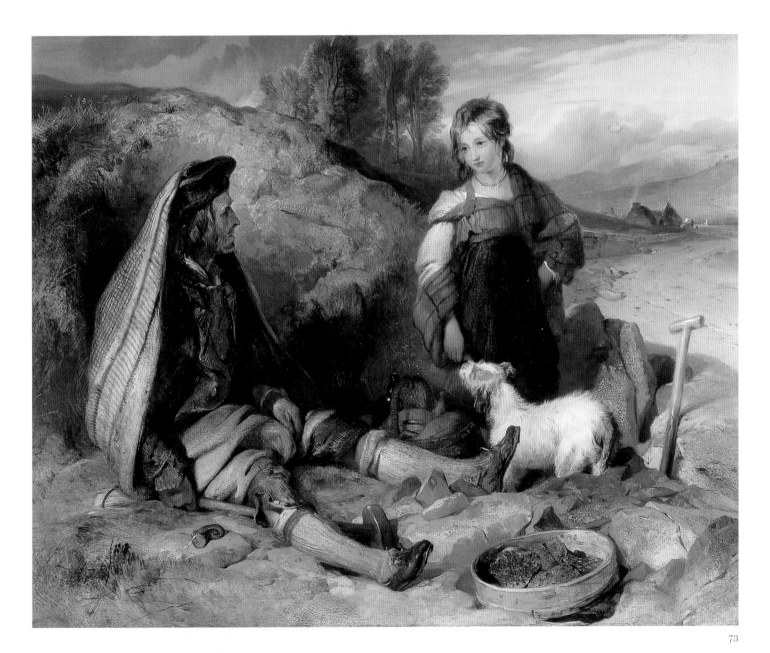

73

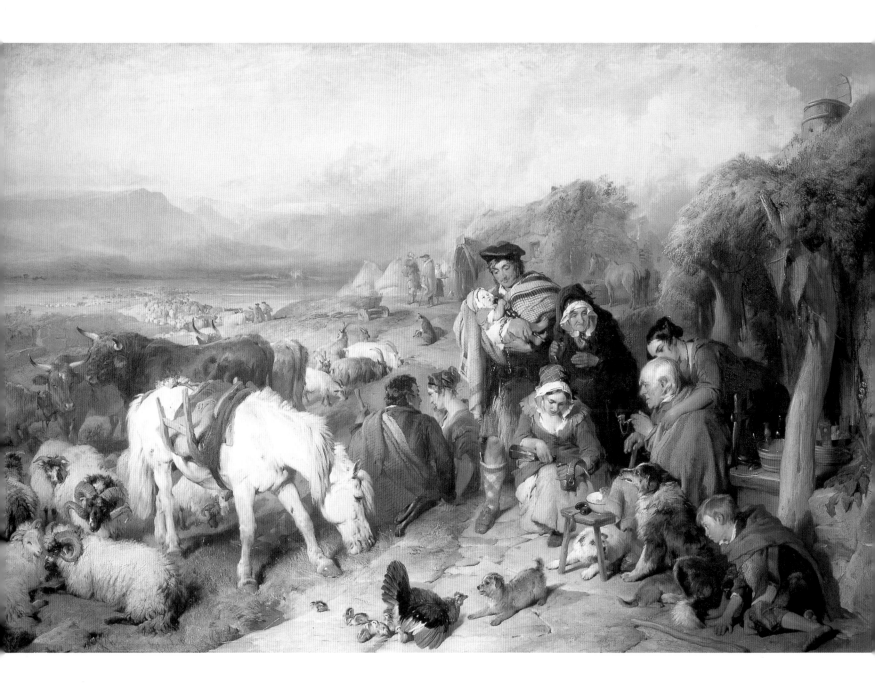

[75] *A Scene in the Grampians – The Drovers' Departure*, c.1835 *

Oil on canvas, 125.8 × 191.2
Victoria & Albert Museum,
London

of the social realists but his stonebreaker remains a remarkable image, far ahead of its time.

A Scene in the Grampians – the Drovers' Departure [plate 75] is the largest and most complex picture in Landseer's series of Highland scenes. For centuries sheep and cattle have been herded south from the Highlands to the markets of Lowland Scotland and northern England. This was one of the staple products of the Highland economy and large numbers of animals were involved. The droves themselves were formidable undertakings, for keeping sheep and cattle fed and healthy over long distances and rough terrain required high levels of skill and experience. The droves were well organized along established routes that stretched far and wide across Scotland. The drovers were an independent body of

men who specialized in the trade, and they were generally employed by agents acting for the farmers and landowners. Sir Walter Scott's short story, 'Two Drovers', vividly captures the rituals and tribulations of the droving way of life.[17]

Landseer's painting is a microcosm of Highland life. It was criticized at the time for being over-burdened with incident and detail. The main action takes place outside a turf-covered bothie with groups of animals and people left and right. A departing drover, babe in arms, stands at the apex of a pyramid of figures that includes an old woman, and two young women fussing over an elderly man, presumably their father, who is smoking his pipe. In the foreground several incidents are taking place: a puppy is taunting a hen which is fiercely defend-

ing its young; and an excited terrier, watched by a crouching boy, looks out from under a bench at a dignified sheep dog suckling a puppy as if about to spring. In the middle distance a pair of seated lovers bid each other a fond farewell. A grey Highland pony with a pack saddle holds the stage centre left with sheep and rams beside it, a Highland bull and cow beyond, and then some goats, a veritable Noah's Ark of domestic animals. In the distance there are more leave-takings, while in the valley massed herds of cattle and sheep are congregating along the road that winds away into the distance. The passage from the homely domesticity of the foreground scene to the distant spectacle of loch and castle and snow-capped mountains is an allegory of the drovers' adventurous journey into the wilds.

There are two paintings which are closely related to the *Drovers' Departure*, both of which were exhibited four years later in 1839. The first of these is *Tethered Rams* [plate 76], adapted from the group of rams in the bottom left-hand corner of the larger picture, with a view possibly of the same loch seen at closer range. The title is a misnomer, for only one of the rams is tethered. Both animals are in a state of excitement occasioned no doubt by the presence of the sheep from whom they are separated. Their sexual

energy and aggression disturbs an otherwise peaceful scene of shepherding: a pair of resting but alert sheepdogs in the foreground; a flock of sheep and a pair of gentle Highland lovers in the middle distance; and behind, the mirror-like surface of a loch, broken only by the line of a sailing boat, and sunlit mountains.

The second picture, *Favourite Pony and Dogs, the Property of Charles William Packe*, MP [plate 77] is an adaptation of the same compositional idea as the *Drovers' Departure*, with a Highland bothie on the right, and a view of a loch on the left. The beautifully groomed pony and the sidesaddle, over which is looped a red cape, represent the upper-class woman who is paying a visit to the bothie, perhaps on a mission of charity. The bothie may be the home of the ferryman, shown on the left pushing off his boat with a pair of passengers, in which case the owner of the pony and dogs is paying a call on the ferryman's wife. The golden sky, with duck flying homewards in formation, bathes the scene in a warm glow, and, like the long shadow cast by the pony, indicates late afternoon as the time of day. The barefoot boy and the animals are a study in patience, and they share the same air of listless inactivity as they await the return of the mistress. The picture contrasts humans and animals, high

[76] *Tethered Rams –
Scene in Scotland, c.1839 **
Oil on panel, 45.8 × 61
Victoria & Albert Museum,
London

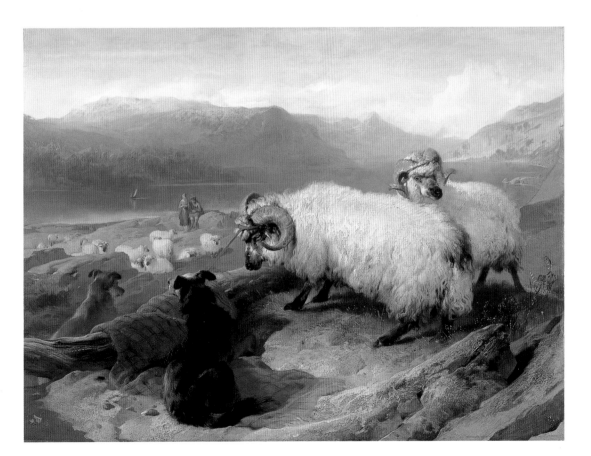

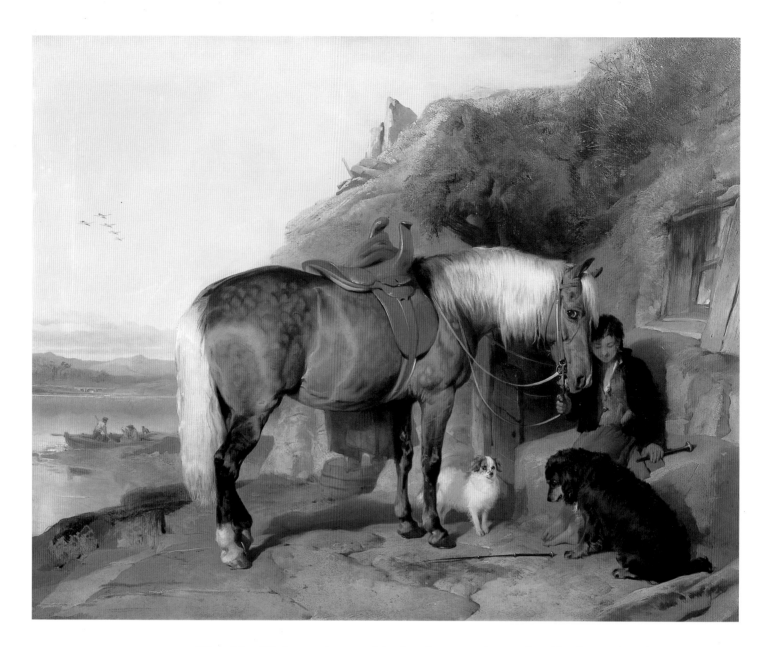

[77] *Favourite Pony and Dogs, the Property of Charles William Packe, MP (also called Miss Packe's Pony), c.1837–9* *

Oil on canvas, 103 × 127
Private Collection

life and low life, but not in any spirit of confrontation; everything about the scene is harmonious. Landseer invents a narrative to give interest to what is essentially a portrait of his patron's favourite animals. We know the names of the pony, Belle, and of the two spaniels, Fairy the Blenheim to the left, Corah the black-and-tan to the right. Charles Packe, who commissioned the picture, was a wealthy landowner and member of parliament with estates in Leicestershire and Dorset. He wrote to the artist in a letter of 24 July 1837 suggesting the inclusion of another dog, 'like his black mother, which would I think greatly add to the beauty of the group'.[18] Landseer's patrons took an active interest in the progress of the works they commissioned and considered it their prerogative to voice criticisms and to suggest changes.

Landseer returned intermittently to the

theme of Highlanders and Highland society in his later years. The searching realism and beautiful touch of his early work had gone, to be replaced by more overtly allegorical subject matter and a broader style of painting. *The Free Kirk* [plate 78], exhibited in 1849, is a reprise of *The Old Shepherd's Chief Mourner* [plate 66], painted a decade earlier. The title is a reference to the Disruption controversy of 1843 which had split the Scottish church, leading to the establishment of a breakaway group, the Free Church. The identification of the object at the front of Landseer's picture as a coffin has only recently been made and a correct reading of the picture established. The dead shepherd's plaid, bonnet and Bible lie atop the coffin together with his soulful terrier. Two sheepdogs and an old woman with spectacles in her hand occupy a high-backed bench. Behind is a bent old man

grasping the back of the bench for support, a handsome Highland couple and a young boy with his face half hidden. We are in the position of the minister looking across at his congregation, or an audience confronting actors on stage. The figures symbolize the character of Highland society as well as the ages of man. The picture is a disquisition on mortality, the nature of faith and religion in a rural community and the effects of grief and mourning, expressed as much by the dogs as the humans. Queen Victoria so admired the picture when she visited Landseer's studio in April 1849 ('It is so typical', she wrote in her Journal) that she bought it as a surprise Christmas present for Prince Albert.[19]

The pair of pictures of the *Highlander* and *Highland Lassie* [plates 79, 80] were also gifts from the Queen to her husband, the first for his birthday on 26 August 1850, and the second for Christmas 1850. Miss Skerrett, the Queen's dresser and confidential go-between, wrote to the artist on 21 November 1849: 'HM thinks Highland lassie should be all *peace & sunshine* – on the other hand the Highlander HM thinks

[78] *The Free Kirk*, *c.*1849
Oil on canvas, 86.4 × 72.4
The Royal Collection

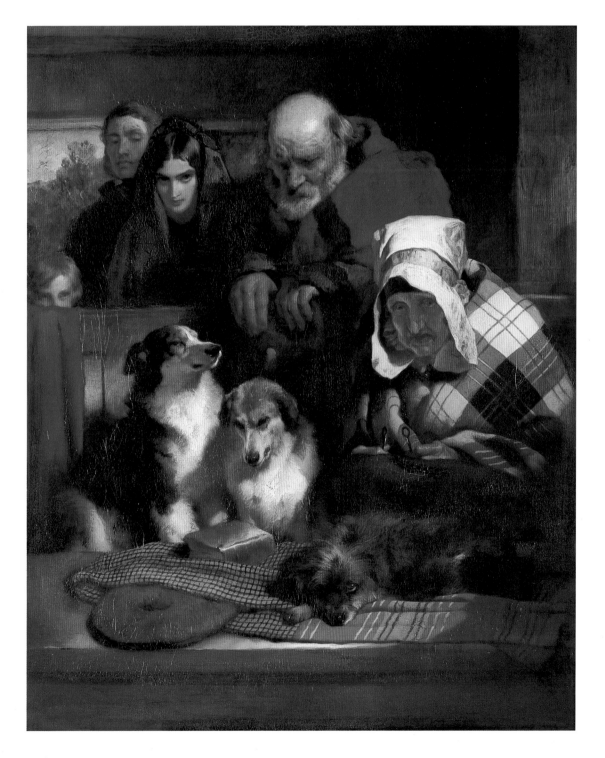

should represent the national sport of the country but perhaps without actual storm.'[20]

The subject of Landseer's *Highlander* is posed on a rock like a statue on a plinth, with a rifle and a game bag slung across his shoulders, and a dead eagle in one hand. Untroubled by the snow falling around him, he stands four-square, representing all that is noblest in the Highland character. The figure was posed by Peter Coutts, one of the Queen's favourite ghillies, and the likeness was taken from *Study for Royal Sports on Hill and Loch* [see plate 137]. The girl in *Highland Lassie* is a seductive shepherdess with bare legs and cleavage, standing on a stepping stone across a stream with two tame fawns. A young boy and a sheep dog are resting by the path, and beyond is a bothie with two comforting plumes of smoke, and in the distance a ridge of mountains. The imagery was derived from a much larger picture of a young Highland woman feeding deer, *The Forester's Family* (1844–8, formerly Owen Edgar Gallery, London), which the Queen of the Belgians had commissioned as a present for her husband, Leopold. In contrast to Landseer's earlier pictures of Highlanders, these later works are idealized and symbolic. The protagonists of *Highlander* and *Highland Lassie*

are extolled as heroic types of their race and as a pattern of strength and virtue worthy of emulation. This view of them is paternalistic, as of a landlord towards his tenants and retainers. The freedom and resilience demonstrated by Landseer's models masked the reality of restricted opportunities and economic dependence.

Landseer's late panorama of Highland life, *Flood in the Highlands* [plate 81] was conceived in the mid-1840s and finished some fifteen years later. It may have been inspired by the famous Moray floods of 1829 which had caused extensive damage and loss of life. A Highland family are shown sheltering on the roof of their bothie in various states of fear and dismay as the flood waters swirl by below them. Seated on a low chair in the centre of the composition is a distraught young mother clutching her infant to her breast with a cradle beside her – a nightmare version of *A Highland Breakfast* [plate 65]. To her right is an old man who appears to be sightless, flanked by two anxious children, one hugging a puppy under his plaid. Surrounding the human figures are groups of frightened animals seeking refuge on the rooftop. A red blanket on a makeshift flag-pole streams out as a signal of distress. We can only hope that all will be saved

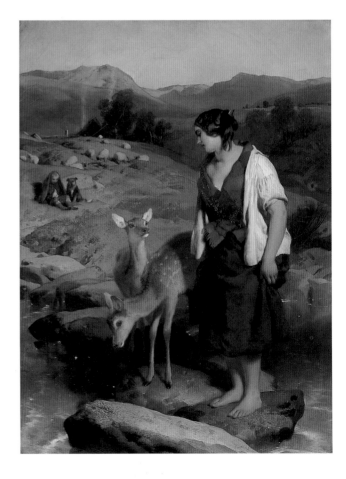

[79] *Highlander*, 1850 *
Oil on canvas, 68 × 51.1
The Royal Collection

[80] *Highland Lassie*, *c.*1850 *
Oil on canvas, 68 × 51.1
The Royal Collection

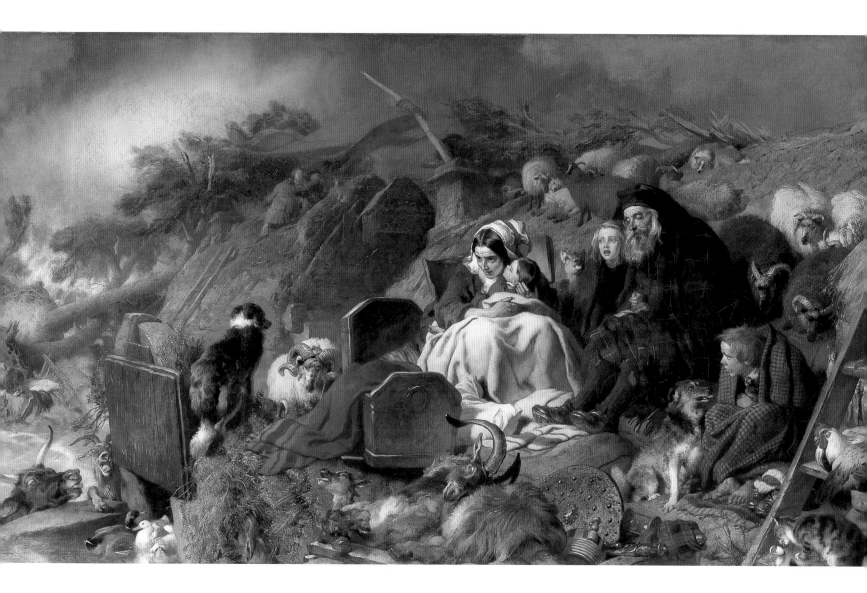

[81] *Flood in the Highlands,*
*c.*1845–60 *
Oil on canvas, 198.5 × 311.2
Aberdeen Art Gallery and
Museums Collection

and not swept to their doom. A cow and a goat and a horse, seen bottom left, struggle frantically to save themselves from the flood water. Figures cling to the roof of a second bothie behind the first and in the distance a sinister burst of light seems to mark the very epicentre of the storm.

This is a dramatic picture on the grand scale, and a psychological study of the effects of fear and despair induced by a natural catastrophe. Like the artist's early genre scenes, it uses detail and anecdote to characterize a society and way of life: the simple clothes and household furniture; the targe (shield), dirk and broadsword recalling the 1745 Jacobite uprising; the cat on the far right sniffing the broken egg dropped by the hen on the step above; and the happy family of ducks on the left swimming about the flooded doorway with its sign board, 'Alick Gordon / Upputting / Stance / Mile East', indicating that the cottage is an inn for drovers ('upputting'), with a pen for their animals ('stance') a mile to the east. Natural

disasters were the stuff of romantic art and in this late scene of Highland life Landseer stressed the threats faced by those living on the margin of civilization.

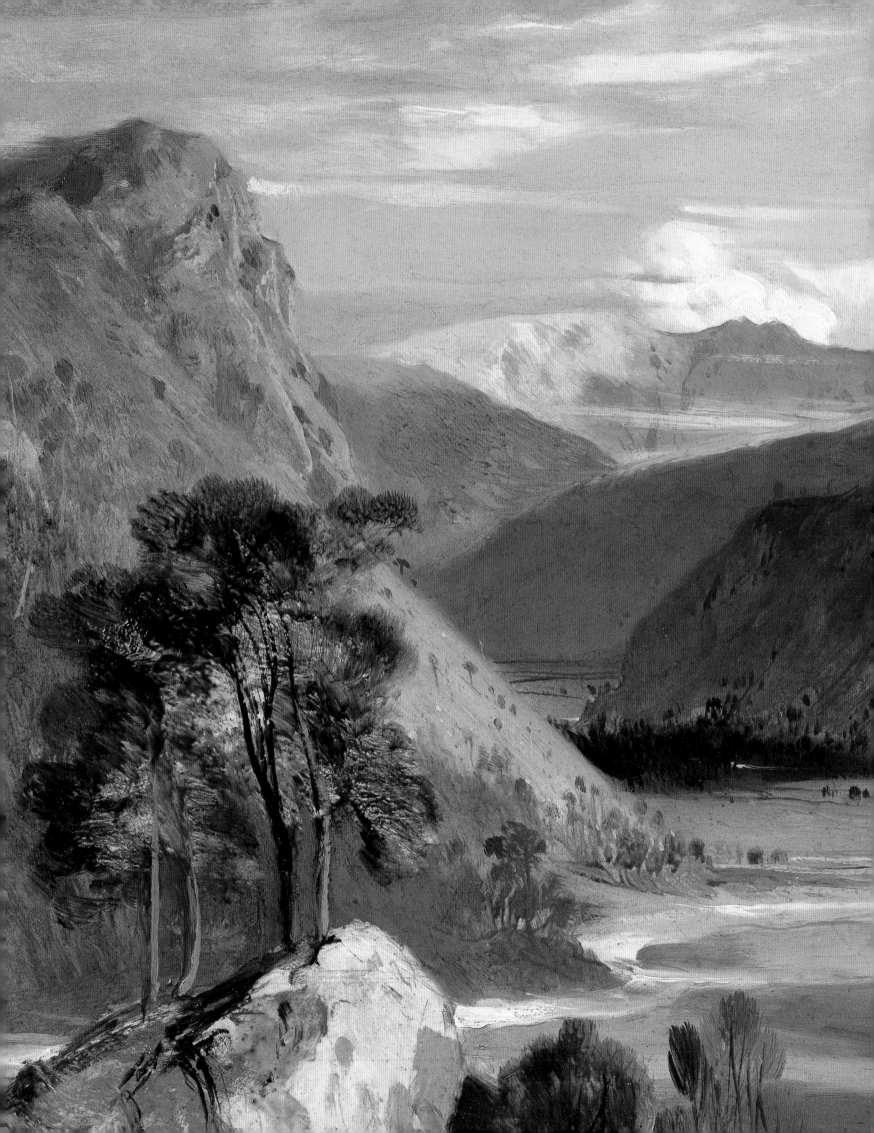

4 · HIGHLAND LANDSCAPES

During his early visits to Scotland in the 1820s and early 1830s, Landseer painted a large number of oil sketches that record his passion for Highland scenery. They were clearly painted outdoors and they record the fleeting effects and the changeable patterns of weather with all the immediacy of something seen and experienced at the moment. *Plein-airisme*, or outdoor sketching, became a widespread practice among European artists in the romantic period. The scenery of the Roman Campagna, with its ancient associations, was popular with this new breed of 'natural' landscapists. Landseer's originality lay less in the fact of his sketching out-of-doors than in his choice of wild Highland scenery. The artist was especially good at conveying the scale and grandeur of the mountains, whether viewed on calm, sunlit days or in conditions of wind and storm. He ranged over flatter stretches of moorland, tumbling waterfalls, placid lochs, and rocky streams seen at close quarters.Unlike more conventional topographical artists, he was not recording the set-pieces of Highland scenery like Dunkeld, Blair Atholl, Loch Katrine, Glencoe, Loch Lomond and the Falls of Clyde. Illustrated accounts of Highland tours proliferate from the late eighteenth century onwards, feeding a popular demand for scenes that were spectacular, sublime and rich in historical association.[1] Landseer avoided the popular sights, painting in remote areas of the Highlands far from the tourist trails. With one exception he never exhibited his landscapes and they are not mentioned in contemporary literature. He seems to have painted them entirely for his own pleasure and they were unknown until his estate sale in 1874, when more than a hundred were put up for auction.[2]

None of the sketches are dated, but the identity of certain views does provide a clue to chronology. For example, the group of sketches painted at Glenfeshie, a remote valley in the heart of the Cairngorms, cannot be earlier than 1830, when the Duchess of Bedford took the lease of The Doune, the family home of the Grants of Rothiemurchus, near Aviemore in the Cairngorms, and established an outpost in Glenfeshie. Situated near the Gordon house at Kinrara, south of Aviemore, where the Duchess had often stayed with her mother, The Doune was of sixteenth-century origin, now largely rebuilt One of the daughters of the house, Elizabeth Grant, published an autobiography that has become a classic, *Memoirs of a Highland Lady*, with a revealing account of Highland, Edinburgh and London society in the early years of the nineteenth century.[3] The Doune was the base from which the Duchess of Bedford launched her expeditions to Glenfeshie, one of the most beautiful of all Highland valleys, lying some fifteen miles south of The Doune in the forests that had once belonged to her father; the Duke of Gordon sold the Glenfeshie estate to Macpherson Grant of Ballindalloch in 1812. At Glenfeshie the Duchess built a series of rough huts to accommodate her friends, where she pretended to live like a native Highlander.

A vivid description of life in the huts is given by the comic actor, Charles James Mathews (1803–78), then a young man practising to be an architect, in a series of letters he wrote to his mother. The Duchess herself intruded into the correspondence, sending a spoof letter as if from Mathews himself telling his mother what a wretched time he was having. He owed his invitation to Glenfeshie to Landseer who had written to 'Dear Mat' on 1 August 1833, just before the expedition to Glenfeshie, urging him to bring his fiddle to a party given by the Duchess in London: 'This is all *my* arrangement, and I

< Detail from plate 90

hope you will not send your guitar to sup without the poor player, as I wish my good friends to become better acquainted with you, as they will most likely be bored by us for a month in the Highlands.'[4]

Mathews describes the party that assembled at The Doune in mid-September 1833 and sallied forth to Glenfeshie.[5] It included the Duchess of Bedford, her daughters Georgiana and Rachel, Miss Balfour, Landseer, and other male friends. The men rode out on shaggy ponies to shoot ptarmigan on their way up to the huts while the women walked along the valley bottom or travelled by tilt cart. Mathews compared the appearance of the huts to an Indian settlement, and described them as looking like the poorer type of peasant's cottage, with walls of turf and roofs of untrimmed spars of birch. There were, according to him, three huts: the largest having three or four bedrooms and the kitchen; the second serving as dining room and parlour; and the third containing more bedrooms. A wash drawing of the huts in the 'Glenfeshie Game Book' [plate 82] shows five structures. The stone foundations for them can still be seen on the ground to this day, at the end of the lower glen where it widens out at the foot of the mountains, beside the track leading to the upper glen. The largest of the six surviving structures measures some fifty by eighteen feet. Landseer painted the entrance to one of the huts, with stags' heads and a Highland targe decorating the portico, two hounds in the doorway, and a glimpse inside of a decanter and lamp standing on a chest of drawers [plate 83].

The women of the party occupied the tiny bedrooms in the huts, sleeping on mattresses stuffed with heather, while the men slept in tents outside, each containing two small couches, a wash stand and foot bath but no chairs, curtains or looking glass. The dining-room/parlour is the subject of two paintings, a watercolour by Mathews at Woburn Abbey, and an oil by an unidentified artist formerly attributed to Landseer [plate 84]. The latter shows a panelled room with high coved ceiling, curtained windows and tartan drapes, a long table running down the centre, various armchairs and stools, and a profusion of antlers and rams' horns. The young woman reading a letter may be one of the Russell daughters and the older woman behind is possibly the Duchess of Bedford.

Queen Victoria described coming across the huts during a tour of the Highlands in the 1850s. She had ridden up the valley to the spot where the glen widens out to what local people called the green 'hard': 'Then we came upon a most lovely spot – the scene of all Landseer's glory – and where there is a little encampment of wooden and turf huts, built by the late Duchess of Bedford; now no longer belonging to the family, and, alas! all falling into decay – among splendid fir trees, the mountains rising abruptly from the sides of the valley. We were quite enchanted with the beauty of the view.'[6]

The dress code for those visiting the huts was

strictly Highland. Mathews says that the men wore kilts and plaids, while the women dressed in the simple style of the country: bed-gown of light material generally striped, blue cloth or grey stuff petticoat, scarlet, grey and blue stockings, aprons and mittens, snoods of red or blue through their hair and coloured handkerchiefs to protect their heads from the elements. Mathews describes the constant round of amusements that kept the party entertained, guitar and piano playing, songs, serenading, parties and dances. Nearby was a hut which had previously been occupied by the Duchess and which was now tenanted by the sportsman Horatio Ross of Rossie (1801–86), a close friend of Landseer, and by the wealthy politician, Edward Ellice of Invergarry (1781–1863) and his son, Edward Ellice junior. Ross and Ellice invited the Duchess and her guests to an evening party, which Mathews describes in detail. They set off from the huts in torrential rain, and, after fording a stream, were met by a piper and half a dozen ghillies who escorted them to the 'Wooden House', as the hut occupied by Ross and Ellice

was known. Landseer drew a caricature sketch of the Duchess and guests being greeted by the immensely tall figure of Ellice, in a re-creation of the rituals of Highland hospitality [plate 85]. 'The banquet was profuse and the dressing exquisite', writes Mathews to his mother, 'Venison in every shape and disguise; ending with cranberry and blackberry tarts, and all sorts of clotted cream, custards, apple-puddings, and turnip-pies. Lots of champagne, claret, moselle, ices, &c., were disposed of, not to allude to the bottled porter, ale, soda-water, and all those sort of luxuries, which abounded.'[7] The piper played throughout the dinner, while outside a bonfire blazed in spite of the hurricane. The evening ended with songs and choruses and the visitors were escorted back home in the same style in which they had arrived.

The day after this memorable dinner, the Duchess gave a dance for all the young men and women of the neighbourhood [see plate 86]. Two fiddlers and a piper played non-stop from eight in the evening till six in the morning. The Duchess had hurt her knee, the subject of

[84] *Interior at Glenfeshie* by an unknown artist, *c.*1833
Oil on board, 42.2 × 52.2
Worcester Art Museum, Worcester, Massachusetts, Charlotte E.W. Buffington Fund

[85] *Reception at Glenfeshie*, with Edward Ellice, the Duchess of Bedford and others, *c.*1833
Pen and ink and wash on paper, 19 × 23
Private Collection

[86] *Arrival at the Ball at Glenfeshie*, *c.*1833
Pen and ink and wash on paper, 19 × 23
Private Collection

[87] *Duchess of Bedford – Rubbing after Sprain*, *c.*1833
Pen and ink and wash drawing
Private Collection

84

85

86

87

another Landseer caricature drawing [plate 87], but in spite of this handicap she danced as energetically as everyone else. Mathews amazed himself: 'The manner in which I walk over the hills, ford the rivers, scale the rocks, and dance reels is past belief. I feel just as strong, and able to support fatigue, as I ever was in my life, and the more I take the stronger I am.'[8]

The simplicity and conviviality of life at Glenfeshie appealed as deeply to Landseer as it did to the Duchess. Away from the prying eyes of the world they could enjoy a cheerful intimacy. The elderly Duke came occasionally to the huts (Lord Tankerville describes him patiently enduring drips from a leaking roof), but he did not share his wife's passion for simple living in the wilds. Landseer is said to have built his own hut, and he was probably as happy in Glenfeshie as he was ever to be. Lord Tankerville (1810–90), then the young Lord Ossulston, recalled sighting the artist for the first time while deerstalking in the environs of Glenfeshie. He and his keeper came on Landseer unawares and mistook him for a poacher:

He was a little, strongly built man, very like a pocket Hercules, or Puck in the 'Midsummer Night's Dream'. He was busily engaged in grallocking his deer. This he did with great quickness and dexterity, not omitting to wash the tallow and other treasures carefully in the burn and deposit them on the stone beside the deer. He next let the head hang over, so as to display the horns, and then, squatting down on a stone opposite, took out of his pocket what I thought would be his pipe or whisky flask; but it was a sketch-book! Seeing that we had mistaken our man, I came out into the open, and then found myself face to face with my friend of many years to come – Landseer.[9]

Since Tankerville mentions Mathews as one of the party at Glenfeshie, and vice-versa, the date of his visit must also have been 1833. At the end of his stay, Tankerville took Landseer and Mathews away with him to Chillingham Castle, the ancestral Tankerville home in Northumberland, where the dramatic events which are recorded in Landseer's *The Death of the Wild Bull* [plate 42] took place. In his description of the artist, Tankerville captures the charm and vivacity which made him so popular in aristocratic society:

He was acknowledged to be the best company of his day. His powers of description, whether of people or of scenery, were most graphic and amusing, and though simple in words, had very much of natural poetry in them. And in his anecdotes, which were full of humour, the marvellous changes of voice and expression of countenance he could assume as a perfect actor brought the persons themselves whom he was speaking of in reality before you.[10]

The sporting activities at Glenfeshie are vividly captured in a game book kept by the Ellice family from 1834 to 1841.[11] This records day-by-day what game was killed, by whom, on what beat, and to whom some of the game was sent. The bags were enormous, and mostly grouse, sixteen hundred and twenty three birds and animals in 1834, two thousand nine hundred and six in 1838. Landseer is several times recorded on the shoots, for example on 2 October 1835, when nothing was bagged, and again a few days later when he and Edward Ellice junior secured one woodcock, one snipe and a roe deer. He and Ellice senior killed twenty-nine grouse on 16 September 1837, and a further nine grouse a fortnight later. In three shooting days in October 1838, he shared a bag of twenty-seven grouse and two blackcock in company with Lord Abercorn, the Duchess of Bedford's son-in-law. The latter, together with other sportsmen, features in Landseer's witty pen-and-ink sketches with which he embellished the Game Book. He also contributed illustrations to a comic Glenfeshie ballad, including one of himself and Dr Thomson dressed as maids:

The Doctor Dad and Lanny had
Seemed most of all to have gone mad.
They danced about with airs and graces
And formal masks disguised their faces.
The D^c's gown was short and scanty
Which made him look both large and lanky.
Enlivened by a glass of Taddy
They danced about with every Lady.[12]

Landseer's enthusiasm for Glenfeshie found expression in a succession of spirited landscape sketches that must date from the early 1830s. In them we experience the sense of exhilaration and freedom that being in the mountains invariably produces. The mood is romantic, for we are faced by the splendour and solitude of nature without the presence of human figures. But the artist did not strain after exaggerated effects nor is he constrained by the conventions of the pictur-

esque. He painted what he saw, and, like his friend Constable, he was a keen student of the weather; his landscapes are convincing records of meteorological phenomena. It is the truth to the thing seen and the sureness of his touch that make his sketches so fresh and alive. Interestingly, he was influenced by neither of the artists to whom he was closest and with whom he collaborated on joint pictures, Augustus Callcott and F.R. Lee (1799–1879).[13] The artists to whom he can best be compared are more often watercolourists than oil painters: the Birmingham painter David Cox (1783–1859), for example, with his wild Welsh scenes, and Thomas Girtin (1775–1802), whose vistas of mountain and stormy skies anticipate the spirit of Landseer's sketches [see plate 88].

Two artists whose animal paintings unquestionably made an impact on the young Landseer may also have influenced his landscape painting. James Ward (1769–1859) is most famous for his vast and gloomy panorama, *Gordale Scar* (Tate, London), but he also painted landscape sketches that are, like those by Landseer, free in handling and fresh in colour. The versatile Philip Reinagle (1740–1833) was equally adept in the genres of portraiture, subject painting, landscape and sport. Several of his sketches, like *A Trout Stream* (Gere Collection), anticipate the composition of works by Landseer.

A landscape painter whose relationship with Landseer is better documented is John Constable (1776–1837). The intermediary here was Charles Robert Leslie (1794–1859) with whom Landseer had travelled on his first journey to Scotland in 1824 [see chapter one, p.20]. The three artists regularly dined with each other, corresponded

and admired each other's work. In November 1831, Constable expressed pleasure that Landseer had visited his retreat in Hampstead, 'besides he fell in love with my eldest daughter – and I could only say nay. It was to paint her – & what may not such a magic pencil as his *lead to*.'[14] A few years later, Constable penned a marvellous description of his younger colleague: 'Landseer was at dinner (perfect) – his shirt frills reaching from his *chin* to below his *navel* – his head was beautifully decorated with 1000 curls. He has great self-knowledge.'[15] Landseer must have been familiar with Constable's work. Around 1832 he requested a print of Flatford Mill and Constable sent him one and three others. Landseer's landscape sketches breathe the same air as Constable's, and his fleeting evocation of fleeting effects of weather and his spirited brushwork reflect the influence of the older painter [see plate 89].

Landseer's sketches at Glenfeshie are readily recognizable from the profile of the two mountains that guard the passage to the upper glen, Creag na Gaibhre and Creag Caillich. Even in the distant view down the valley, represented in *Highland Landscape* (private collection), we can recognize the distinctive shape of the mountains in the distance. In this sketch, the broad foreground expanse of field, road and stream gives way to a panorama of purple hills and stormy sky. In most of the Glenfeshie sketches we are closer to the mountains, looking up at them from the valley bottom. In one of the most beautiful of the sketches, we are on an eminence marked out by rocks and trees looking across to the opening between the mountains [plate 90]. Our eye is led along the milky line of the stream as it winds

[88] *Near Beddgelert*
by Thomas Girtin, *c.*1798
Watercolour on paper, 29 × 43.2
The British Museum, London

[89] *Branch Hill Pond*
by John Constable, 1819
Oil on canvas, 25.4 × 30
Victoria & Albert Museum,
London

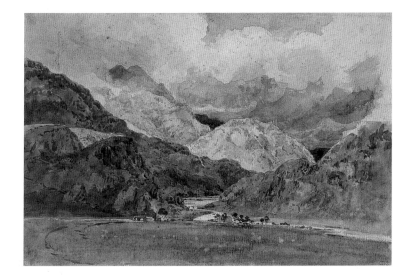

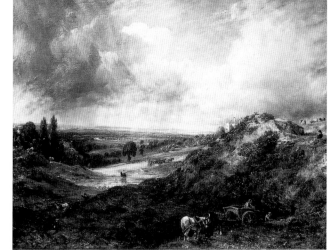

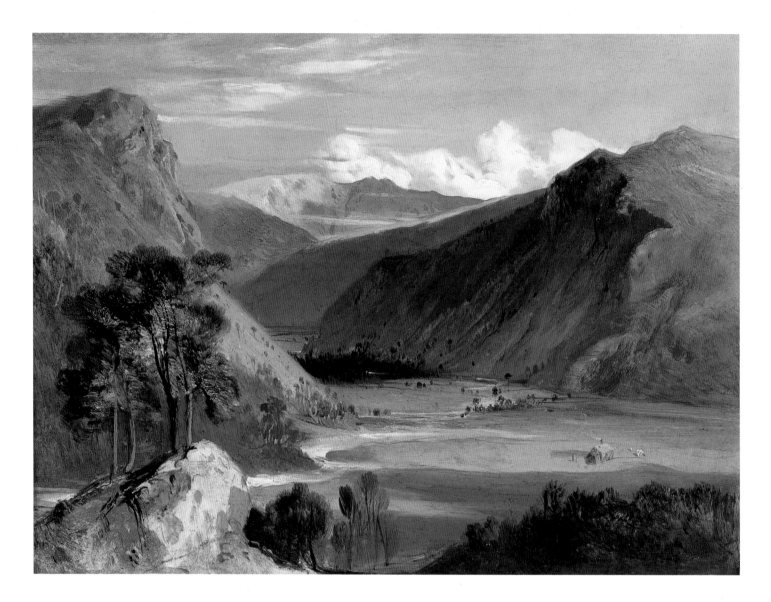

[90] *Glenfeshie, c.*1830–5 *
Oil on board, 25.4 × 34.3
Private Collection, courtesy
Simon C. Dickinson Ltd

along the valley under the flanks of the two mountains, only to disappear into the recesses of the upper glen. The only sign of human habitation is a simple bothy (not the Duchess of Bedford's huts), with smoke rising from the chimney, and two figures and a cow or horse visible beside it. Landseer conveys the freshness of a sunlit autumn morning with parts of the landscape still in shadow and trails of mist hanging on the flanks of the farther ridge. Parts of the sketch are painted quite thinly, the rocky outcrop in front, for example, where the painting's ground is allowed to show through to convey the whiteness of the rocks. Landseer grasps the essentials of the scene, the structure of mountain and valley and the shimmering effects of sunlight in a style that feels both improvised and spontaneous. The sketch belonged to Charles James Mathews and may have been a gift to him from the artist in 1833.

There are several other sketches depicting the home mountains of the glen. A picture sometimes called 'Glencoe' is much more likely to be Glenfeshie [plate 91]. The concave shape made by the curving slopes of the mountains, meeting in a point near the bottom, was a motif of which Landseer never tired. In one sketch of Glenfeshie, the downward slope of a rough horse-shelter mimics the flank of Creag Caillich to the left; the mountain to the right is Slochd Beag, and the entrance to the upper glen lies on the far left. In another view [plate 92], we look across at the same two mountains from the level of the stream which fills the foreground. A white rocky bank in front with a fallen tree is set against the deep brown tones of the water; beyond is a vision of green meadow, hillsides bathed in soft mauvish light and a blue sky. The same view was painted under conditions of rain and storm [plate 93]. Landseer includes the blasted trunk of a fir tree, brightly lit against the darkening landscape, as a romantic symbol for the

destructive forces of nature. The rain clouds sweep across the sky turning the mountains almost black and veiling them in a misty haze. The foreground, by contrast, is closely observed, with grasses and branches picked out in sharp detail. A view of the upper reaches of Glenfeshie shows the characteristic concave shape of mountain slopes but this time within the narrow confines of the valley [plate 94].

A popular place to visit in the environs of Glenfeshie was Loch Avon, a beautiful loch sited deep in the mountains and high up, between Cairngorm to the north, Beinn Mheadhoin to the east and Beinn Macdui to the south, surrounded by precipices of porphyry and granite. Lord Tankerville describes an expedition to the loch on the same visit when he first met Landseer [see p.84].[16] The party set out after breakfast at the huts; the Duchess of Bedford, her daughters and two female friends riding on ponies, each accompanied by a ghillie; and the men, Tankerville, Mathews and Landseer, on foot. Landseer's witty caricature of the stout Duchess on a pony, stumbling downhill, may have been drawn at this time [plate 95]. It is one of a large number of caricatures which he tossed off for the amusement of his friends.[17] After a strenuous climb over landslips and along a zig-zag path of

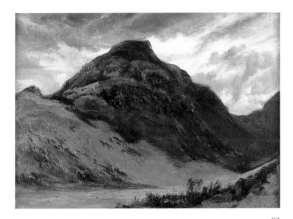

91

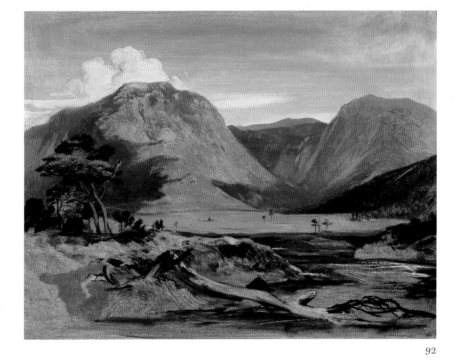

92

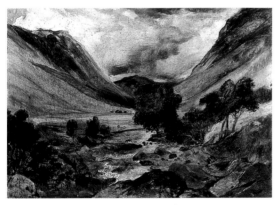

94

[91] *Highland Landscape* (also called *Glencoe*), *c.*1830–5 *
Oil on board, 25.4 × 35.6 · Private Collection

[92] *Glenfeshie* (also called *A Highland River*), *c.*1830–5 *
Oil on board 26.7 × 33.7 · Simon C. Dickinson Ltd

[93] *Glenfeshie* (also called *A Rainy Day in the Highlands*), *c.*1830–5 *
Oil on board, 35 × 45 · Private Collection

[94] *Glenfeshie*, *c.*1830–5 *
Oil on board, 25.4 × 34.3 · Private Collection

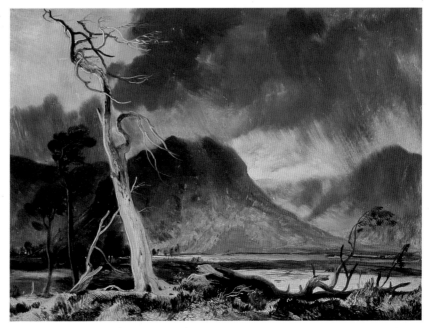

93

rolling stones, the expedition arrived at the plateau, 'where the lovely lake lay before us, the bright sun giving a splendid reflection of the peaks of Ben Avon frowning over it'.[18]

Tents were pitched in a hollow and a fire lighted, over which there swung a large cauldron. Landseer's sketch, *An Encampment on Loch Avon* [plate 96], may be a record of the scene, though there were doubtless other expeditions to the loch, and the weather in the sketch is stormy and not the bright sunlight of Tankerville's description. After a supper of freshly caught char and what Tankerville calls a Scotch hodge-podge (cutlets of black-faced mutton), the party passed a pleasant hour or two by the camp fire singing Scotch ballads and glees. 'The Highlanders, who love their national songs, gathered around to listen; and the blaze of the fire upon the group, as it had now got dark, made quite a pretty picture.'[19] Charles Mathews sang one of his typical songs in Welsh, 'Jimmie Jones', and the Highlanders danced the strathspey to the piercing sound of the pipes. The women slept rough in the tents while the men were consigned to Poachers Cave, lying amidst a waste of rocks. Early the next day, the party made an early start for the descent to Glenfeshie, 'bidding good-bye to one of the most charming scenes (by universal consent) that can be found in the Highlands'.[20]

Landseer's picture of *An Encampment on Loch Avon* shows the loch in the distance with the landscape opening out to the left, and the slopes of Beinn Mheadhoin on the right. Much of the loch is hidden from view by the low-lying ridge in the middle distance. Ragged storm clouds stream across the sky and the party in front, gathered round the camp fire, are in danger of a soaking. A second view of the loch is taken from the other end looking up its length westwards into the heart of the mountains [plate 97]. The foreground is sunlit and the loch possesses that sinister stillness which precedes a storm. Black clouds are massing behind the peaks lit here and there by shafts of sunlight. There is a Wordsworthian sense of 'something far more deeply interfused' in this vision of Highland scenery at its most sublime.

Loch Avon was the setting for the one early landscape which Landseer exhibited, *The Eagle's Nest* [plate 98]. The reason why it is less successful as a landscape has everything to do with its subject. The focus of the picture is the family of eagles, seen cawing to one another, as father brings home the supper. The foreground rocks are arranged like a stage set, and the bird's eye view of Loch Avon is little more than a backcloth. Other pictures of lochs by Landseer tend to be more pastoral and meditative in mood, like the beautiful study called *Loch Caun* and the unidentified *Lake Scene* [plates 99, 100].

Few of the locations of Landseer's landscapes can be identified nor can most of them be dated with any precision. An exception is *Figures Resting by a River in a Highland Landscape* [plate 101], for it relates closely to *Scene on the River Tilt, in the Grounds of His Grace the Duke of Bedford* [already described in chapter 2, pp.42–3; plate 32], which is dated 1824. The figures of local Highlanders in the sketch were to be replaced in the latter work by the Duke of Bedford's children. *Landscape with Dunrobin Castle* [plate 102] relates to the portrait of the Duke of Sutherland's children, *The Marquess of Stafford and the Lady Evelyn Gower with Dunrobin Castle in the Distance* (1835–8, Dunrobin Castle, Sutherland), for the view of the castle is similar in both works. Apart from these instances, Landseer does not appear to have used his landscape sketches for the backgrounds of his figure subjects.

The dates of *Figures Resting by a River in a Highland Landscape* (c.1824) and *Dunrobin Castle* (c.1835) mark the limits of the decade during which Landseer was most active as a landscapist. Certain sketches can be grouped by theme and composition, but there is no certainty that landscapes of a similar type were painted at the same period. It is difficult to demonstrate any pronounced stylistic developments in the artist's landscape art that would assist in establishing a tentative chronology. Subject matter and tech-

[96] *An Encampment on Loch Avon*, c.1833

Oil on board, 21.6 × 31.2

Untraced

[97] *Loch Avon and the Cairngorm Mountains* (also called *A Lake Scene: Effect of a Storm*), c.1833 *

Oil on panel, 35.6 × 44.5

Tate, London, purchased 1947

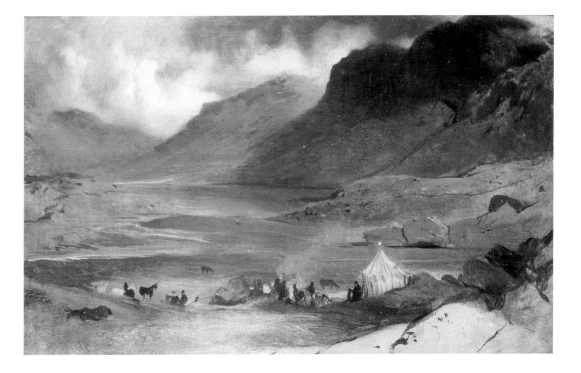

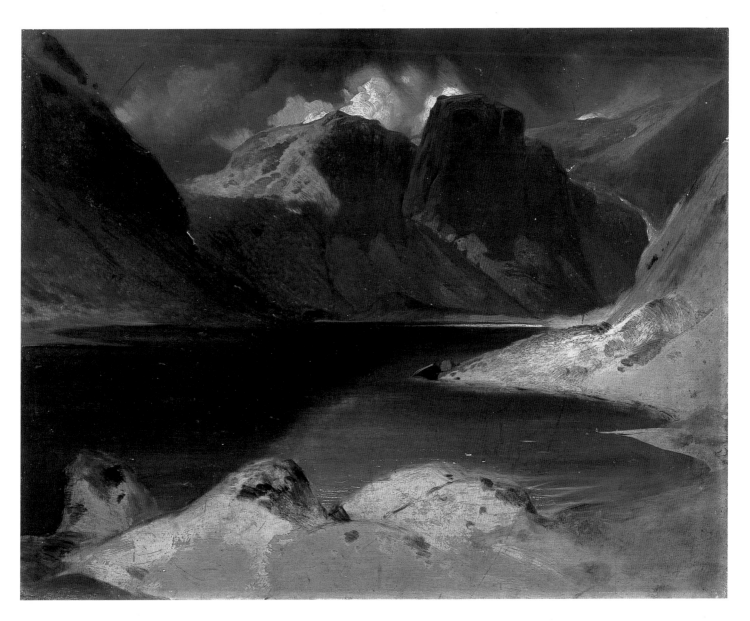

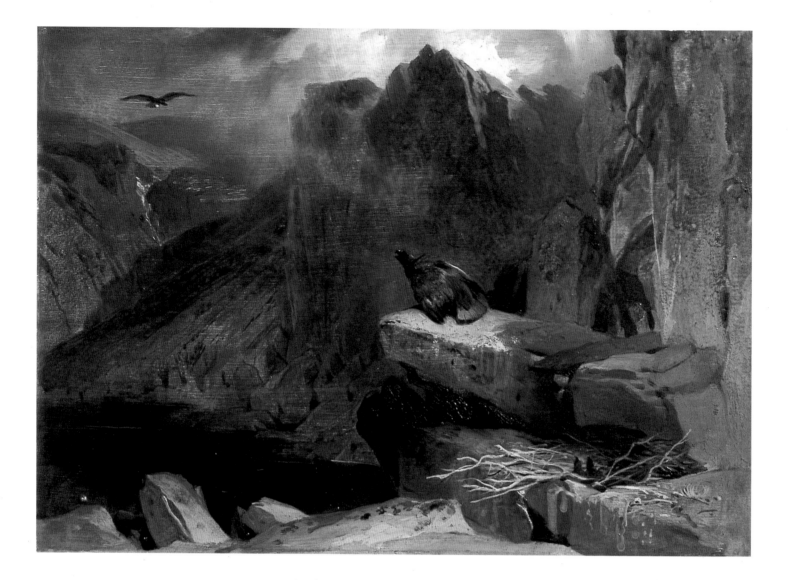

[98] *The Eagle's Nest,*
c.1833 *
Oil on board, 25.4 × 35.6
Victoria & Albert Museum,
London

[99] *Loch Caun, c.1830–5*
Oil on board, 25.4 × 35.6
Private Collection

[100] *Lake Scene,*
*c.*1830–5 *

Oil on board, 20.5 × 25.5
National Museums Liverpool
(Sudley House)

[101] *Figures Resting*
by a River in a Highland
*Landscape, c.*1824 *

Oil on board, 23.5 × 32.4
Private Collection

[102] *Landscape with*
*Dunrobin Castle, c.*1835

Oil on board, 26.3 × 34
Untraced

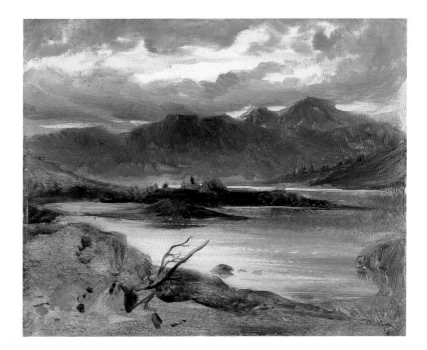

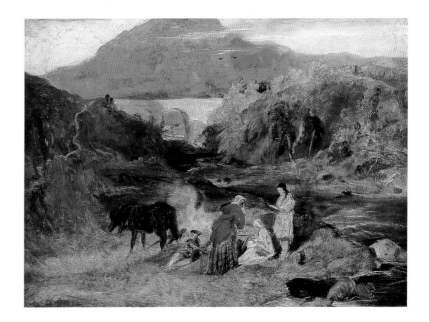

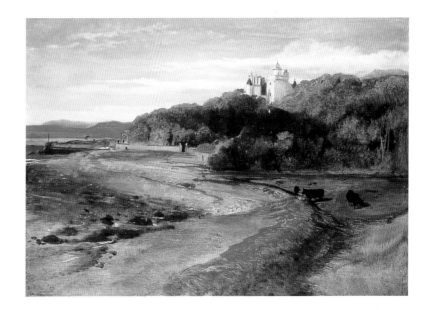

[103] *Moorland Landscape,*
*c.*1830–5 *

Oil on board, 19 × 24.1
From the Loyd Collection

[104] *River Scene with Cattle*
*in a Meadow, c.*1830–3 *

Oil on board, 26.7 × 36.2
Anglesey Abbey, The Fairhaven
Collection (The National Trust)

[105] *The River Teith,*
*Perthshire, c.*1830–5 *

Oil on board, 24.1 × 34.3
Private Collection

103

105

104

nique vary little over the span of the corpus as a whole.

In contrast to the grandeur of the Glenfeshie views, Landseer painted a group of quieter, more pastoral scenes. In these the landscape is treated in a series of horizontal bands, with foreground of field or stream, a middle ground of trees and a distant view of low ridges and hills. Diagonal lines of view draw the eye into the depth of the picture space. Though human figures are notable by their absence, we are in a countryside that is cultivated and inhabited. In *Moorland Landscape* [plate 103], there is a path in the foreground, orderly lines of trees on the far side of the stream and smoke on the distant hillside where the heather has been fired. *River Scene with Cattle in a Meadow* [plate 104] is similar in composition, with the nearer riverbank and a fallen tree trunk providing the diagonal axis

drawing the eye inwards on the right. In addition to the cow and calf several bothies can be seen above the river bank to the left. The landscape traditionally identified as *The River Teith, Perthshire* [plate 105] shows a broad stream running down a valley of well tended fields, with fences and hedges. The rippling stream, wind blown trees and boisterous sky give movement and life to an otherwise placid scene. There is always in Landseer's sketches a sense of the elemental forces of nature. In *A Highland Landscape* [plate 106], the view, framed by an upright support and wooden balustrade, has the intimacy of a scene painted from the backdoor of a house or hut. Across the gleaming pool, fringed by bushes, what looks like a golden cornfield opens up before us with visionary intensity. In the distance the brown slopes of a low hill give way to a purple ridge of mountains veiled by a shower of rain.

Distant views and scudding clouds represent one aspect of Landseer's landscape art. Close-up views of streams and rocks represent another. The artist was skilled at capturing the transparent passage of water over rocks, the milky froth of rapids and the deep translucency of still pools. The rocks and boulders that cascade down the sides of the streams are powerfully three-dimensional in form with hard, unyielding surfaces. What fascinated the painter was the ceaseless flow of water for ever wearing away and sculpting the ancient, lichen-covered stone. The scenes are solitary and often melancholy in mood. They range from small brooks to quite substantial rivers. Though we are given clues to the mountainous terrain through which the streams pass, Landseer's vision is focussed on the foreground of rocks and water.

It has been suggested that the *Highland Stream* [plate 107] represents the well-known 'Pots of Gartness' at Drymen, twenty miles to the west of Stirling, though it is not a place on the artist's normal itinerary. After a run of a quarter of a mile, Endrick Water traverses a natural cleft in the rock and enters a cauldron-shaped cavity, the 'Pots of Gartness', with a picturesque cascade. Landseer's sketch shows the stream issuing from a pool and rushing downwards between smooth and weathered slabs of rock. The dynamic foreground is set against the still pool enclosed by dark banks and dense vegetation. Some areas of the sketch are barely touched, in others the artist dilutes the medium to paint like water-colour, achieving a remarkable transparency of effect. The touch is swift and decisive and the control of tone and chiaroscuro confident

and assured. This is *plein-air* painting of a high order.

In *Deer at Bay* (private collection) the artist has introduced a sporting scene, with a stag in the foreground pool about to be dispatched by a sportsman crouched behind rocks. *Highland Stream* [plate 108] has been called 'On the Tilt, Perthshire' in the mistaken belief that it was the picture exhibited as *Scene on the River Tilt, in the Grounds of His Grace the Duke of Bedford*. In fact, the exhibited picture was a quite different work [see plate 32]. The composition of the landscape is articulated by the geometrical shaping of the bank that resembles a half octagon. The geometry is continued in the hut with its square sides and sloping roof. The river is framed by these strong rectangular shapes and it tumbles downward over ledges of rock in con-

[106] *A Highland Landscape, c.*1830–5

Oil on board, 20.3 × 25.4
Yale Center for British Art, Paul Mellon Collection

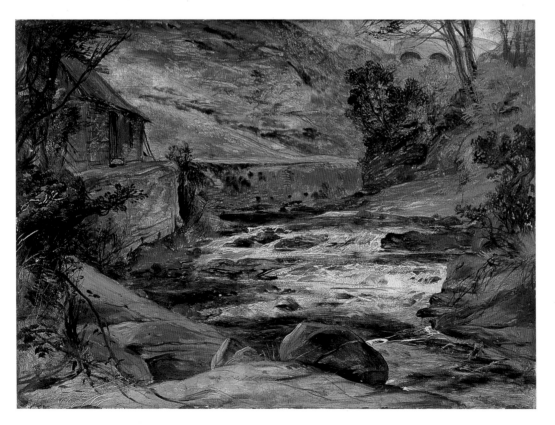

[107] *Highland Stream*
(also called *The Pots of Gartocharn* or *The Pots of Gartness*), *c.*1830–5 *
Oil on board, 25.1 × 35.4
Fitzwilliam Museum, Cambridge

[108] *Highland Stream*
(also called *On the Tilt*),
*c.*1830–5 *
Oil on board, 25.4 × 35.6
Manchester City Galleries

[109] *Rocks and Rivulet*,
*c.*1830–5 *

Oil on board, 20.2 × 25.2
National Museums Liverpool
(The Walker)

[110] *Highland Landscape*
(also called *Glenfeshie*),
*c.*1830–5 *

Oil on board, 34.3 × 25.4
Private Collection

[111] *Highland Landscape*
(also called *Glen Tilt*),
*c.*1830–5

Oil on board, 33 × 25.4
Private Collection

109

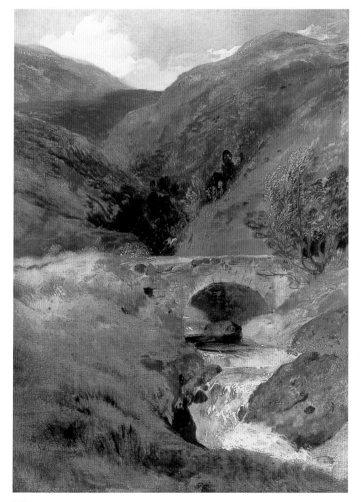

110

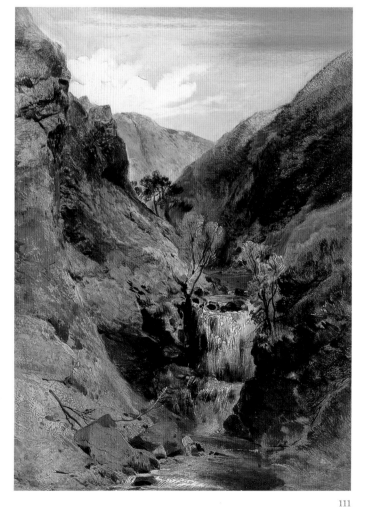

111

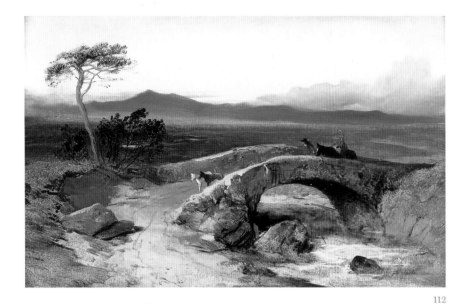

112

[112] *Return from Deerstalking,*
*c.*1830–5 *
Oil on board, 28.6 × 47 · Private Collection

[113] *Highland Pool, c.*1830–5 *
Oil on board, 35.6 × 25.4 · Private Collection

[114] *Highland Landscape with Split*
*Scotch Pine, c.*1830–5 *
Oil on canvas, 36.2 × 26 · Private Collection

stant flux. *Rocks and Rivulet* [plate 109] is a picture that might have appealed to John Ruskin in its precise descriptive detail. But there is always in Landseer's work a romantic instinct for mood and feeling that draws him away from the objective recording of nature sought by the Pre-Raphaelites. He is not analysing geological strata as John Everett Millais (1829–96) was to do in his portrait of the great art critic, *John Ruskin at Glenfinlas* (1853–4, private collection), or John Brett (1830–1902) in his painting of the *Val d'Aosta* (1858, collection of Lord Lloyd Webber).[21]

A matching pair of upright landscapes represent a different type of landscape composition [plates 110, 111]. They have been variously identified as Glenfeshie and Glen Tilt, but it seems more likely that they are different views of the same stream, for the profile of the mountains is similar in both. We are down below looking up at the stream, and overawed by the spectacle of the mountains above us. Patches of sunlight, windswept trees and the bubbling water bring the landscapes to life, for there is nothing static in Landseer's view of nature. The rough textures of the grassy hillside are painted in smooth, light-

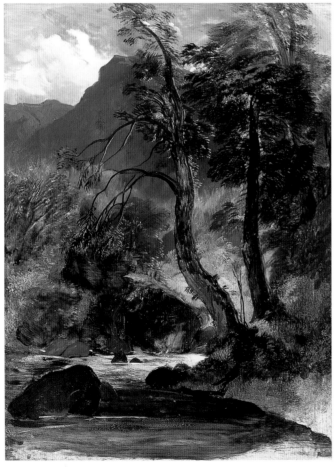

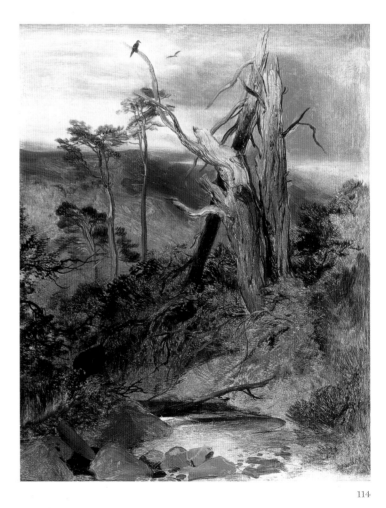

113

114

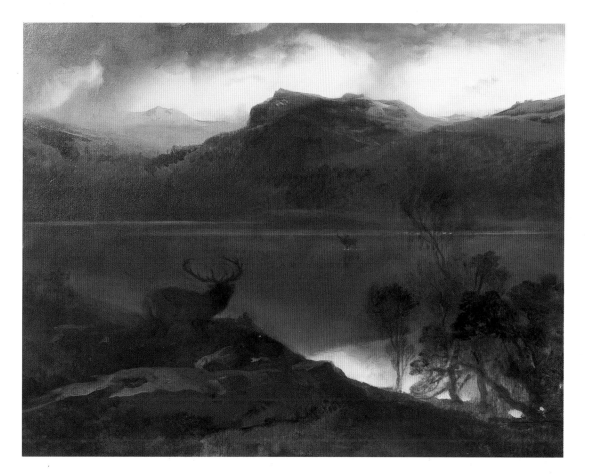

[115] *Evening Scene in the Highlands*, c.1849

Oil on canvas, 69.3 × 89.5

Private Collection

toned sweeps of impasto, over which the artist dashes in the darker detail of rocks and vegetation. Bridges are a common feature in Landseer's landscapes; that in *Return from Deerstalking* [plate 112] is a humbler version of the one in the foreground of *Return from the Staghunt* [plate 43].

The *Highland Pool* and *Highland Landscape with Split Scotch Pine* [plates 113, 114] are more intimate landscapes. Both of them feature trees dramatically placed on the banks of Highland streams. The first is dominated by the sinuously curving trunk of a Scotch pine reaching from the low bank in front to the top of the picture space. Its waving branches, catching the light from behind, seem to address us in mute appeal. The shadowed pool gives way to a bright strip of water with rocks and trees on the farther bank. A dark slab of mountain towers over the scene to give us a sense of the sublime. The two Scotch pines in the other sketch, one snapped in two, are characteristic of romantic art, where the blasted tree symbolizes death and destruction – a point emphasized by the two birds of prey. The trees are boldly silhouetted against a stormy landscape and sky, and surrounded by fallen branches and clumps of heather.

Landscape in Landseer's later work is restricted to the backgrounds of his deer paintings. They become increasingly visionary and transcendental to match the heroic and idealized character of the deer themselves. *Evening Scene in the Highlands* [plate 115] is a rare, independent landscape exhibited at the Royal Academy in 1849.[22] The last gleams of sunset light up the evening sky and are reflected in the still waters of the loch. The picture includes two stags, eyeing each other as a prelude to battle, but they are barely discernible in the encroaching darkness and they are wholly subservient to the natural elements. Landseer is in high romantic mode, turning the Highlands into a place of unearthly beauty and ineffable mystery.

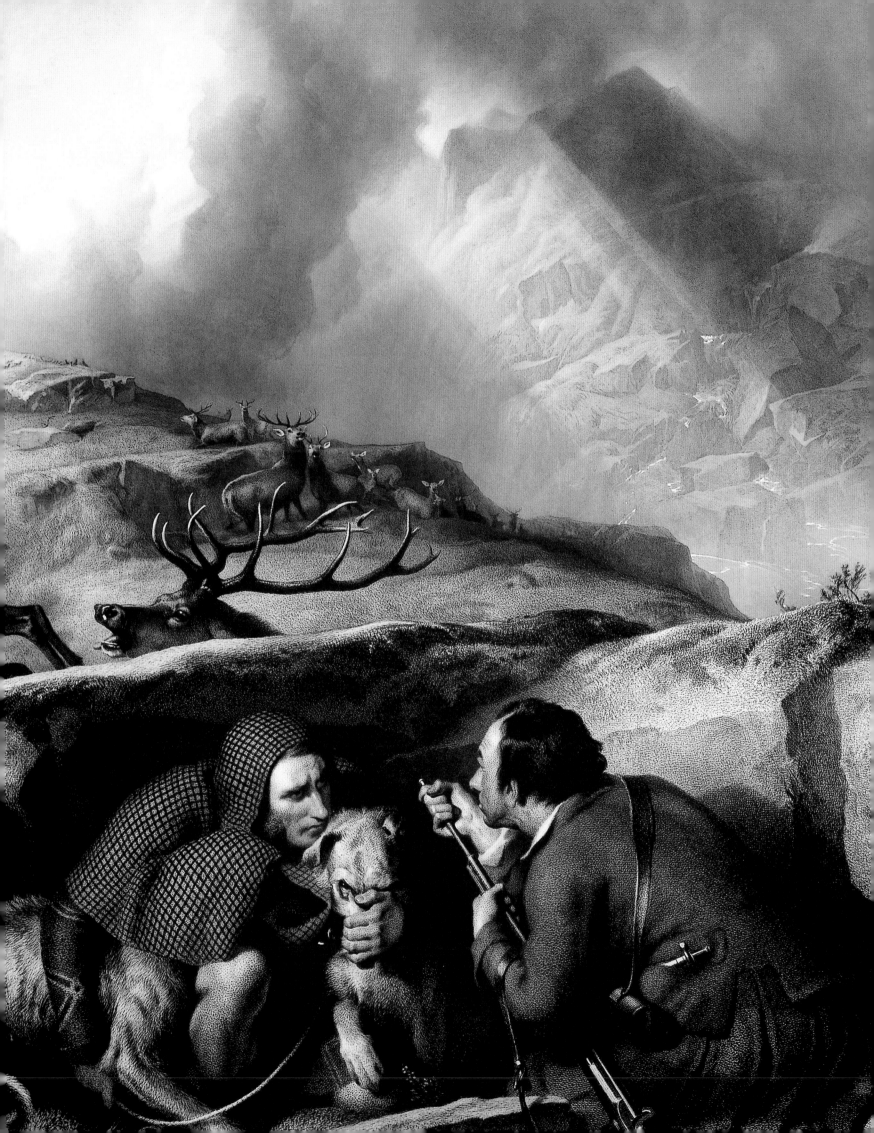

5 · PATRONS AND PRINTS

Landseer was a shrewd operator in the market-place for which he produced his Highland subjects. He was fortunate in securing aristocratic patronage from the time of his first visit to Scotland in 1824, because that assured him of profitable commissions, with money up-front. The two large sporting groups he painted for the Dukes of Gordon and Atholl [plates 35, 37], *The Hunting of Chevy Chase* [plate 10] for the Duke of Bedford, and *An Illicit Whisky Still* [plate 57] for the Duke of Wellington, were not works he would have undertaken without a commission. Painted over a five-year period, between 1824 and 1829, they helped to establish his reputation for Scottish subjects, and smoothed his path into the highest reaches of society. The Duke and Duchess of Bedford gave him lesser commissions for portraits of their children [see plates 28, 29, 30, 32, 33], and for cabinet pictures like *A Scene at Abbotsford* [plate 5]. Landseer also painted portraits of children and favourite pets for a variety of high-born patrons: *A Favourite Shooting Pony* [plate 36] for the Duke of Gordon, *Lord Richard Cavendish with a Favourite Greyhound and Hawks* for the Duke of Devonshire (Trustees of the Chatsworth Settlement), and *Jocko with a Hedgehog* [see plate 8] for the Buckinghamshire landowner and member of parliament, Owen Williams.

This pattern of patronage continued through the 1830s. The one big history picture of the decade, *Bolton Abbey in the Olden Time* [plate 15], was a commission from the Duke of Devonshire, together with a portrait of the Duke himself (Chatsworth). The large sporting groups, *The Death of the Wild Bull* and *Return from Hawking* [plates 42, 21] were ordered by the Earl of Tankerville and Lord Francis Egerton (later Earl of Ellesmere), respectively. Towards the end of the decade, Landseer began to make a special-

ity of life-size group portraits of aristocratic children with pets. Those with Highland connections include *Ladies Harriet and Beatrice Hamilton, Children of the Marquess and Marchioness of Abercorn* (c.1836, private collection) and *Portraits of the Marquess of Stafford and the Lady Evelyn Gower – Dunrobin Castle in the Distance* (1835–8, Dunrobin Castle). And for pictures of dogs and horses belonging to the artist's sporting patrons, like *Favourite Pony and Dogs* [plate 77], there was a continuing demand. It was as an animal painter that Landseer first came into royal favour, painting Princess Victoria's much loved spaniel, *Dash* (Royal Collection), a year before her accession to the throne in 1837, and subsequent groups of royal dogs in palace settings.

Monarchs and aristocrats have always wanted pictures of themselves, their families and their pets, and Landseer was looked on as one of their own. When it came to other forms of painting, he had to fend for himself in a highly competitive market-place. His pictures of Highlanders, deer and dead game were exhibited for sale each year, at the Royal Academy of Arts and the British Institution. During the 1820s and 1830s, the artist could not always be sure that his pictures would sell, and the reappearance of certain works in the British Institution, following their first exhibition at the Royal Academy a year earlier, is evidence that finding buyers could be a problem. Landseer was, however, fortunate in attracting the patronage of several leading collectors of the day, most notably Robert Vernon (1774–1849), John Sheepshanks (1787–1863), and William Wells of Redleaf (1768–1847); the last two in particular became close friends and supporters. They were representatives of a new class of entrepreneur collectors, who bought contemporary works of art on the basis of subject content and aesthetic quality. They believed that art should

address the imagination and appeal directly to the emotions of the spectator. In 1857 Sheepshanks gave over two hundred paintings and nearly three hundred water-colours, drawings and etchings to the South Kensington Museum (now the Victoria & Albert Museum), as the foundation of a national collection of British art, because he believed in the power of art to stimulate thought, arouse sympathy and teach lessons. He was a populist who wanted accessible forms of art to be freely available to all classes of society.

Robert Vernon also gave his collection of modern art to the nation, offering it to the National Gallery in 1847. It is clear from recent research that Vernon was not so much of a self-made man, as has previously been assumed, but had inherited a substantial livery stable business from his father. This he expanded, becoming vastly rich in the process.[1] His father had also owned pictures and prints, so collecting obviously ran in the family, but Vernon's decision to concentrate on the contemporary field seems to have been his own. No doubt he saw patronage of the arts as one way of 'lifting him[self] out of obscurity into some sort of *locus standi* in the world',[2] but he was knowledgeable and discriminating, buying works of high quality, especially landscapes and genre paintings. Among his early purchases were two of Landseer's finest Highland subjects of the early 1830s, *Highland Music* and *Deer and Deerhounds in a Mountain Torrent* [plates 61, 50], as well as *Buck, Game and Pheasant* [untraced] and *The Hawking Party* [see plate 19], illustrating Sir Walter Scott's novel, *The Betrothed*.[3] A row over a commissioned picture of Vernon's favourite spaniels was happily resolved when Vernon accepted *The Cavalier's Pets* (*c*.1845, Tate, London) in lieu of the original work.[4] Vernon went on to commission three large works, *Time of War* and *Time of Peace* (*c*.1846, Tate, destroyed in the Thames flood of 1928), and *Dialogue at Waterloo* (*c*.1850, Tate, London), a picture of the Duke of Wellington and his daughter-in-law revisiting the battlefield at Waterloo.

William Wells of Redleaf, the former shipbuilder turned landowner, was Landseer's single most prolific patron. Sportsmen and artists were always welcome at his hospitable hearth, for sport and art were his twin passions, and in Landseer he found them happily combined. The painter looked on Redleaf in Kent as his second home, he had his own studio there and he went to stay for protracted periods of time. Of the thirty-three pictures by Landseer owned by Wells, nine were game pictures, chiefly of birds [see plates 51, 52]; four were scenes with Highlanders, including *The Bogwood Gatherer* and *Interior of a Highlander's House* [plates 63–4]; two were of hawks [plates 23–4]; and six were deer subjects, including *Red Deer* and *Fallow Deer, Roe Deer* and *None but the Brave Deserve the Fair* [plates 122–5]. Wells's taste in contemporary art ran to landscape, sport and genre, and the artists he collected belonged to the same milieu as Landseer – among them F.R. Lee, William Mulready, David Roberts, Clarkson Stanfield, J.M.W. Turner, Thomas Webster and Sir David Wilkie. He also built up a significant collection of old masters, especially strong in artists of the Dutch school. His nephew, Billy Wells, who inherited much of the collection, was another passionate sportsman and he often entertained Landseer at his house, Holme Wood in Huntingdonshire. Their friendship is recorded in more than two hundred letters preserved in the National Art Library at the Victoria & Albert Museum.[5]

The third of Landseer's key early patrons, John Sheepshanks, was a wealthy cloth manufacturer from Leeds. He had retired from business in 1828 and moved to London. He first amassed a huge collection of old master prints which he sold to the British Museum in 1836, before going on to patronize contemporary artists. His particular taste was for well-made cabinet pictures that told a story, and among his favourite artists were Edward Cooke, C.W. Cope, Francis Danby, J.C. Horsley, Landseer, C.R. Leslie, William Mulready and Thomas Uwins. He often entertained artists to dinner at his home, Park Place, in Blackheath, together with leading engravers such as B.P. Gibbon, J.H. Robinson and John Burnet, for he championed the process of widening access to art through the medium of the print. He often conducted negotiations with print publishers on behalf of his artist friends. Sheepshanks amassed the finest collection of Landseer's Highland subjects, among them *The Stonebreaker, A Highland Breakfast, The Eagle's Nest, The Drovers' Departure, Comical Dogs, The Old Shepherd's Chief Mourner, Tethered Rams,* and *Young Roebuck and Rough Hounds* [plates 73, 65, 98, 75, 67, 66, 76, 54].

Sheepshanks was not a sportsman, nor is he recorded as a visitor to Scotland, so his taste for Landseer's Highland scenes was strictly that of a connoisseur. He bought his first picture from the artist in 1822, *Twa Dogs* (Victoria & Albert Museum), at an exhibition organized by the Northern Society for the Encouragement of the Fine Arts in Leeds. He bought further works in 1824, but it was in the 1830s that he made his major purchases from Landseer, and chiefly of Highland subjects.

Surviving correspondence between Sheepshanks and Landseer shows how closely entwined with picture buying was the whole process of print production. In a letter of 22 February 1835, Landseer apologized to Sheepshanks and the engraver, J.H. Robinson, for time lost in authorising a print of *Little Red Riding Hood*. He went on to thank his patron for a set of 'splendid impressions' of *Jack in Office*, left by B.P. Gibbon: 'The engraver deserves all the praise and congratulation he met with. Nothing can be more successful than the plate. The trade tell me it will sell better than any work that has been done of late. I have also to thank you for the most dandy and beyond measure the best slippers I ever possessed.'[6]

In April 1837, Sheepshanks wrote excitedly to Landseer:
My eyes were so dazzled with your pictures, that I went away absolutely confounded & forgot to ask the first refusal for Mr Gibbon to engrave Mr Wells' picture of Two Dogs. If Wells won't part with the picture, will you paint me a subject of similar size containing two or three dogs of the high aristocratic breed, to be engraved as a centre to the two mezzotints already mentioned. At the sale on Saturday ratcatchers sold for 111 gns. It is quite safe for you to double your prices on purchases – I will be glad to get out of debt if you let me know the sum. I hope the two pictures of Highland family and Ram of Derby will be finished in a few weeks.[7]

Later in the same year, Landseer wrote to Sheepshanks:
The whole tribe of publishers, all swear to the copyright of the 'Egerton Picture' – I answer Messrs Boys and Hodgson by stating that Mr Moon has clearly proved to me his previous claim and have this morning decided on Threadneedle St. The sum they each offered was two hundred
The reason I prefer Mr Moon is simply your

having smiled on him – in short he came up with your name in his mouth … to make up for the disappointment of the other two losers I have offered them the choice of 4 subjects (now in progress) – Do you think Moon come down with the ready at once or to pay half? (100) Forgive the trouble I venture to give you – you are always so friendly and kindly disposed to think for me …[8]

Landseer's reliance on others for business advice began early on: his father, patrons like the Duke of Bedford and John Sheepshanks, the chemist Jacob Bell, who lifted most of the burden of negotiation from his shoulders, and at the end of his life Thomas Hyde Hills. Here is Landseer again to Sheepshanks in 1838:
Mr Wat [the engraver J.H. Wat] *is all anxiety to commence the Engraving. I rather feel inclined to let him have it on the terms he proposes (with which you are fully acquainted) if he confines the profits to two persons, viz. him and I. He, this mo[r]n[in]g, said he should wish to be solely guided by any arrangements you thought best for me, in the meantime he is to have the Picture to study – do you think I have done wrong in granting him his request?*[9]

By this date royalties from copyright in his pictures represented a substantial part of Landseer's income. As his popularity grew so did the prices he could command from print publishers, not only for current works but those painted several years earlier. Most of the Highland subjects of the 1820s and 1830s were engraved after 1840, when the print market had expanded, and his images were more widely sought after.

Engraving was a complicated business, requiring substantial investment, as a single large plate could take up to three years to complete. Only then would a publisher see any return on his outlay.[10] A highly finished drawing was usually made by the engraver from the original picture which had to be borrowed for the purpose (another process of negotiation, in this instance with reluctant owners). The plate went through various proof stages, from outline etching to finished print with letterpress. Landseer was punctilious in correcting the engraver's work, and there are a number of proof impressions in the British Museum, with extensive over-drawing in his hand. Prints were marketed and sold in print shops up and down the country, often by subscription. Eager for work and burdened with expensive studios, engravers often initiated negotiations

with painters, but they could do nothing without the support of a publisher who commissioned the plate and marketed the prints. An artist like Landseer was often in negotiation both with engraver and publisher and endeavouring to exert some form of quality control over people driven by time and profit. A letter from Jacob Bell to Landseer of 1842 provides an insight into the negotiations surrounding copyright, and the relatively large sums of money involved:

Boys [Thomas] has just been here and consented to give our price for the copyright of the Royal Mother & Brats ... Moon [F.G.] has called on me to pay 200 gs for Breeze ... I shall also call on McLean [Thomas] for his 230 gs. Boys has given up the Princess: I shall therefore draw up an agreement with Graves [Henry] for 500 gs the two pictures ... I have not been able to settle the Candy dog & monkey. Graves paused & wished to look at it again. I sounded Boys but finding that he did not admire the dog, I said nothing about the Copyright. There seems to be a little prejudice against the dog's legs. If Graves consents to what he originally seemed anxious to give, 100 gs, I shall close; it is my policy to be quite independent and not to appear at all anxious to dispose of the copyrights.[11]

Although Landseer's bank accounts survive,[12] it is not easy to identify sums paid for individual pictures and copyrights because income is rarely itemised, and because payments from patrons and publishers were usually made in instalments. Typically, Landseer was charging two to three hundred guineas for a medium-sized picture and the same for copyright. With important works the rewards were much higher. An account among Jacob Bell's papers, probably dating from 1851,[13] is headed: 'Pictures Completed, cash likely to come in during the next twelve months without any further trouble except touching proofs':

Waterloo due from Graves	1000
Do – on completion of plate	1000
Do from Trustees [of Robert Vernon]	500
Russell plates	100
Titania	300
Sir R. Peel's picture	300
Offered	
Heathcote's sketch	100
Do copyright	200
	3600 *guineas*
	or £3780

The other side of the account is headed 'Pictures not quite finished':

The Queen's picture on delivery for engraving	50
Six months after delivery	500
The flood, picture and copyright, at least	3000
Stag swimming picture & copyright	1500
Prince Picture & copyright	1000
The Marquis of Worcester horses dogs &c picture & copyright	1500
	8000

The Telescope deerstalking
Work is also on the cards
And Lord Sefton's horses
Mr Sheridan (the invalid)
And several others.

Jacob Bell was an astute businessman, and, once he began to manage Landseer's affairs, the artist's income rose dramatically. In 1832 the artist earned £1,017 and £3,298 in 1839, but by 1847 this figure had risen to £6,432, of which £3,162 represented copyright fees. Landseer's income remained close to this figure for the next decade, reaching a highpoint of £17,352 in 1865, but this was an altogether exceptional year. The artist was highly paid by comparison with other successful professional men, though he never achieved the huge sums paid for famous works of contemporary art later in the century.

The number of engraved plates after Landseer's work declared at the Office of the Printsellers' Association in London between 1847 and 1891 is three hundred and eighty-three.[14] No other artist of the period came close to this level of production. If you add the engraved plates produced before 1847, the number of engraved subjects totals around five hundred, with an output of prints running into the hundreds of thousands. No wonder that Landseer's images became so firmly embedded in the consciousness of the Victorian public, and not only in Britain. Engravings after his work were distributed in Europe and America, giving them international currency. A measure of his popularity is provided by the number of his pictures which were parodied in the magazine *Punch*, that venerable Victorian institution [see plate 116], with a wide readership.[15] The joke in a *Punch* cartoon, usually satirizing a political figure, depended on recognition of the source image. The fact that Landseer's work was so regularly drawn on by cartoonists points to its high visibility.

"COMING EVENTS CAST THEIR SHADOWS BEFORE."

[116] *Coming Events Cast their Shadows Before*, cartoon from *Punch*, vol.XVI, 1849, p.180. Tory Benjamin Disraeli confronts radical John Roebuck in a take off of Landseer's picture (plate 128).

The print after *The Monarch of the Glen* by Landseer's brother Thomas [see plate 117] was declared in 1852, with twenty-five presentation prints, three hundred artist's proofs at ten guineas each, two hundred proofs before letters at eight guineas, a hundred line prints at five guineas and an unlimited edition of ordinary prints at three guineas each. This was the general level of pricing for first-time prints after important paintings by Landseer. Smaller engravings after these same paintings, published later, and prints after less significant pictures sold for proportionately less. Artist's proofs of *Crossing the Bridge* by J.T. Willimore went as high as fifteen guineas, but there was no general edition of prints, and proofs of the exceptionally large *Drive* [plate 118] sold for twelve guineas. Thomas Boys, on the other hand, offered signed artist's proofs of *Bolton Abbey in the Olden Time* [see plate 15] by W.T. Davey at five guineas and ordinary prints at

a guinea, but the editions of the various qualities of print were much larger than those for *The Monarch of the Glen*. The fact that an earlier plate of *Bolton Abbey* by Samuel Cousins had been published in 1837 constrained the publisher and dictated his pricing strategy. He had probably paid less than usual for the copyright and he could, therefore, afford to undercut his rivals.

Jacob Bell's correspondence with publishers and engravers on Landseer's behalf reveals the wrangles and conflicts that went on behind the scenes. Engravers invariably complained about the demands put on them by publishers and the uneconomic terms they were offered for labour intensive contracts. Publishers retaliated by accusing engravers of being slow and unreliable. Writing to Bell in 1848, Landseer's improvident brother, Tom, described his work on the large plate of *The Drive* [plate 118] as 'a fag', and, worried that he had undersold himself, asked Bell to intercede with the publisher Ernest Gambart for an advance. Continuing delays with the plate led Gambart to request an unfinished proof that he could show to customers in the trade. On Landseer's instruction, Tom refused, and this led to a row. A furious Gambart told Tom that the publisher 'must be the best judge of what proofs may be shown', and he protested to Bell at Landseer's unwarranted interference. He explained to Bell that an unfinished proof whetted people's appetite, while with a finished print, 'the illusion ceases'. An unrepentant Landseer wrote to Bell: 'It is quite time to give this Frenchman up [Gambart was in fact Belgian], he only thinks of himself not the least feeling for art or the reputation of the Author or Authors – a Heartless, flattering humbug. If possible I should like to take other things in progress out of his hands.'[16] It was left to Bell as usual to smooth things over.

Gambart was involved in another row, this time involving the engraver Charles G. Lewis, brother of the painter J.F. Lewis, and a companion of Landseer's boyhood. Lewis had been so moved by the poetry of *The Random Shot* [plate 129] that he had badgered publishers to let him engrave it, telling Henry Graves that he would 'almost' do it for love. 'Almost' translated into a proposed fee of three hundred guineas, and, when Gambart turned him down, Lewis asked Bell to stop Gambart from calling with his promises 'like bubbles'. Gambart in reply told Bell that acceding to Lewis's demands would push up

[117] *The Monarch of the Glen*, engraving by Thomas Landseer, after his brother's picture [plate 132], 1852

Steel engraving, 59.7 × 61.3
The Royal Collection

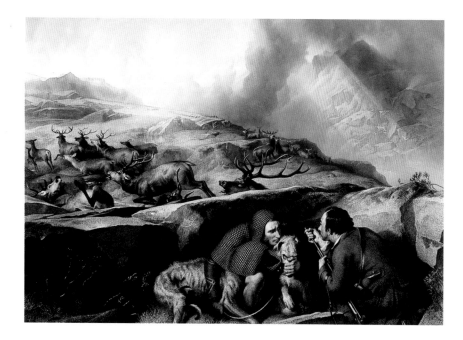

[118] *The Drive*, engraving by Thomas Landseer, after his brother's picture, 1852
Steel engraving, 71.8 × 101.7
The Royal Collection

[119] *Night*, engraving by Thomas Landseer, after his brother's picture, 1855
Steel engraving, 57.2 × 90.2
The British Museum, London

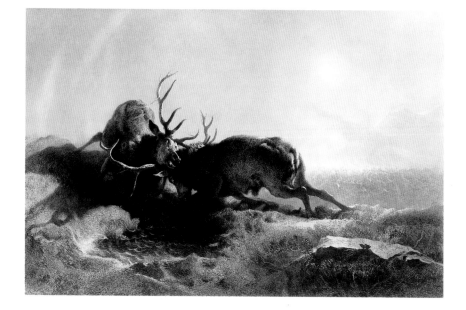

the price of the prints to uneconomic levels and that he could get the plate done more cheaply with another engraver. He pointed out that Charles Mottram, a specialist in background effects, would, in any case, carry out the snow and the sky. He did, however, send a cooling letter to Lewis, who ended up completing the plate, though on what terms is not recorded.[17]

Landseer's relationship with the impetuous Lewis plummeted when the engraver accepted a private commission to engrave the equestrian portraits of *Lord Cosmo Russell* [plate 30] and *Lord Alexander Russell* (Guildhall Museum, London) for the Duchess of Bedford. In May 1850, Landseer berated Lewis for breaking his engagement, and he wrote fiercely a year later: 'The Duchess of Bedford is impatient to have the

pictures of her Equestrian sons home immediately.'[18] Delays over Lewis's plates for the *Forest* series led to further acrimonious correspondence, and in 1855, Henry Graves, with Landseer's backing, went to law over Lewis's failure to deliver a satisfactory plate of *Collie Dogs*. The emotional Lewis declared that 'he would hand down to posterity the infamy of Edwin Landseer', but the case was quickly settled when he agreed to complete the plate to an acceptable standard within a stipulated period of time.[19]

Landseer used most of the leading London publishers of the day, including Thomas Boys, Thomas McLean and F.G. Moon, but his favourite was Henry Graves, who published the vast majority of his later output. Only a handful of letters between the two men survives,[20] but the relationship between them seems to have been a cordial and professional one. Graves had built up a successful print publishing business, and he seems to have had a genuine interest in the arts. He was a founding member of both the *Art Journal* and the *Illustrated London News*. In view of his long association with the artist, it was fitting that his son, Algernon Graves, should have undertaken the catalogues of both Landseer's engraved works and of his paintings. The latter, *Catalogue of the Works of the late Sir Edwin Landseer, R.A.* (London, c.1876), remains an invaluable source book and a model of its kind.

Patronage for Landseer's later Highland subjects follows the pattern established in the 1820s and 1830s. The aristocratic supporters of his youth, the Northumberlands, Russells, Sutherlands and Tankervilles continued to give him commissions and they were joined by new admirers, the second Marquess of Breadalbane (1796–1862), for example, and the second Viscount Hardinge (1822–1894). The latter was a particular friend and his home, South Park in Kent, was a regular refuge for the artist. Hardinge, the son of a distinguished general and a cultivated man, later to be chairman of the National Portrait Gallery trustees, commissioned the companion pair of deer pictures, *Night* and *Morning* [see plates 119, 120], in the 1850s. *The Stag at Bay* [plate 130] went to Breadalbane, a Highland chieftain of the old school, who later gave up his claim to *The Drive* [see plate 118], the largest of all Landseer's deer subjects, in favour of Prince Albert. The fourth Duke of

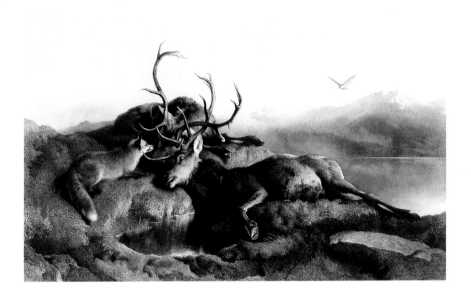

[120] *Morning*, engraving by
Thomas Landseer, after his
brother's picture, 1855
Steel engraving, 57.2 × 90.2
The British Museum, London

Northumberland, who had bought *Highlanders
Returning from Deerstalking* [plate 44] in 1827,
claimed *Coming Events Cast their Shadow Before
Them* [plate 128] in 1844. And Lord Tankerville,
the hero of *The Death of the Wild Bull* [plate 42]
placed an order thirty years later for two large
companion works, *Deer of Chillingham Park* and
Wild Cattle of Chillingham (Laing Art Gallery,
Newcastle-on-Tyne), to decorate his dining-
room, along with the earlier picture.

Landseer was never able to survive solely on
royal and aristocratic patronage. The entrepre-
neur patrons of his younger days, John Sheep-
shanks, Robert Vernon and William Wells of
Redleaf, gave way to serious professional men,
several of them engineers. Isambard Kingdom
Brunel (1806–59), famous for his bridges and
ships, included Landseer among the artists he
selected to decorate his dining-room with Shake-
spearian subjects.[21] Another successful railway
engineer, Sir John Fowler (1817–98), bought *The
Ptarmigan Hill* [plate 145] in 1869 and went on
to amass a significant collection of the artist's
work.[22] Sir John Pender (1815–96), pioneer of
submarine telegraphy, commissioned *An Event
in the Forest* [plate 140] as a pair to *Lost Sheep*
(*c.*1850, untraced), which he had acquired at
auction in 1863. The brilliant geologist, Sir
Roderick Impey Murchison, persevered with his
commission for *Rent Day in the Wilderness*
[plate 26], despite having to wait thirteen years
for it.

Landseer was fortunate to have such patrons
who liked and understood him. The silk broker,
Henry William Eaton (1816–91), later first Baron
Cheylesmore, bought *Flood in the Highlands*

[plate 81] at the Royal Academy of 1860, and he
acquired a collection of more than twenty-five
works by the artist, many of them Highland
subjects.[23] The stockbroker, E.J. Coleman
(d.1885), came to occupy the place as hospitable
friend and confidante formerly held by William
Wells, and his house, Stoke Park in Buckingham-
shire, became a second Redleaf. Landseer's
surviving correspondence with Coleman reveals
how much he relied on him for sympathy and
advice.[24] As well as acquiring the artist's polar
masterpiece, *Man Proposes, God Disposes*
(*c.*1864, Royal Holloway College, Egham, Sur-
rey), Coleman also owned two Highland works,
the large-scale pastel of *The Chase* (*c.*1866,
Beaverbrook Art Gallery, Fredericton, New
Brunswick) and *Odds and Ends, Trophies for a
Hall* [plate 146].

Landseer's work retained its popularity after
the artist's death for more than thirty years. The
prices realized by his paintings tell their own
story. Four pictures in the Coleman sale at
Christie's, London, in 1881, *Well-bred Sitters that
never say they are bored* (private collection,
Scotland), *Man Proposes, God Disposes*, *The
Chase* and *Digging out the Otter* (finished by Sir
J.E. Millais, private collection), made respec-
tively £5,250, £6,615, £5,250 and £3,076.10*s.*,
sums well in excess of £100,000 each in today's
money. *The Monarch of the Glen* [plate 132]
made £6,510 in 1884, and a staggering £7,245
eight years later when it appeared in the
Cheylesmore sale (this was the highest price paid
for a Landseer up to that date, and for more than
half a century afterwards). Prices did not signifi-
cantly diminish as the century came to an end.
Scene in Braemar [plate 133] made £5,097 in
1888, *None but the Brave Deserve the Fair* [plate
125] £4,620 in 1890, and *Dog and Dead Deer*
[plate 141]) £5,985 in 1895. Prices moderated
after 1900, but even so a picture like *Red Deer*
[plate 122] sold for a healthy £2,835 in 1907.
The First World War put an end to the boom in
Landseer prices, and by the 1920s his stock had
fallen low, reflecting the disparagement of Victo-
rian art in general, and Landseer's in particular.
His work was judged to be meretricious, anecdo-
tal and sentimental. The Landseer exhibition at
the the Royal Academy in 1961 was the first
serious reassessment of his art for more than
fifty years, and it marked the beginning of his
rehabilitation.

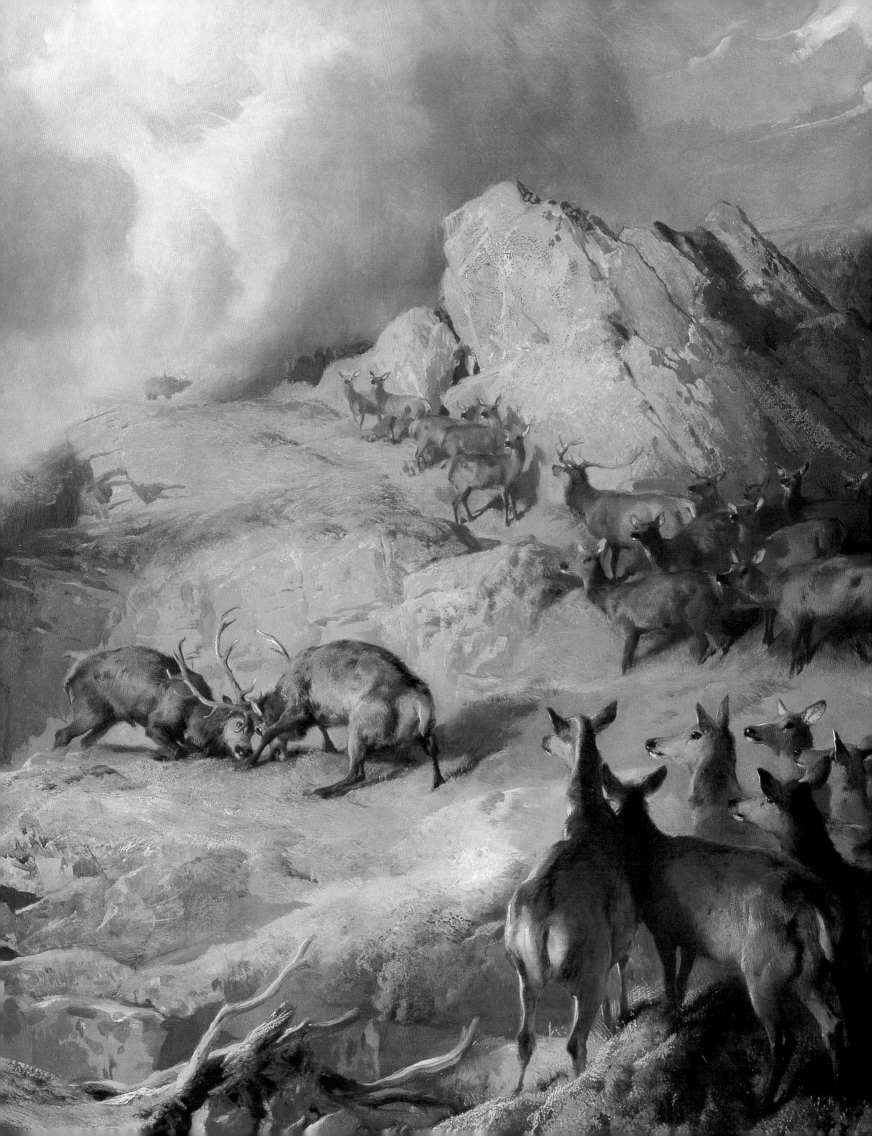

6 · THE MONARCH OF THE GLEN

The year 1840 marked a decisive change in the circumstances of Landseer's personal and professional life. In that year he suffered a severe mental breakdown that would cast a long shadow over his life, leading to recurrent bouts of depression and instability. The signs of nervous stress were already in evidence in the artist's erratic behaviour, his quickness to take offence, and his inability to complete commissions. He is said to have proposed to the recently widowed Duchess of Bedford, and her refusal, if true, might well have tipped him over the edge. The death of his mother in 1840 may also have been a contributory factor, marking as it did the break-up of the close-knit family circle.

The breakdown itself was sudden and dramatic, leaving the artist in a pitiable state and a prey to delusions. He described his feelings to his intimate friend, the dandy Count d'Orsay: *Since I have received fishing, Farming and regular Pilling, my nervous system has in part regained its strength. The only thing against me is self-torture. My unfinished works haunt me – visions of noble Dukes in armour give me nightly scowls and pokings ... my imagination is full of children in the shape of good pictorial subjects. Until I am safely delivered, fits of agitation will continue their attacks.*[1]

Landseer's symptoms were those of a manic-depressive and modern drugs would have done much to alleviate his condition. The cure then was a leisurely continental tour through Belgium, Germany and Switzerland, in the charge of Jacob Bell, the chemist and art collector.[2] Until his death in 1859, Bell, in concert with his brother James, acted as Landseer's business agent and trusted adviser, relieving him of the burden of business correspondence, the importunities of patrons and publishers and the necessity of making decisions.

It would be easy to exaggerate Landseer's mental instability in the years immediately following his breakdown. He was prone to bouts of hypochondria and self-pity at the best of times, and his letters, with their note of querulous complaint, are not always an accurate index to his state of mind. He was at the height of his powers throughout the decade of the 1840s, producing some of his grandest and most original compositions. The production of prints, often from earlier works, began in earnest after 1840, reaching out to a mass audience and making him the best-known artist of his day. A knighthood in 1850 served to confirm his pre-eminence, and it was followed five years later by the award of a gold medal at the *Exposition Universelle* in Paris, confirming his international reputation.

Landseer remained much in demand in society, renowned for his wit and his powers as a raconteur. He regularly dined in the houses of the great and the good, many of whom were his friends and his patrons. He was part of the intimate circle of Charles Dickens and John Forster, and a frequent guest at Gore House, home of Lady Blessington and Count d'Orsay. Other circles in which he figured include those of the poet Samuel Rogers, the blue-stockings Caroline Norton, Lady Eastlake and Mrs Jameson, the actor W.C. Macready and the artists William Boxall and Francis Grant.

Landseer's annual visits to Scotland in the late summer and autumn remained one of the anchor points around which his life revolved. Shooting or sketching out on the heather helped him to recuperate and relax, and provided the tonic he needed to keep going. The people with whom he stayed were among his oldest friends and they made few demands on him: the Duchess of Bedford at The Doune in the Cairngorms; her son-in-law and daughter Louisa, the

< Detail from plate 125

Marquess and Marchioness of Abercorn at Ard-verikie on Loch Laggan; the Marquess and Marchioness of Breadalbane at Taymouth Castle and Black Mount in the forests of Glenorchy; Edward Ellice and his wife at Glenquoich west of Invergarry; and the Balfours at Balbirnie in Forfarshire. To these must be added Queen Victoria and Prince Albert at Balmoral, and newer friends like Louisa Stewart Mackenzie at Loch Luichart near Dingwall. Like his friends, Landseer remained a keen sportsman, though not a great shot, and much of his time in the Highlands was spent stalking and shooting game.

Landseer's autumn visits to the Highlands followed a familiar pattern. That of 1844 is well documented in his letters to Jacob Bell.[3] He arrived in Edinburgh on 12 September, in company with his brother Charles, and set off in fine weather for Taymouth Castle to stay with the

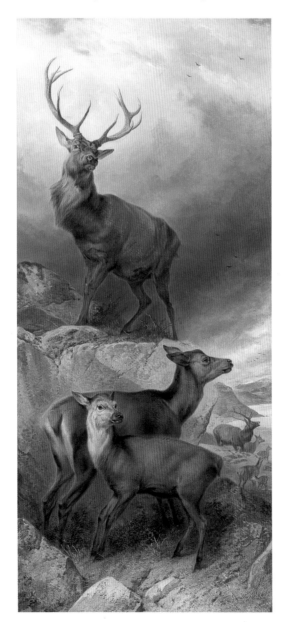

[121] *The Deer Forest*
by Richard Ansdell, *c*.1870
Oil on canvas, 165 × 76
The Drambuie Collection,
Edinburgh, Scotland

Breadalbanes. He went on to Black Mount, near the Bridge of Orchy, on 16 September, writing to Bell three days later: 'My health goes on *bravely*. I have been out two days Deerstalking. Nothing can be more beautiful or so healthy as this place.' On 25 September he set off across country to stay with the Duchess of Bedford, first at The Doune, later at Glenfeshie: 'yesterday I was motionless for an hour and a half in *deep snow* watching a herd of Deer in the hopes of a Shot which did not come off – I saw them through my Glass going ahead in their various flirtations – Stags Fighting &c.' In October he was describing floods in the neighbourhood: 'danger to the Houses – and great alarm to our breed of Ladykind – who were sadly put to their shifts as the *necessary* was washed away! ... I wounded a stag yesterday – and knocked myself up following him.' He returned to Taymouth Castle on 3 November, where he was soon out on the snow-clad mountains, killing seven hares, and fourteen brace of grouse and blackcock. He spent a week with the Balfours at Balbirnie, declined an invitation from the Duke of Argyll, and returned to London via Edinburgh on the weekend of 16–17 November, having been away for two months.

The Highlands remained as potent an inspiration for Landseer as they had always been, but the focus of his art was changing. He painted only one great sporting group after 1840, *Royal Sports on Hill and Loch* [see plate 137 for the colour sketch], and that, significantly, remained unfinished at his death. History painting, apart from one late commission, *Rent Day in the Wilderness* [plate 26], was abandoned, and contemporary scenes of Highlanders and Highland life are few and far between. What increasingly absorbed the artist was the character and behaviour of the deer themselves. His later art can be seen as a celebration of these noble beasts, symbolizing the power, beauty and violence of the natural world. His major deer subjects are monumental in scale and couched in the language of myth and emblem. The deer are not ordinary animals inhabiting the natural landscape but heroic presences dominating their surroundings. Before them we sense something grander and more sublime than ourselves, an elemental force and splendour that defies the baying hounds and the stalker's rifle.

External factors played their part in the shifting pattern of Landseer's art. The

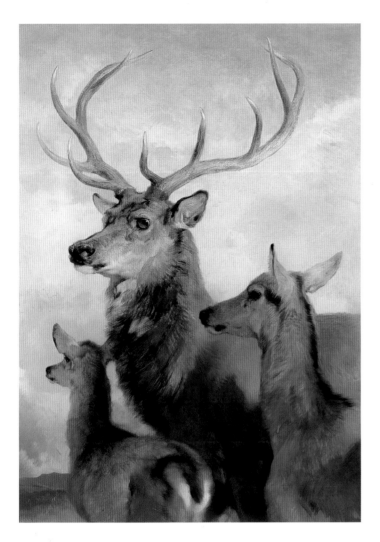

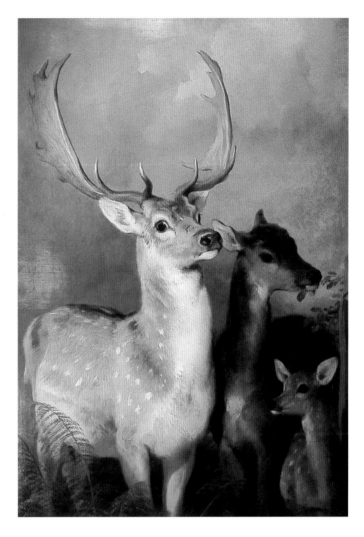

[122] *Red Deer, c.1839* *
Oil on canvas, 137.2 × 96.5
Private Collection

[123] *Fallow Deer, c.1839* *
Oil on canvas, 134.6 × 96.5
Private Collection

renaissance of history painting and high art, stimulated by the competitions for mural commissions in the new Palace of Westminster during the 1840s, encouraged paintings of a more serious character on a grander scale. *Coming Events Cast their Shadow before Them* and *The Stag at Bay* [plates 128, 130] were Landseer's answer to the rise of history painting, monumental in conception, and many-layered in message and allusion. His attraction to large-scale designs can be seen in the chalk cartoons he roughed out on the walls of the lodge at Ardverikie in 1842, which provided ideas for the composition of several later works.[4] *The Monarch of the Glen* [plate 132] was originally intended for one of three sporting panels in the House of Lords refreshment room, which would have held their own against the frescoes by William Dyce and Daniel Maclise elsewhere in the Palace. Landseer's later pastels of deer on the scale of life have the look of cartoons for wall paintings. In the 1840s, Landseer transformed his images of deer from sporting subjects to the stuff of epic.

He was not alone in this. The sporting pictures by his younger contemporary, Richard Ansdell (1815–85), who could be described both as follower and rival, are couched in the same heroic language [plate 121]. Stags at bay, stags fighting, deerhounds, and deerstalkers returning with dead game, become the staple of mid-Victorian sporting art. And Landseer's influence spread beyond the confines of Britain, to influence continental artists as diverse as Gustave Courbet and Rosa Bonheur.[5] It was in the second phase of his career that Landseer left his most enduring mark as the creator of Highland imagery that is romantic, larger-than-life and still potent today. His pictures were designed to appeal to an urban and metropolitan audience eager to experience the thrill of the chase and the wildness of the elements from the safe distance of their drawing-rooms. His art provided an avenue of escapism while confirming the notion that the Highlands represented the true spirit of Scotland. Nobody bought into that vision more completely than

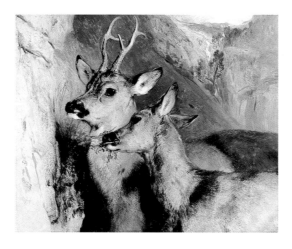

[124] *Roe Deer, c.*1838
Oil on canvas, 62.2 × 77.2
Private Collection

[125] *None but the Brave Deserve the Fair, c.*1838 *
Oil on canvas, 71 × 92
Private Collection

The transformation of Landseer's style and subject matter began a little before 1840. In a pair of pictures painted for his great friend, William Wells of Redleaf, *Red Deer* and *Fallow Deer* [plates 122, 123],[6] which he exhibited in 1839, he illustrated the essential differences between the two breeds, hart, hind and fawn in the case of red deer, buck, doe and fawn in the case of fallow deer. Happy deer families such as these are a figment of the artist's imagination, for males pair off with females only to mate, but the artist was here drawing a human parallel, which his contemporaries would have appreciated. The deer are seen at close range, which would be impossible in the wild, and they mark a shift in Landseer's style from realistic hunting scenes towards a form of heroicizing portraiture. The heads of the animals fill most of the picture space, with the dominant antlers of the stag and buck silhouetted against the sky. Whether their

Queen Victoria and Prince Albert, who, as passionate converts, seemed to become more Highland than the Highlanders. They delighted in the associations of a romantic history with the pursuit of game and the picturesque rituals of Highland life. They were, of course, ardent admirers of the painter.

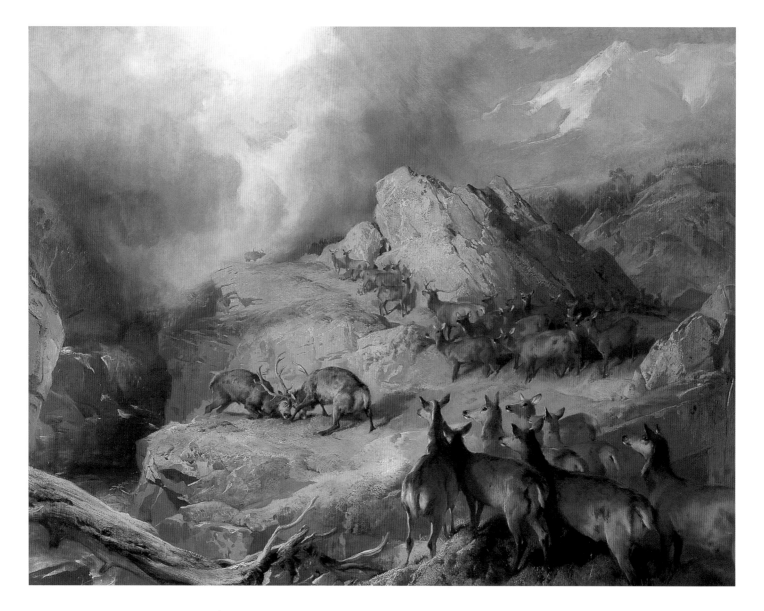

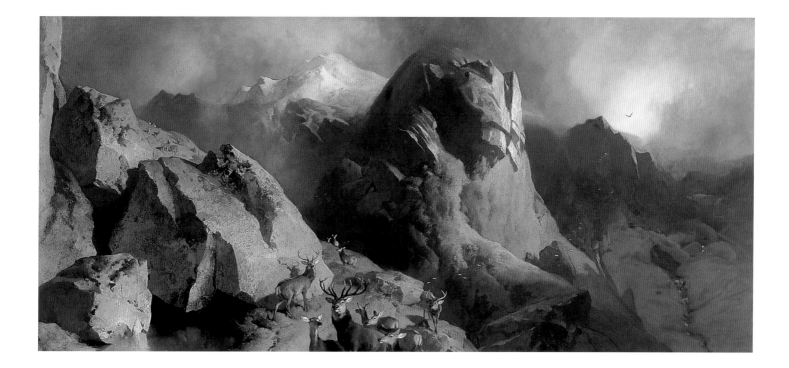

[126] *The Deer Pass*, c.1852
Oil on canvas, 99.1 × 213.4
JKM Collection, National
Museum of Wildlife Art, Jackson,
USA

air of alertness is to be interpreted as a response to human intrusion or some other cause is not explained. We might be disinterested spectators of deer behaviour or predators intent on their destruction.

Roe Deer [plate 124] is a picture in the same vein, but more overtly sentimental, with the deer behaving like a pair of lovers. They are shown as part of the Highland scenery and not abstracted from it like the two deer families. *None but the Brave Deserve the Fair* [plate 125],[7] a fourth Wells commission, represents another new departure. Here we are spectators at that most typical of deer rituals, the rut, when the stags fight for the right to serve the females, and then mate with them to the point of exhaustion. In the picture, Landseer highlights the fighting stags, like gladiators in an amphitheatre, watched by a tense audience of hinds. A single stag in their midst turns to watch the advance of a fourth stag from the pass in the distance – the prelude no doubt to another contest. The spectacle of storm clouds and mountain peaks gives a drama and significance to the subject out of all proportion to the reality of the rut. The stags are shown like human heroes battling for some greater cause than the mere gratification of the sexual instinct. Like the hinds, we are caught up in the excitement of the fight, sitting on the edge of our seats to await the outcome. Landseer draws on the ordinary processes of animal life to dwell on

deeper issues of life and death. A later picture in the same vein is *The Deer Pass* [plate 126]. Here among storm-laden peaks, a herd of deer, alert to danger, pause warily before proceeding up the mountain.

The Sanctuary [plate 127], exhibited in 1842, is the first of Landseer's large, panoramic deer subjects. An exhausted stag has swum to safety on one of the islands of Loch Maree, a famous loch in the county of Ross and Cromarty on the west coast of Scotland.[8] In coming ashore, with dripping fur, the stag puts up a flight of ducks who head off in formation towards the setting sun. The violence from which the stag has escaped is thrown into relief by the extreme stillness and serenity of the scene, and the luminous quality of light. The loch reflects the pink and orange sky, which changes at the top to ethereal blue. Landseer had painted many peaceful Highland landscapes but never with such visionary intensity. The picture is redolent of poetic imagery and one can find parallels in its mystical conception of nature in the work of the romantic poets. Landseer appended a quotation from a poem, 'Loch Maree', by his close friend, William Russell, in the Royal Academy exhibition catalogue of 1842:

See where the startled wild fowl screaming rise
And seek in marshalled flight those golden skies.
Yon wearied swimmer scarce can win the land,
His limbs yet falter on the water strand.

Poor hunted hart! The painful struggle o'er,
How blessed the shelter of that island shore!
There, whilst he sobs, his panting heart to rest,
No hound nor hunter shall his lair molest.

In its imagery of sanctuary and salvation, the picture may have had a personal significance for the artist, then emerging from the shadows of his breakdown. The picture was commissioned by William Wells, Landseer's staunchest patron at this time, but he agreed to stand aside for the Queen, who gave it to her husband as a birthday present in August 1842. It was the first of Landseer's Highland pictures to enter the royal collection, in the very year that Queen Victoria and Prince Albert made their first tour of Scotland.

The second of Landseer's large deer subjects, *Coming Events Cast their Shadow before Them* [plate 128],[9] took its title from a poem by Thomas Campbell, 'Lochiel's Warning' (1802). A wizard warns the hero of the poem of his impending fate at the battle of Culloden in 1745: *'Tis the sunset of life gives me mystical lore,* *And coming events cast their shadows before.*

The shadow in this case is that of the stag standing on the shore and bellowing defiance at a rival seen swimming across the lake towards him, leaving a wide trail in his wake. The shadow of the antlers cast on the sand seems to foretell the death of one or both animals in the coming struggle. Introducing the shadow of an image to anticipate a coming event is a typological device often found in religious painting of the period. In Holman Hunt's picture, *The Shadow of Death* (1869–73, Manchester City Art Galleries), the figure of Christ in the carpenter's shop, with arms upraised, creates a shadow on the wall like that of the crucifixion. Landseer's picture has about it a mystical and unearthly quality, of vast spaces and icy heights seen in raking moonlight, and it may not be too far-fetched to read into it a religious significance.

The intense evangelical mood of the mid-nineteenth century is reflected in a number of Landseer's later works, though he was not himself overtly devout. In *The Shepherd's Prayer* (*c.*1845, private collection, USA), a Belgian shepherd kneels before a crucifix on the battlefield of Waterloo, with a vast flock of sheep stretching away to the horizon. Christ the good shepherd is here associated with the theme of sacrifice and redemption in a place of war. *The Lost Sheep* (*c.*1850, untraced), a Highland scene of sheep being rescued from snowdrifts, was exhibited with a quotation from St. Luke's gospel (15: 4): 'What man of you, having a hundred sheep, if he lost one of them, doth not leave the ninety and nine in the wilderness, and go after that which is lost, until he find it?' The text for *An Offering* (*c.*1861, untraced), a picture of a bound goat on a

[127] *The Sanctuary, c.*1842 *
Oil on canvas, 61 × 152.5
The Royal Collection

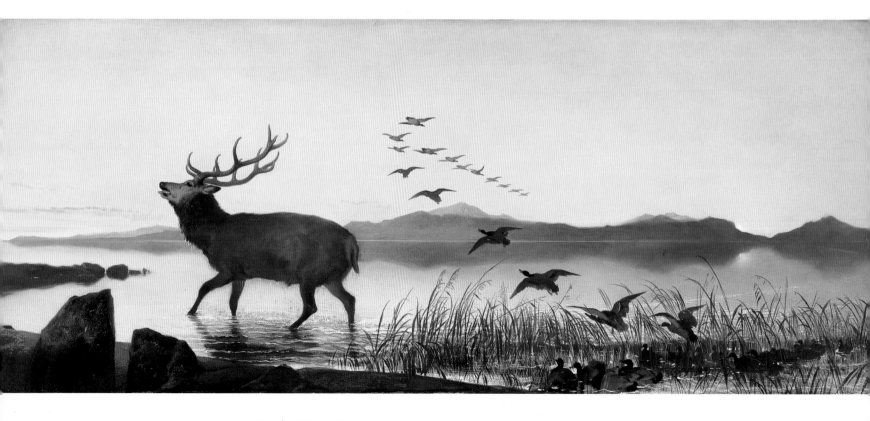

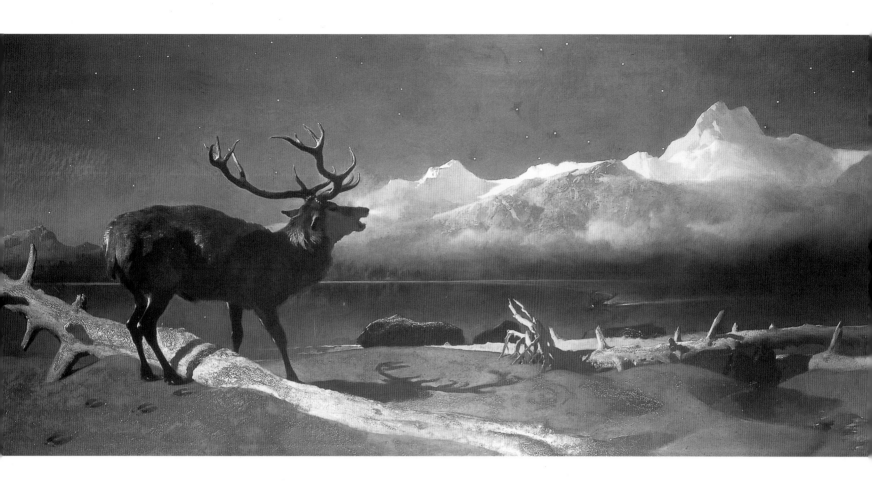

sacrificial pyre, is Leviticus (9: 15): 'And he brought the people's offering, and took the goat, which *was* the sin offering for the people, and slew it, and offered it for sin, as the first.' The quotation was not included in the catalogue when the picture was exhibited at the British Institution in 1861, and several critics were puzzled by its meaning. What Landseer intended with the goat was to prefigure Christ's greater sacrifice for the sins of the world. There is a close parallel here with Holman Hunt's picture of the *The Scapegoat* (1854, Manchester City Art Galleries), showing a sacrificial goat cast into the wilderness to atone for the sins of the people (Leviticus, 16: 22). Holman Hunt had first thought of offering the subject to Landseer before deciding to tackle it himself. His painting of the goat by the Dead Sea is a virtuoso display of animal painting, even more meticulously detailed than Landseer's work.

The fallen hind in *The Random Shot* [plate 129] is represented as another sacrificial victim, though there is no specific biblical reference. The quotation in the Royal Academy catalogue of 1848 was taken from Sir Walter Scott's epic poem, *The Lord of the Isles* (canto 5, no.18). Landseer's extract is not an accurate

transcription of Scott's published text:

> *Full many a shot at random sent,*
> *Finds mark the archer little meant*
> *And many a word at random spoken*
> *May hurt or heal a heart half broken.*

No self-respecting sportsman would shoot a deer with its young, and the hind is represented as the victim of gratuitous violence. The pathos of its end can be read in the unsteady tracks in the snow and the poignant drops of blood. The fawn, forlornly seeking nourishment, is doomed like its mother. The unearthly beauty of the mountain top at sunset raises the tragedy to one of universal significance, and it invokes a sense of religious awe.

The Stag at Bay [plate 130], Landseer's largest work to date, features another victim, but of a different kind.[10] Here an animal of enormous size and majestic presence turns on its pursuers and stands defiant in the face of death. The huge form of the stag and the twelve points of its antlers dominate the composition. Two hounds, one on its back and wounded, have brought the stag to bay in the shallows of a loch, and the cropping of their bodies brings the action right to the front of the picture space. Beyond the animals, the waters of the lake are

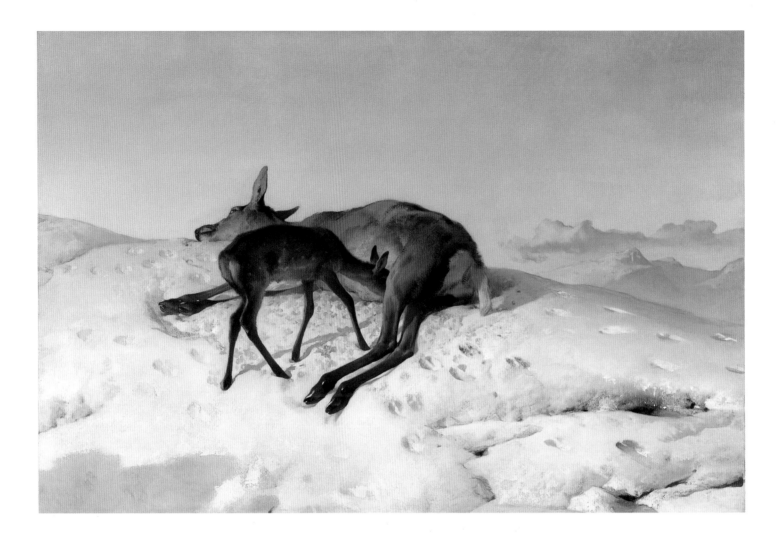

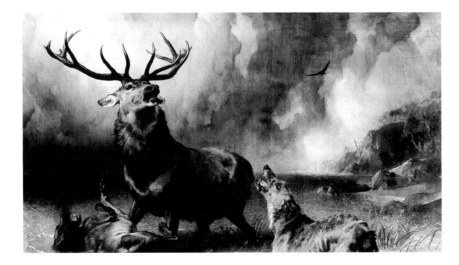

[129] *A Random Shot*,
c.1848 *
Oil on canvas, 122 × 183
Bury Art Gallery and Museum

[130] *The Stag at Bay*, *c*.1846
Oil on canvas, 183 × 274.3
Dublin Castle, on loan from the
Guinness family

swallowed up in black storm clouds, underscoring the theme of death. What comes through most powerfully is the indomitable courage and spirit of the stag. It represents just those values of bravery, fortitude, pride, resolution, willpower and refusal to surrender, which Victorians admired and which helped to sustain the Empire. One is reminded here of the defence of Lucknow, during the Indian Mutiny, and Rorke's Drift in the Zulu wars, where British soldiers held out against overwhelming odds. In Landseer's picture we see the stag as hero, transcending its animal nature to demonstrate virtues of a higher order. It was the humanizing aspect of his deer subjects that stirred the imagination of Landseer's audience so deeply and made his work so popular. *The Hunted Stag* [plate 131] is another scene of confrontation. A terrified stag desperately attempts to evade its pursuers by swimming out into the loch, putting up a flock of ducks in the process. We experience the shock of what is happening, because the animals are presented in close-up right up against the front of the picture space, bodies immersed in water, mouths open in fear and cruelty, winds sweeping across the reeds and churning the water, a black storm in the background. The violence and physicality of it all is overwhelming. The quotation in the Royal Academy catalogue for 1859 suggests that the stag's case is not hopeless: 'Bran will never put another stag to bay; and Oscar will not make out by himself. The deer will do fine yet!'

The Stag at Bay is the prototype for *The Monarch of the Glen* [plate 132]. In both pictures the powerful body of the stag is shown in profile and cropped at the legs, the head turned forward and the antlers silhouetted against sky. The sense of untamed freedom in this magnificent beast, the communion with nature at its most sublime and the exhilaration of wild and solitary places – all those things that drew people to the Highlands – are here enshrined by the artist in a single monumental image. The picture was originally designed for one of three panels illustrating hunting scenes in the refreshment room of the House of Lords. Landseer accepted the commission in a letter of 24 June 1849 to Sir Charles Eastlake, secretary of the Fine Arts

Commssion), who still hoped to place *The Monarch of the Glen* on one of the staircases at Westminster. In the event, the artist sold the picture privately to the recently ennobled Lord Londesborough.[12]

The image of *The Monarch of the Glen* is so iconic that it is difficult to look at the painting with a fresh eye but it is, in fact, a work of wonderful accomplishment. The body and fur of the deer are painted with that precision and virtuosity for which Landseer was famous. The foreground grasses are swept in with a few broad strokes, and the landscape behind, with the morning sun dispersing the mist, is painted in a sparkling key. The entry for the picture in the Royal Academy catalogue of 1851 included a

[131] *The Hunted Stag, c.*1859
Oil on canvas, 105.5 × 276.9
The Beaverbrook Art Gallery,
Fredericton, Canada, Gift of the
Sir James Dunn Foundation

Commission (the body charged with redecorating the new Palace of Westminster), quoting a fee of one thousand guineas: 'I name this sum without any fixed idea as to the class of subject, which would greatly depend on the scheme for the general embellishment of the apartment. If *only* three pictures are placed – rather above the level of the eye, the subjects represented should, I think, be larger.'[11] Landseer had questioned whether the refreshment room was the most appropriate setting for his work, and this point was raised when the estimates for the Fine Arts Commission were being debated in Parliament in May 1850. As a result, the sum for Landseer's panels was struck out, much to the annoyance of Eastlake and Prince Albert (the president of the

stanza from a poem by an unknown author identified as the 'Legends of Glenorchay':

> When first the day-star's clear cool light
> Chasing night's shadows grey,
> With silver touched each rocky height
> That girded wild Glen-Strae,
> Uprose the Monarch of the Glen
> Majestic from his lair,
> Surveyed the scene with piercing ken,
> And snuffed the fragrant air.

The forests of Glenorchy lie on the Black Mount estate, then owned by Lord Breadalbane, where Landseer often hunted, and it was probably there that he first conceived the subject of his painting.

Scene in Braemar [plate 133] is the sequel to *The Monarch of the Glen*, but in a darker key. It

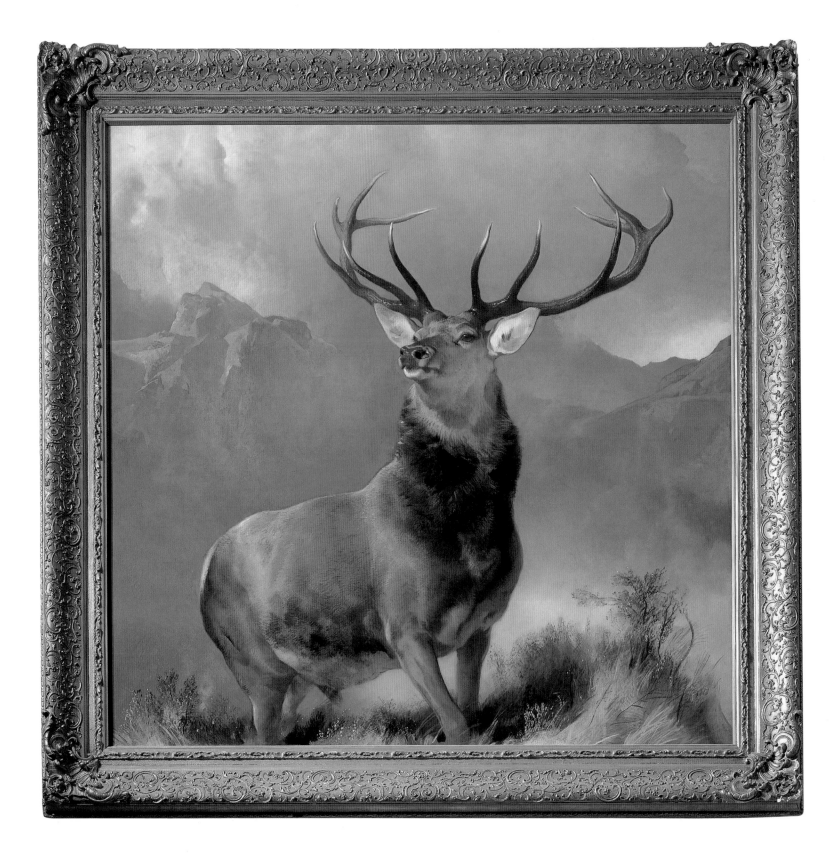

[132] *The Monarch of the Glen, c.1851* *

Oil on canvas, 163.8 × 168.9

By kind permission of Diageo, on loan to the

National Museums of Scotland

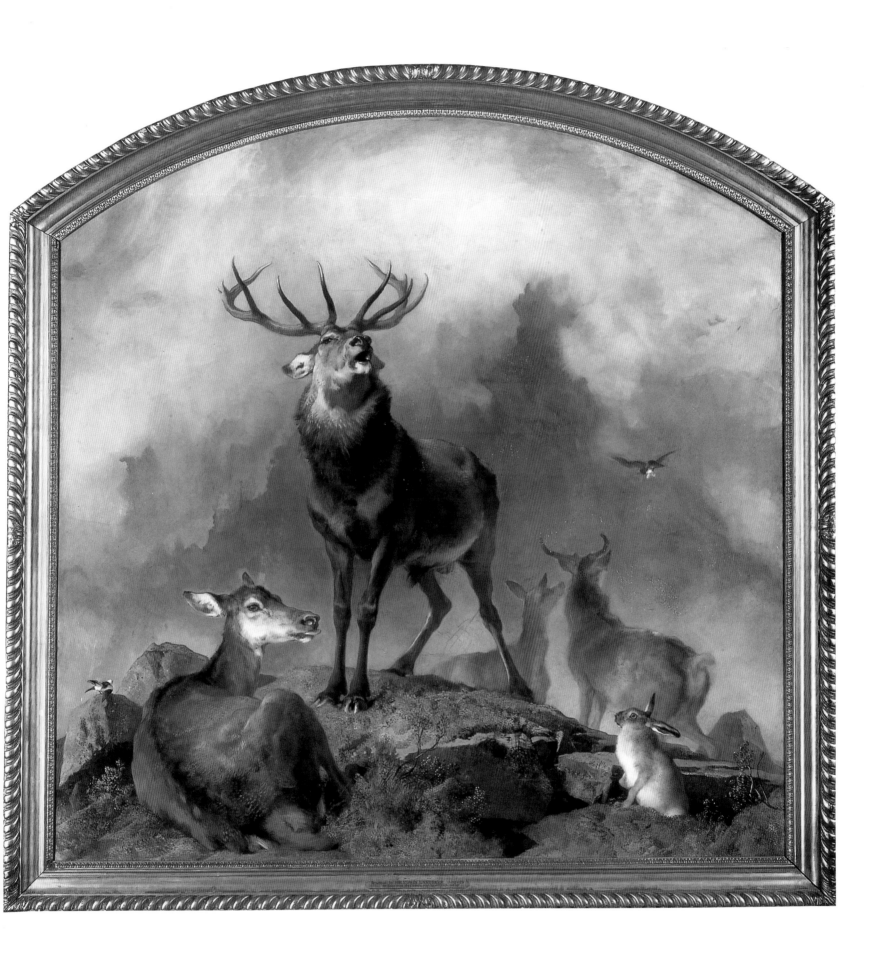

[133] *Scene in Braemar, c.1857* *
Oil on canvas, 271.8 × 251.5
Mr and Mrs Duncan Davidson

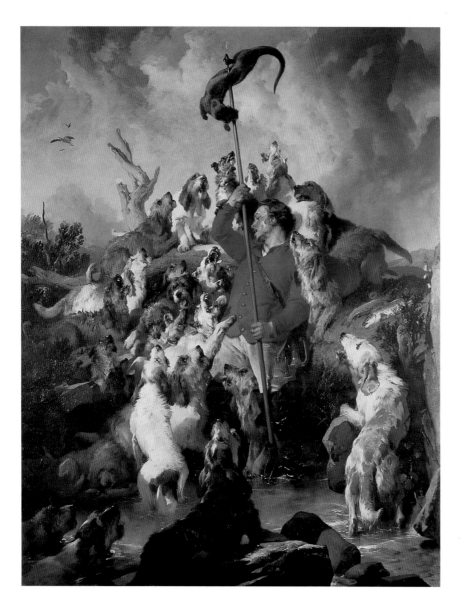

about it'.[14] The picture was widely admired at the time of its exhibition at the Royal Academy of 1857, and it remained one of Landseer's most popular compositions. Critics commented on the slightness of the execution – one called it 'slovenliness' – but this was not felt to be a serious flaw in a work of such power and nobility.[15]

Violence is never far below the surface of Landseer's art, and two sporting pictures, neither of them deer subjects, demonstrate it to a marked degree, *The Otter Hunt* and *The Swannery Invaded by Sea Eagles* [plates 134, 135]. The otter squirming on the end of a spear in the first of these provokes the same kind of reaction in today's audience as the monkey forcing the cat to remove chestnuts from the red-hot stove in *The Cat's Paw* of 1824 (Minneapolis Institute of Arts). We know such cruelty exists but it is horrifying to see it catalogued in such detail and with such apparent relish. The spearing of otters was banned at the close of the nineteenth century when it was recognized as an unnecessarily cruel method of slaughter.

The action in Landseer's picture takes place on the banks of a rocky stream in the vicinity of Haddo House, the Aberdeenshire home of the fourth Earl of Aberdeen (1784–1860), who had commissioned the picture. He was both statesman and man of learning, foreign secretary at this time in Sir Robert Peel's Tory administration and president of the Society of Antiquaries. The otter has been speared by the huntsman and held aloft, still biting the shaft of the spear. The depredations of the otter are indicated by two partially gnawed salmon lying on the riverbank to the right. The picture captures the excitement of the chase and the blood lust at its end in a frenzied pyramid of dogs grouped around the red-coated huntsman and the speared otter. The very contrivance of the design suggests a parallel with human cruelty and even with the crucifixion, which gives it an added dimension. Victim and mob play out their roles in a dance of death that is as true to human experience as it is to the animal world, and equally shocking.

The picture, begun in 1838, proceeded slowly, partly due to the demands of Landseer's patron. Lord Aberdeen recommended changes to the composition, and he requested that the work be made smaller because it was one that he would 'wish to *live with*'.[16] Landseer's original conception of the subject seems to be that recorded in

[134] *The Otter Hunt (also called The Otter Speared, Portrait of the Earl of Aberdeen's Deerhounds),* c.1844 *

Oil on canvas, 200 × 153.7
Laing Art Gallery, Newcastle upon Tyne (Tyne and Wear Museums)

takes its name from the town of Braemar in the eastern Highlands, close to Mar Lodge where Landseer frequently stayed. A huge stag stands on a rocky eminence bellowing defiance, perhaps to warn off potential rivals. A hind lies meekly at the stag's feet, while a white mountain hare pops out of its burrow to see what all the fuss is about; this last feature suggested to one reviewer a story from Aesop's fables.[13] Behind the foreground group of animals, two hinds with their backs to us gaze up at an eagle carrying prey in its talons. The high viewpoint of the painting may have been dictated by the prominent position it occupied in the dining room at Preston Hall, Lancashire, home of the artist's wealthy patron, E.L. Betts. When Landseer went to see the picture *in situ* in the company of a party of friends, he replied to the chorus of praise with the wry comment: 'If you could see the picture with my eyes, you wouldn't say so many pretty things

the panoramic picture of huntsman and dogs called *Digging out the Otter* (private collection), which was finished after Landseer's death by his friend, Sir John Everett Millais. It was apparently to this picture that Aberdeen referred as 'the one with the hounds in the water', when, in 1841, he again repeated his demand for a work of 'small dimensions',[17] suggesting as a compromise that Landseer might like to paint two pictures instead of one. The present work was probably begun at this time and completed three years later. Its enthusiastic reception at the Royal Academy of 1844 may seem surprising in view of its violent character, but the critics were swept away by the intense drama of the scene and the brilliant handling of the paint. Here is the critic of the *Athenaeum*:

What a baying and writhing and struggling and brawling is here! what an agony in the poor hunted vermin! who nevertheless is better off, twisting aloft on the spear, than if thrown down to the gaping and clamorous pack who are wrangling for the choice morsels! What a shout from the tough and brawny carl in the midst, whose chiding drowns the impatience of the rabble leaping round him! Nor has Mr. Edwin Landseer been often happier as to hand-work; the picture has more than his usual force, lustre, and texture.[18]

The Swannery Invaded by Sea Eagles [plate 135] is a violent picture of a different order.[19] A band of sea eagles has flown into a swannery to massacre its inhabitants. One swan lies dead, flanked by two companions fighting for their lives, while in the distance a fourth swan is attacked on the wing, while other swans make their escape. The white plumage of the foreground birds, which are smeared with blood, stands out against the black shapes of their assailants and the stormy background with brilliant effect. The destruction of creatures of such grace and beauty is made to seem almost sacrilegious. Landseer is drawing here on a traditional form of imagery, common in seventeenth-century Dutch and Flemish art, in which combat between different types of animal is used as a commentary on contemporary political events. A pair of animal paintings by Melchior d'Hondecoeter (Holkham Hall, Norfolk), for example, are said to symbolize the wars between

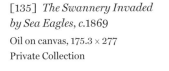

[135] *The Swannery Invaded by Sea Eagles, c.*1869
Oil on canvas, 175.3 × 277
Private Collection

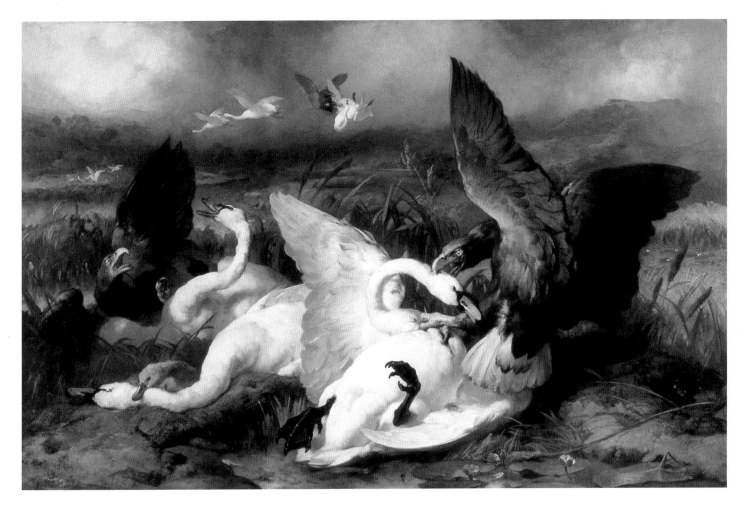

[136] *Queen Victoria Sketching at Loch Laggan,* 1847 *
Oil on panel, 34.1 × 49.5
The Royal Collection

William III and Louis XIV. The unidentified poem appended to the catalogue entry for Landseer's picture at the Royal Academy of 1869 underlined the human parallel:

As rapt I gazed upon the sedgy pool,
Where in majestic calm serenely sailed
Its arch-necked princes in their snow white
 plumes —
Cleaving the air with sharp and strident sound,
Down swooped the tyrants of the sea-girt caves
Screaming for blood and in their ancient holds
'Fluttered the Volsces' of that tranquil reign.

Landseer's picture has little substance in reality. Sea eagles, which became extinct in Scotland later in the century, inhabit the wildest stretches of the coast far from the haunts of swans, and the idea of a massed assault belongs to the realms of fantasy. According to J.G. Millais, a sea eagle 'never touches anything in life which might offer the slightest resistance, and would as soon think of assailing a mute swan in flight (a bird half as big again as itself) as a hansom cab'.[20] The *Times* reviewer cited Norse raids as an historical precedent, while other

critics correctly interpreted the picture as an allusion to the impending struggle between France and Germany.[21] Landseer's earlier paintings, *Time of Peace* and *Time of War* (destroyed in Tate Gallery flood of 1928), had been inspired by the threat of invasion following the revolution in France of 1848, and renewed Anglo-French tensions. Twenty years later, Europe was again on the verge of conflict and Landseer's emblematic painting presents a tragic vision of the horrors of war.

The adoption of Scotland by Queen Victoria and Prince Albert lent fresh impetus to Landseer's art. He had already painted many portraits, both human and animal, for his royal patrons. As their favourite court painter, he was now requisitioned to give expression to their newly-found passion for all things Highland. The royal couple saw themselves as benign chieftains whose idyllic family life in the wild mirrored the peace and prosperity of the realm. The were never happier than in Scotland, enjoying sport and other outdoor activities away from the press of official business. Their visits north of the

border, beginning in 1842, soon became an annual event and in 1848 they leased Balmoral Castle on Deeside, which they later bought and remodelled.

Landseer's first Highland commission was *Queen Victoria Sketching at Loch Laggan* [plate 136]. The idea of the subject was conceived in September 1847 when both the artist and the Queen were staying with the Marquess and Marchioness of Abercorn at Ardverikie, their hunting lodge on Loch Laggan. Landseer had already used the loch as the setting for another Highland subject, *The Forester's Daughter* (formerly Owen Edgar Gallery, London), which had been commissioned by the Queen of the Belgians as a present for her husband. Queen Victoria commissioned her own picture as a 'surprise' Christmas present for Prince Albert, and she had the usual difficulty in persuading the artist to finish it. With less than a month to go, Miss Skerrett, the Queen's dresser and confidential go-between, wrote ingenuously to Landseer, 'HM has not the least *doubt* of the picture coming'.[22] On this occasion the artist was true to his word (the Queen of the Belgians had to wait six years for hers), and he wrote to his friend Count d'Orsay at the end of December:

Since I returned from the North I have worked like a loyal subject for Her My. A miniature picture 19 inches by 13 containing the Q. Pss R and P. of Wales. Forester with deerhounds, Pony, deer on his back &c. The Q. and P. Albert are quite (to use your word) mad about it.[23]

Landseer's conversation piece presents the Queen in a simple Scotch dress and jacket, with her eldest children, Princess Victoria and Prince Edward (respectively six and five) dressed in tartan and kilt. Her sketchpad stands on a low easel before the spectacular view of loch and mountains she has been recording. Confronting the royal party is a respectful ghillie showing off the dead stag strapped on the back of a shooting pony. The young prince points excitedly to the trophy of his absent father's sporting prowess. The virile arena of Highland sport is here contrasted with the gentler values of art and nature, male and female, active and passive, savage and pastoral, servant and master. The Queen with her sketchbook has 'civilized' the Highlands while her husband has conquered its wild life. The dogs no less than the figures symbolize the divide between these competing aspects of Highland life, domestic terrier beside the Queen, working deerhound beside the ghillie.

As the foremost painter of Highland subjects, Landseer occupied a special place in the

[137] *Study for Royal Sports on Hill and Loch (also called Queen Victoria Landing at Loch Muick), c.*1850–1 *
Oil on canvas, 43.2 × 77.2
The Royal Collection

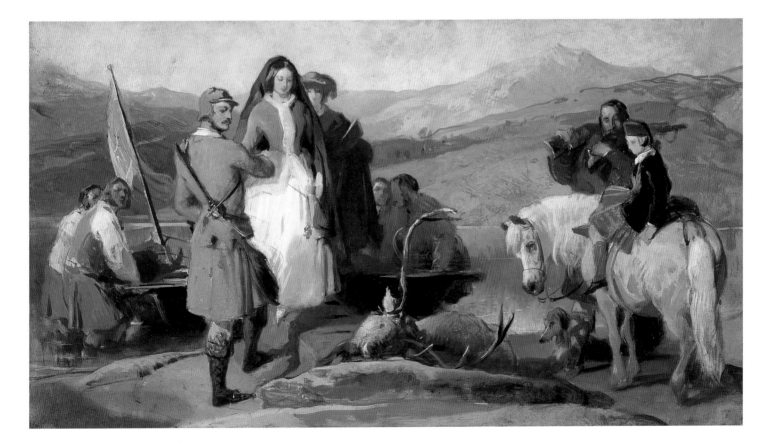

affections of the Queen and Prince Albert. They carried other artists in their train to record royal life in the wild, but for them Landseer struck a deeper, more symbolic vein. In 1847, Prince Albert had persuaded the Marquess of Breadalbane to cede him *The Drive* [see plate 118], the largest sporting work ever undertaken by the artist. A herd of red deer in full flight pass before rocks shielding a sportsman reloading his gun and a keeper muzzling his hound. In the same year, Queen Victoria made drawings of Landseer's rough charcoal cartoons on the walls of Ardverikie Lodge where she was staying. In the book she wrote about her visits to Scotland, *Leaves from a Highland Journal*, she often regretted that Landseer was not present to record a particular scene or effect. At the end of the decade she bought or commissioned three Highland subjects as presents for her husband, *The Free Kirk*, *Highlander* and *Highland Lassie* [plates 78–80; see pp.76–8 for a description].

In 1850, Landseer was summoned to Balmoral to undertake a large group portrait which would become known as *Royal Sports on Hill and Loch* [see plate 137 for the colour sketch]. The composition of the work, with its layers of meaning, was carefully planned in collaboration with the Queen, who wrote in her Journal:

It is to be thus: I, stepping out of the boat at Loch Muich, Albert, in his Highland dress, assisting me out, & I am looking at a stag which he is supposed to have just killed. Bertie is on the deer pony with McDonald (whom Landseer much admires) standing behind, with rifles & plaids on his shoulder. In the water, holding the boat, are several of the men in their kilts, – salmon are also lying on the ground. The picture is intended to represent me as meeting Albert, who has been stalking, whilst I have been fishing, & the whole is quite consonant with the truth. The solitude, the sport, the Highlanders in the water, &c will be, as Landseer says, a beautiful historical exemplification of peaceful times, & of the independent life we lead in the dear Highlands. It is quite a new conception, & I think the manner in which he has composed it, will be singularly dignified, poetical & totally novel, for no other Queen has ever enjoyed, what I am fortunate enough to enjoy in our peaceful happy life here. It will tell a great deal, & it is beautiful.[24]

The picture got off to a good start, with the artist visiting Loch Muich for the first time on a flawless September day. His patrons were enchanted with his first 'squiggle' for the composi-

[138] *Prince Albert at Balmoral (*also called *Sunshine: Balmoral in 1860 or Death of the Royal Stag with the Queen Riding up to Congratulate His Royal Highness)*, 1865–7 *
Coloured chalks on paper,
85 × 110.5
The Royal Collection

[139] *Queen Victoria at Osborne (Sorrow)*, 1867
Oil on canvas,
147.3 × 208
The Royal Collection

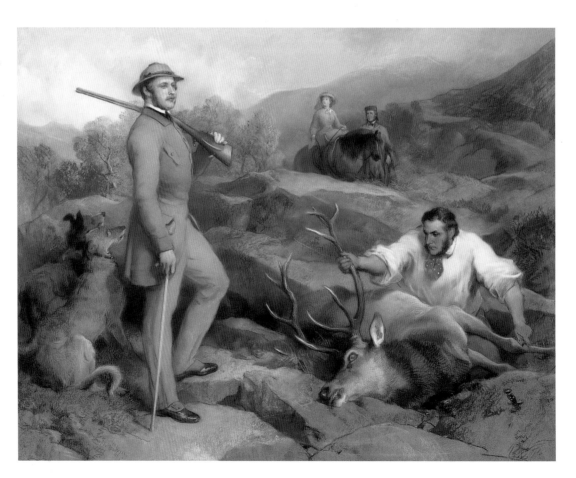

tion, and they watched with keen interest as he drew the ghillies, making them look like apostles, for there is an undercurrent of religious imagery throughout the work. In April 1851, the artist brought the colour sketch [plate 137] to show the Queen who thought the effect quite 'beautiful'. But as the picture progressed, with numerous sittings and further visits to Balmoral, the artist was unable to translate the verve of the sketch into the complexities of large-scale design, and he could not achieve satisfactory likenesses. The picture was exhibited in an unfinished state at the Royal Academy of 1854 to mixed reviews.

Royal Sports weighed heavily on Landseer's spirits as he spent the next fifteen years struggling to bring the work to a satisfactory conclusion. The artist, G.D. Leslie, son of his old friend, C.R. Leslie, records how the artist would scrape out parts he had finished until the floor of the studio was covered with flakes of paint. In April 1870 he wrote crossly to William Russell: 'The Balmoral picture criticized on the most trifling points of accuracy such as McDonald always wore a white shirt and grey stockings. I have made up my mind never to accept another commission and not to go to Osborne.'[25] When the picture appeared at the Academy for a second

time in 1870, the artist 'shuddered' when he saw it on the walls, and the critics passed it over in silence. Landseer was persuaded to give up the picture sometime around 1873, but the final bill of two thousand pounds was only settled posthumously. The picture was put in storage after Queen Victoria's death, and it was destroyed by order of George V due to its poor condition; an engraving by W.H. Simmons, published in 1874, records its final appearance.

Landseer's failure to complete *Royal Sports on Hill and Loch* led to a cessation of royal patronage for more than a decade. And then, on a chance visit to the artist's studio in May 1861, Queen Victoria was seized with the idea for a pair of chalk drawings,

the one representing dearest Albert with a stag he had shot, at his feet, & I coming up in the distance, with one of the Children to look at it. Then the reverse of that bright happy time, I, as I am now, sad & lonely seated on my pony, led by Brown, with a representation of Osborne & a dedication telling the present sad truth. Sir E. Landseer is delighted at the idea & most ready to do it.[26]

As completed in 1867, the two large chalk drawings, *Sunshine* and *Sorrow*, reflect the

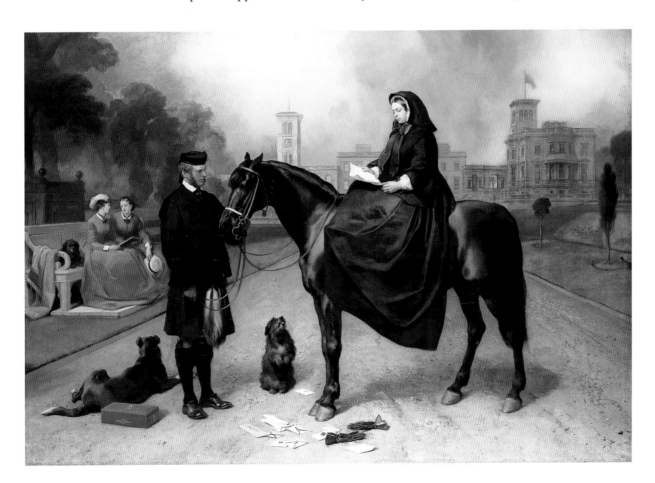

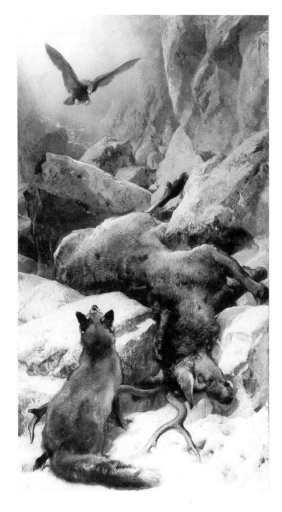

[140] *An Event in the Forest,*
*c.*1865

Oil on canvas, 144.8 × 77.5
Untraced

in front a keeper, John Grant, exhibiting the antlers. In the distance Queen Victoria rides up on a pony led by John Brown. In the companion drawing, which also exists as a version in oils [plate 139], Queen Victoria is shown dressed in widow's weeds, seated on horseback and attended by John Brown, reading state papers before a view of Osborne House on the Isle of Wight. The two drawings were the subject of extensive correspondence, some of it acrimonious, as the Queen's demands grew and the artist's enthusiasm flagged. Landseer made use of photographs for both works, which were finally completed in August 1867, after visits both to Balmoral and Osborne. He subsequently collaborated with J.A. Vintner over the production of lithographic plates for private circulation.

Queen Victoria's friendship and loyalty to Landseer never wavered in spite of her difficulties in dealing with him in his later years. He was inextricably bound up with memories of the happy time before her widowhood, which he had enshrined in so many moving images of all she held dear. She continued to visit his London studio, invited him to stay, showed sympathy at times of mental breakdown and offered him commissions. The last picture he painted for her was *The Baptismal Font* (Royal Collection), a commission the Queen had taken over from the famous philanthropist, Baroness Burdett-Coutts, in 1870. She showed acuity in gaining possession

Queen's vision of what she wanted. In the first [plate 138], a virile Prince Albert stands commandingly beside a stag he has just shot, his rifle over his shoulder, two hounds behind him, and

[141] *Dog and Dead Deer*
(also called *Chevy*), *c.*1868

Oil on canvas, 137.2 × 208.3
The Detroit Institute of Arts

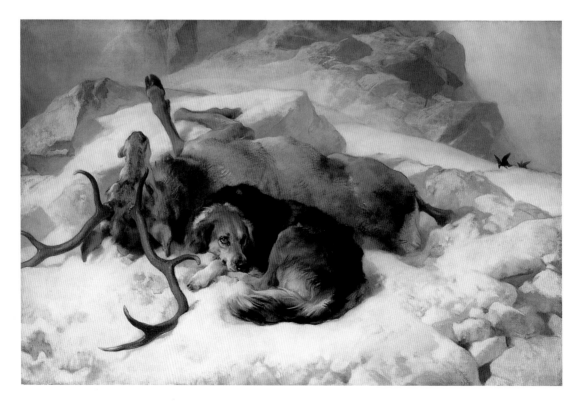

[142] *Stags Rutting*, 1844
Coloured chalks on paper,
35.6 × 50.8
Collection of the Duke of Bedford

of the work after the Royal Academy exhibition of 1872, writing a personal plea to the artist to release the work rather than approaching him indirectly through the president of the Royal Academy – a tactic which worked.

From the mid 1850s, Landseer increasingly suffered from breakdowns and bouts of depression. Alcohol abuse and drug dependence added to the artist's problems as he grew older, rendering him an increasingly lonely and pathetic figure. His correspondence charts the ups and downs of his mental state and his psychosomatic ailments in exhaustive and self-pitying detail. Here is Landseer writing to his physician, Dr Tweedie, during a relapse in the summer and autumn of 1857:

Yesterday my head was inclined to run riot again it went off towards the close of the day – this morng I am annoyed by the old sensations in my Brest not so strong *but still there – with weak restless desire to run to to the w.c. – tho these visits do not amount to any thing very alarming rarely more than twice in the day ... a line from you will comfort.*[27]

Landseer's friends remained remarkably loyal and long-suffering, and he continued to frequent some of the great aristocratic houses and those belonging to his mercantile patrons. Autumn found him as always in his beloved Highlands. In August 1855 he stayed at Mar Lodge, 'weak and queer'; in October 1858 he was 'wandering from place to place in Sutherland' after visiting Dunrobin Castle and the home of his erstwhile flame, Louisa Stewart Mackenzie[28] on Loch

Luichart; in the autumn of 1861 he was at Glenquoich with the Ellices and the following year at Black Mount; September 1865 found him at Blair Castle and Forest Lodge up Glen Tilt, before travelling on to Drummond Castle at Muthill in Perthshire (Earl of Ancaster), and Chillingham Castle (Lord Tankerville) in Northumberland. In November 1865 he was injured in a railway accident en route to Wortley Hall, near Sheffield (Lord Wharncliffe), and shipwrecked the following October in the Duke of Sutherland's yacht. He could still be amusing company and those who did not know him well were often unaware of his unstable condition. By 1871 he was, in the words of the artist Richard Redgrave, in a 'state bordering on insanity, one day well and the next day in a state of intense nervous irritation'.[29] The following year he was declared lunatic, a decision referred to W.E. Gladstone and other leading men, such was the eminence of the artist and the delicacy of the issue.

In spite of his declining health, Landseer remained devoted to his art and a slave to his studio. When incapacitated, it was his urge to 'get back into harness' that helped to speed his recovery. In the final decade of his life he produced some of his grandest works, including *Man Proposes, God Disposes* (exhibited 1864, Royal Holloway and Bedford College, Egham), *Red Deer of Chillingham* and *Wild Cattle of Chillingham* (exhibited 1867, Laing Art Gallery, Newcastle-upon-Tyne), *Rent Day in the Wilderness* [plate 26], *The Swannery Invaded by Sea Eagles* [plate 135] and *The Baptismal Font* (exhibited 1872, Royal Collection). He also completed the models for the four great bronze lions at the base of Nelson's Column in Trafalgar Square in 1867.[30] Landseer had occasionally designed objects in silver and bronze, but this was his only large-scale piece of sculpture. We know from the account of G.D. Leslie, who lent him assistance, how hard he wrestled in his later work with the medium of paint, as his marvellous facility with the brush finally began to fail him.[31] But the imaginative powers remained undimmed until almost the end, a testament to the artist's dedication and professionalism.

There are fewer deer subjects among his later works. In some works he was content to repeat the formula of an earlier composition. The inspiration for *An Event in the Forest* of c.1865 [plate 140], with its vertiginous composition of

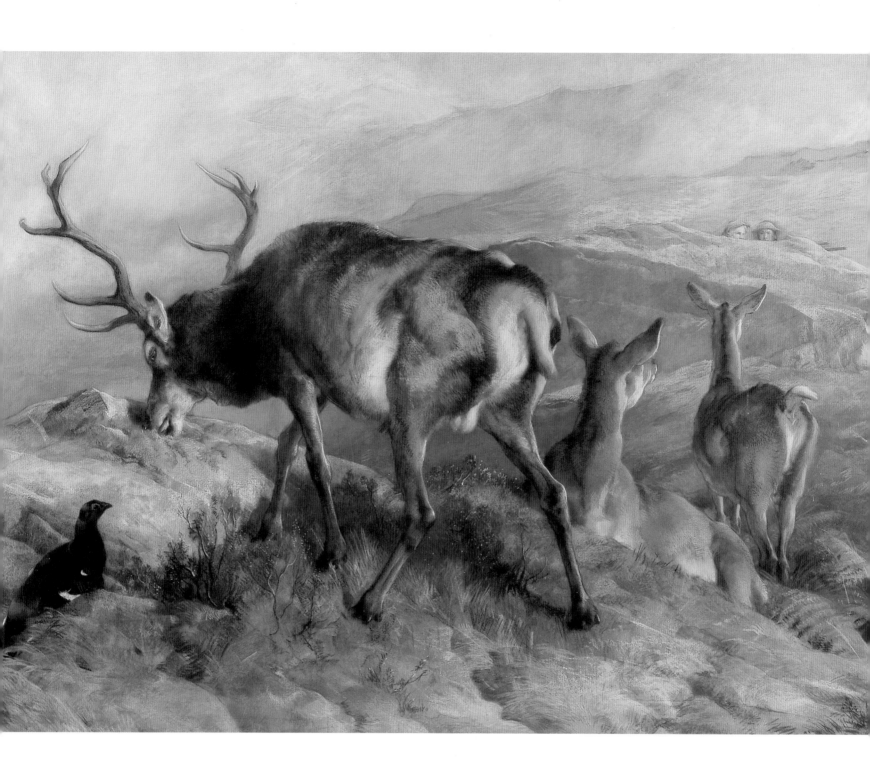

[143] *Browsing*, c.1857
Coloured chalks on paper,
195.6 × 274.3
Private Collection

dead stag and predators, goes back to pictures dating from the 1820s, like *Deer Fallen from a Precipice* and *Dead Deer with Ghillie and Hounds* [plates 46, 49]. *Dog and Dead Deer* [plate 141],[32] exhibited in 1868, is a work in the same vein, although painted on a much grander scale than those beautifully crafted cabinet pictures of his youth.

The series of large-scale pastels on which Landseer embarked in his later years mark one important development in his art. He was a skilled draughtsman and he had begun doing highly worked chalk drawings of deer subjects

from the mid–1840s. A number of these, like *Stags Rutting* [plate 142], were later collected together by the artist and reproductions published as a portfolio under the title of *The Forest*. The earliest of the large pastels is *Browsing* [plate 143],[33] a work almost eight by ten feet. A large stag, oblivious of danger, chomps at a patch of moss on a rocky outcrop, while his female companions have been alerted to the presence of intruders, in the shape of two sportsmen crouching behind rocks in the middle distance, the tips of their rifles just visible. Landseer's mastery of the medium gives a sure-

ness of touch to his drawing of the animals and wonderful effects of colour and texture that is sometimes lacking in his oil painting. He may well have decided to use pastel precisely because it was an easier and more flexible medium than paint, allowing him close study of animal forms without the necessity of working up the picture to any degree of finish.

Browsing was followed four years later by *The Fatal Duel* (private collection), a magnificent work of slightly smaller dimensions which Landseer exhibited at the Royal Academy in 1861. A stag lies dying at the feet of his rival who bellows in triumph. Deep hoof marks in the snow and a broken antler testify to the violence of the encounter, with its fatal outcome. The wintry landscape sweeps up the slope behind the deer to outcrops of rock and swirling cloud. The treatment of the subject, pitched in a high romantic key, is as forceful as anything Landseer was to paint in oils. *The Chase* (Beaverbrook Art Gallery, Fredericton, New Brunswick) is a later pastel on the same scale, representing a hound running down a terrified stag. *Children of the Mist* [plate 144] is a smaller work drawn at Dunrobin in 1866, which shows a familiar scene of a stag and hinds scenting danger.

Landseer's last deer paintings are mostly in a quieter mode. *Red Deer of Chillingham* (exhib-ited 1867, Laing Art Gallery, Newcastle upon Tyne), a reworking of *Red Deer* [plate 122], exhibited thirty years earlier, presents us with an idealized vision of a deer family. *The Ptarmigan Hill* [plate 145] captures the spirit of the Highlands in early winter and probably represents the Cairngorms. A pair of Gordon setters, one lying on a rock, the other stealthily advancing, are seen with a group of ptarmigan. It is possible that the dogs are on the point of putting up the birds, but at first sight the scene seems to be one of peaceful co-existence, not unlike Landseer's picture of *The Lion and Lamb* (Johannesburg Art Gallery), exhibited three years later, with its biblical sub-text. The rocks in *The Ptarmigan Hill* create the powerful axes around which the composition is organized, and the magnificent view of ice-blue mountains in the background is as fine as anything Landseer had painted.

Landseer's death on 1 October 1873 was, in the words of Queen Victoria, 'a merciful release', 'as for the last three years he had been in a most distressing state, half out of his mind. Yet not entirely so.'[34] On the day of his funeral, 11 October 1873, many houses and shops had their blinds closed; flags flew at half mast; his bronze lions in Trafalgar Square had wreaths in their jaws; large crowds lined the route of his funeral cortege from St John's Wood to St Paul's

[144] *Children of the Mist,* *c.*1866 *
Coloured chalks on paper,
50.2 × 66
The Royal Collection

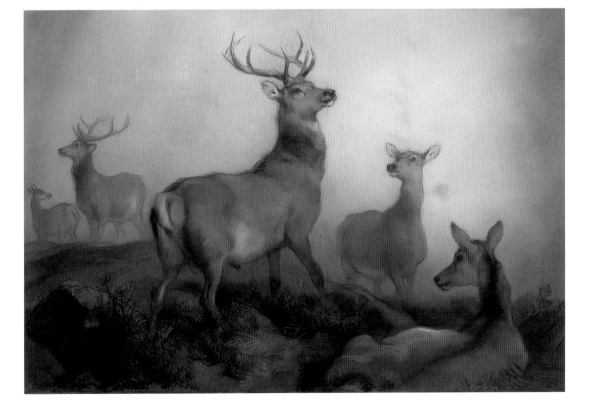

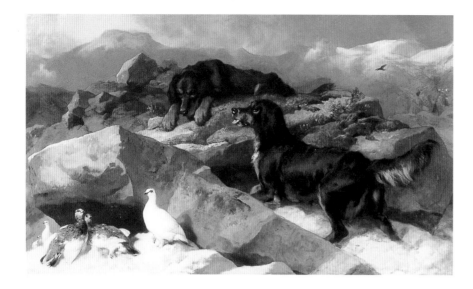

[145] *The Ptarmigan Hill,*
*c.*1869
Oil on canvas, 129.5 × 223.5
Private Collection

[146] *Odds and Ends.*
*Trophy for a Hall, c.*1866
Oil on canvas, 139.1 × 109.2
Private Collection

No painter of animal life can for a moment be
compared to him for intelligent invention, for
humour and its congenial pathos, for breadth,
variety and subtlety of observation. No painter
has ever so widened and deepened our sympa-
thies with the dumb creatures that minister so
largely to our pleasure and necessities.[35]

Other commentators underlined the artist's
love of the mysterious and the sublime, his
soaring imagination and his technical virtuos-
ity. Landseer's name was a household word in
Victorian Britain. Even during the years of
critical neglect in the first half of the twentieth
century, when his work was held up as the
epitome of Victorian sentimentality, he re-
tained a popular following through the univer-
sality of his printed images. The appeal of
Landseer's work lies less in its obvious narrative
and anecdotal character than in its broad
romantic spirit, and nowhere is that more
evident than in the long sequence of his
Highland subjects.

Cathedral, where he now lies buried. As an artist
he had to an extraordinary degree possessed the
common touch, and he had been able to reach
out to affect the hearts and minds of his contem-
poraries. As an obituary writer for the *Illustrated*
London News put it:

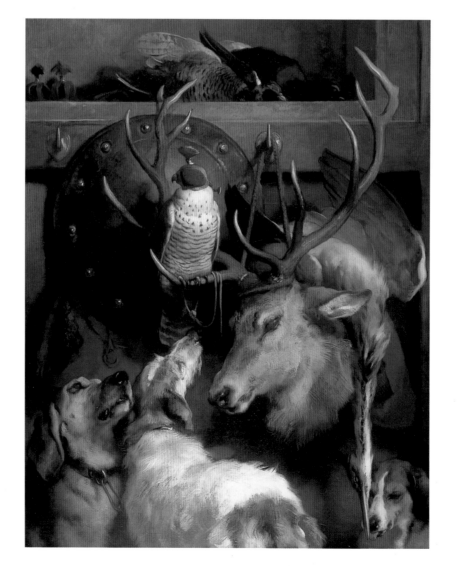

EXHIBITION CHECKLIST

Loans have been subdivided according to the chapters of the present book and the broad thematic groupings represented in the exhibition itself. The sequence within sections is chronological. The titles of individual works are those assigned by or traceable to the artist. Alternative titles not associated with the artist himself are given in brackets where appropriate. Measurements are in centimetres, height before width.

SIR WALTER SCOTT AND HISTORY

*Sir Walter Scott, c.*1824
Oil on canvas, 61 × 51
National Museums Liverpool (The Walker)
Plate 3

*Study for The Hunting of Chevy Chase, c.*1825
Oil on panel, 45.8 × 61
Private Collection
Plate 14

The Hunting of Chevy Chase, 1825–6
Oil on canvas, 143 × 170.8
Birmingham Museums and Art Gallery
Plate 10

*A Scene at Abbotsford, c.*1827
Oil on panel, 44.5 × 59.7
Tate, London, presented by Sir Henry Tate, 1894
Plate 5

*Jocko with a Hedgehog, c.*1828
Oil on canvas, 102 × 127
Private Collection
Plate 8

*The Death of Elspeth Mucklebackit, c.*1830
Oil on panel, 48.2 × 61
Private Collection

*A Visit to the Falconer's, c.*1830
Oil on board, 33 × 42
Private Collection
Plate 20

Hawking (also called *Hawking in the Olden Time*), *c.*1832
Oil on canvas, 152.5 × 183
English Heritage (The Iveagh Bequest, Kenwood)
Plate 17

*Sir Walter Scott in Rhymer's Glen, c.*1833
Oil on canvas, 152.5 × 122
Private Collection, courtesy of
Simon C. Dickinson Ltd
Plate 4

Interior of a Castle Courtyard (also called *Bolton Court in Olden Time*), *c.*1834
Oil on canvas, 101.6 × 127
Sunderland Museum and Art Gallery
Plate 16

*Return from Hawking (Lord Francis Egerton and Family), c.*1835–7
Oil on canvas, 148.6 × 238.8
Private Collection
Plate 21

*The Duke of Beaufort on Horseback, c.*1839–42
Oil on canvas, 89 × 68.6
Property of the Somerset Trust
Plate 18

*Extract from a Journal whilst at Abbotsford, c.*1858
Oil on canvas, 43.8 × 59
Private Collection
Plate 6

Rent Day in the Wilderness, 1855–68
Oil on canvas, 122 × 265.5
National Gallery of Scotland, Edinburgh.
Bequest of Sir Roderic Murchiston
Plate 26

SPORTING PICTURES

Scene on the River Tilt, in the Grounds of His Grace The Duke of Bedford (also called *The Fishing Party in the Highlands* or *The Highland Picnic*), 1824
Oil on panel, 47 × 61
Private Collection
Plate 32

John Crerar (also called *The Keeper John Crerar with his Pony*), 1824
Oil on board, 58.5 × 44.5
Perth Museum and Art Gallery, Perth & Kinross Council, purchased with the financial assistance of the National Art Collections Fund and the Local Museums Purchase Fund
Plate 40

Dead Deer and Deerhound, 1825
Oil on panel, 62.2 × 67.3
Private Collection
Plate 45

Study for The Death of the Stag in Glen Tilt (also called *Taking the Deer: The Duke of Atholl with Foresters*), *c.*1824–5
Oil on board, 48.2 × 63.4
National Museums Liverpool (The Walker)
Plate 38

The Death of the Stag in Glen Tilt, 1824–30
Oil on canvas, 149.8 × 200.8
The Blair Charitable Trust, Blair Castle
Plate 37

Scene in the Highlands, with Portraits of the Duchess of Bedford, the Duke of Gordon and Lord Alexander Russell (also called *Sport in the Highlands*), *c.*1825–8
Oil on canvas, 130.5 × 166
Private Collection, on loan to the National Gallery of Scotland, Edinburgh
Plate 35

*Highlanders Returning from
Deerstalking, c.*1827
Oil on panel, 60.3 × 73
Collection of the Duke of Northumberland,
Alnwick Castle
Plate 44

*Deer Fallen from a Precipice, c.*1828
Oil on board, 47 × 59.7
Private Collection
Plate 46

*Deer Just Shot, c.*1829
Oil on board, 47 × 59.7
Private Collection
Plate 47

*Dead Deer with Ghillie and Hounds, c.*1830
Oil on board, 48.2 × 61
Private Collection
Plate 49

*The Marchioness of Abercorn and her Eldest
Child, c.*1833
Oil on copper, 53 × 42
Tate, London, presented by Edwin L Mackenzie,
1914
Plate 34

*Deer and Deerhounds in a Mountain
Torrent* (also called *The Hunted Stag*),
*c.*1833
Oil on panel, 70 × 90
Tate, London, presented by Robert Vernon, 1847
Plate 50

*Grouse, c.*1833
Oil on panel, 50.2 × 59.3
Private Collection
Plate 52

*Young Roebuck and Rough Hounds, c.*1840
Oil on panel, 53.3 × 43.2
Victoria & Albert Museum, London
Plate 54

HIGHLANDERS

An Illicit Whisky Still in the Highlands,
1826–9
Oil on panel, 80 × 100.3
English Heritage (Apsley House, London)
Plate 57

The Bogwood Gatherers (also called *The
Wood Cutter*), *c.*1828
Oil on panel, 31.8 × 61
Private Collection, courtesy of Robert Holden Ltd
Plate 63

*Young Girl Carding Wool, c.*1830
Oil on board, 33 × 22.8
Private Collection
Plate 60

*The Stonebreaker, c.*1830
Oil on panel, 45.8 × 54.4
Victoria & Albert Museum, London
Plate 73

*Highland Music, c.*1830
Oil on panel, 47 × 59
Tate, London, presented by Robert Vernon, 1847
Plate 61

Interior of a Highlander's House
(also called *Highland Interior*), *c.*1831
Oil on panel, 69.8 × 85
Private Collection, Scotland
Plate 64

Poachers Deerstalking
(also called *Getting a Shot*), *c.*1831
Oil on panel, 50.8 × 61
Private Collection
Plate 69

*Study for Harvest in the Highlands, c.*1833
Oil on panel, 40.6 × 58.4
From the Loyd Collection
Plate 72

*Harvest in the Highlands, c.*1833
by Sir Edwin Landseer and Sir Augustus
Wall Callcott
Oil on canvas, 85.8 × 148
Private Collection, courtesy of Alexander
Meddowes
Plate 71

*A Highland Breakfast, c.*1834
Oil on panel, 50.8 × 66
Victoria & Albert Museum, London
Plate 65

*A Scene in the Grampians – The Drovers'
Departure, c.*1835
Oil on canvas, 125.8 × 191.2
Victoria & Albert Museum, London
Plate 75

*Comical Dogs, c.*1836
Oil on panel, 69.8 × 76.2
Victoria & Albert Museum, London
Plate 67

*The Old Shepherd's Chief Mourner, c.*1837
Oil on panel, 45.8 × 66
Victoria & Albert Museum, London
Plate 66

*Favourite Pony and Dogs, the Property
of Charles William Packe,* MP
(also called *Miss Packe's Pony*), *c.*1837–9
Oil on canvas, 103 × 127
Private Collection
Plate 77

*Tethered Rams – Scene in Scotland, c.*1839
Oil on panel, 45.8 × 61
Victoria & Albert Museum, London
Plate 76

*Flood in the Highlands, c.*1845–60
Oil on canvas, 198.5 × 311.2
Aberdeen Art Gallery and Museums Collection
Plate 81

Highlander, 1850
Oil on canvas, 68 × 51.1
The Royal Collection
Plate 79

*Highland Lassie, c.*1850
Oil on canvas, 68 × 51.1
The Royal Collection
Plate 80

HIGHLAND LANDSCAPES

*Figures Resting by a River in a Highland
Landscape, c.*1824
Oil on board, 23.5 × 32.4
Private Collection
Plate 101

*River Scene with Cattle in a Meadow, c.*1830–3
Oil on board, 26.7 × 36.2
Anglesey Abbey, The Fairhaven Collection
(The National Trust)
Plate 104

*Glenfeshie, c.*1830–5
Oil on panel, 20.3 × 35.6
Owned by John E.B. Hill

*Glenfeshie, c.*1830–5
Oil on board, 25.4 × 34.3
Private Collection, courtesy of Simon C. Dickinson Ltd
Plate 90

*Glenfeshie, c.*1830–5
Oil on board, 24.8 × 34.3
Private Collection

Glenfeshie (also called *A Highland River*),
*c.*1830–5
Oil on board, 26.7 × 33.7
Simon C. Dickinson Ltd
Plate 92

Glenfeshie (also called *A Rainy Day in the Highlands*), *c.*1830–5
Oil on board, 35 × 45
Private Collection
Plate 93

Glenfeshie, *c.*1830–5
Oil on board, 25.4 × 34.3
Private Collection
Plate 94

Highland Landscape (also called *Glenfeshie*), *c.*1830–5
Oil on board, 34.3 × 25.4
Private Collection
Plate 110

Highland Stream (also called *The Pots of Gartocharn* or *The Pots of Gartness*), *c.*1830–5
Oil on board, 25.1 × 35.4
Fitzwilliam Museum, Cambridge
Plate 107

Highland Stream (also called *On The Tilt*), *c.*1830–5
Oil on board, 25.4 × 35.6
Manchester City Galleries
Plate 108

The River Teith, Perthshire, *c.*1830–5
Oil on board, 24.1 × 34.3
Private Collection
Plate 105

Highland Landscape (also called *Glencoe*), *c.*1830–5
Oil on board, 25.4 × 35.6
Private Collection
Plate 91

Highland Landscape with Split Scotch Pine, *c.*1830–5
Oil on canvas, 36.2 × 26
Private Collection
Plate 114

Highland Pool, *c.*1830–5
Oil on board, 35.6 × 25.4
Private Collection
Plate 113

Lake Scene, *c.*1830–5
Oil on board, 20.5 × 25.5
National Museums Liverpool (Sudley House)
Plate 100

Rocks and Rivulet, *c.*1830–5
Oil on board, 20.2 × 25.2
National Museums Liverpool (The Walker)
Plate 109

Moorland Landscape, *c.*1830–5
Oil on board, 19 × 24.1
From the Loyd Collection
Plate 103

Shepherd and his Flock in a Highland Landscape, *c.*1830–5
Oil on board, 19.4 × 26.7
Private Collection

Deer at Bay, *c.*1830–5
Oil on board, 28 × 39.4
Private Collection

Return from Deerstalking, *c.*1830–5
Oil on board, 28.6 × 47
Private Collection
Plate 112

Loch Avon and the Cairngorm Mountains (also called *A Lake Scene: Effect of a Storm*), *c.*1833
Oil on panel, 35.6 × 44.5
Tate, London, purchased 1947
Plate 97

The Eagle's Nest, *c.*1833
Oil on board, 25.4 × 35.6
Victoria & Albert Museum, London
Plate 98

Evening Scene in the Highlands, *c.*1849
Oil on canvas, 69.3 × 89.5
Private Collection
Plate 115

THE MONARCH OF THE GLEN

None but the Brave Deserve the Fair, *c.*1838
Oil on canvas, 71 × 92
Private Collection
Plate 125

Red Deer, *c.*1839
Oil on canvas, 137.2 × 96.5
Private Collection
Plate 122

Fallow Deer, *c.*1839
Oil on canvas, 134.6 × 96.5
Private Collection
Plate 123

The Sanctuary, *c.*1842
Oil on canvas, 61 × 152.5
The Royal Collection
Plate 127

Coming Events Cast their Shadow before Them (also called *The Challenge*), *c.*1844
Oil on canvas, 96.5 × 211
Collection of the Duke of Northumberland, Alnwick Castle
Plate 128

The Otter Hunt (also called *The Otter Speared, Portrait of the Earl of Aberdeen's Deerhounds*), *c.*1844
Oil on canvas, 200 × 153.7
Laing Art Gallery, Newcastle upon Tyne (Tyne and Wear Museums)
Plate 134

Queen Victoria Sketching at Loch Laggan, 1847
Oil on panel, 34.1 × 49.5
The Royal Collection
Plate 136

A Random Shot, *c.*1848
Oil on canvas, 122 × 183
Bury Art Gallery and Museum
Plate 129

Study for Royal Sports on Hill and Loch (also called *Queen Victoria Landing at Loch Muick*), *c.*1850–1
Oil on canvas, 43.2 × 77.2
The Royal Collection
Plate 137

The Monarch of the Glen, *c.*1851
Oil on canvas, 163.8 × 168.9
By kind permission of Diageo, on loan to the National Museums of Scotland
Plate 132

Scene in Braemar, *c.*1857
Oil on canvas, 271.8 × 251.5
Mr and Mrs Duncan Davidson
Plate 135

Prince Albert at Balmoral (also called *Sunshine: Balmoral in 1860* or *Death of the Royal Stag with the Queen Riding up to Congratulate His Royal Highness*), 1865–7
Coloured chalks on paper, 85 × 110.5
The Royal Collection
Plate 138

Children of the Mist, *c.*1866
Coloured chalks on paper, 50.2 × 66
The Royal Collection
Plate 144

CHRONOLOGY

The details of Landseer's journeys to the Highlands are derived from his extensive surviving correspondence, particularly the letters to Jacob Bell (Royal Institution, London) and to William (Billy) Wells (National Art Library, Victoria & Albert Museum, London), and the letters written to the artist (National Art Library).

1802 Birth of the artist on 7 March at 88 Queen Anne Street East, Marylebone.

1815 Exhibits pictures of a mule and a pointer bitch and puppy at the Royal Academy. Awarded silver medal from the Society of Arts, London, for the drawing of a hunter. With his brothers, works in the studio of B.R. Haydon.

1816 Enters Royal Academy Schools.

1820 Exhibits *Alpine Mastiffs Reanimating a Distressed Traveller* at the Royal Academy.

1823 Visits Woburn Abbey (Duke of Bedford).

1824 Exhibits *The Cat's Paw* at the British Institution. In August visits Scotland for the first time, Edinburgh, Blair Atholl (Duke of Atholl), Forest Lodge, Glen Tilt (Duke of Bedford) and Abbotsford (Sir Walter Scott).

1825 Moves to 1 St John's Wood Road, Regent's Park, his lifelong home. In the autumn visits Blair Atholl and Gordon Castle (Marquess of Huntly, later Duke of Gordon).

1826 Exhibits *The Hunting of Chevy Chase* at the Royal Academy. In the autumn visits Blair Atholl and Kinrara House (Duchess of Gordon). Elected an associate of the Royal Academy.

1827 Visits Invereshie, Kingussie (Duchess of Bedford). Meets Sir Walter Scott in Edinburgh.

1828 Exhibits *Scene in the Highlands with Portraits of the Duchess of Bedford, the Duke of Gordon and Lord Alexander Russell* at the Royal Academy.

1829 Exhibits *An Illicit Whisky Still in the Highlands* at the Royal Academy. In the autumn visits Glenfeshie (Duchess of Bedford).

1830 Exhibits *Attachment* and *The Death of the Stag in Glen Tilt* at the Royal Academy. Visits Highlands in the autumn.

1831 Elected a Royal Academician. Visits Chatsworth (Duke of Devonshire) and Redleaf (William Wells).

1833 Exhibits *Sir Walter Scott in Rhymer's Glen* and *Deer and Deerhounds in a Torrent* at the Royal Academy, and pictures of Highland game at the British Institution. In the autumn visits The Doune, near Aviemore (Duchess of Bedford), Glenfeshie and Chillingham Castle, Northumberland (Earl of Tankerville).

1834 Exhibits *Bolton Abbey in the Olden Time* at the Royal Academy. In the autumn visits The Doune and Glenfeshie.

1835 Exhibits *A Scene in the Grampians – the Drovers' Departure* at the Royal Academy. In the autumn visits The Doune, Glenfeshie and Kinrara House.

1836 Exhibits *The Death of the Wild Bull* at the Royal Academy. In the autumn visits The Doune and Glenfeshie.

[147] Sir Edwin Landseer, *c.*1860
Photograph by John and Charles Watkins
The Royal Collection

1837 Paints Queen Victoria's spaniel, *Dash*, his first royal commission; many pictures of the royal family and of their pets follow. Exhibits *The Old Shepherd's Chief Mourner* at the Royal Academy. In the autumn visits The Doune and Glenfeshie.

1838 Exhibits *'The Life's in the Old Dog Yet'* and *None but the Brave Deserve the Fair* at the Royal Academy, and *Red Deer* and *Fallow Deer* at the British Institution. In the autumn visits Haddo House (Lord Aberdeen), Glenfeshie, Ardverikie on Loch Laggan (Marquess of Abercorn) and Balbirnie (Balfour).

1839 Alterations to 1 St. John's Wood Road. Exhibits *Favourite Pony and Dogs, the Property of Charles William Packe, MP.* at the Royal Academy. In the autumn visits The Doune, Glenfeshie and Haddo House. Death of the 6th Duke of Bedford.

1840 Death of the artist's mother, Jane Landseer, in January. Continental tour in November and December following a severe mental breakdown.

1841 Recuperates at Ramsgate in the spring. In the summer at work on royal commissions at Windsor Castle.

1842 Queen Victoria presents *The Sanctuary* to Prince Albert on his birthday in August. In the autumn visits The Doune and Ardverikie, where he draws large chalk cartoons on the walls of the lodge (destroyed by fire).

1843 In the autumn visits The Doune, Ardverikie and Black Mount (Marquess of Breadalbane).

1844 Exhibits *The Otter Speared* and *Coming Events Cast their Shadow before Them* at the Royal Academy. In the autumn visits Edinburgh, Taymouth Castle (Marquess of Breadalbane), Forest House, Lyndrum and The Doune. In November moves to Redleaf for several months while his house is remodelled.

1845 In the autumn visits The Doune. In November *Windsor Castle in Modern Times* is completed and hung after five years' work.

1846 Exhibits *The Stag at Bay* at the Royal Academy. In the autumn visits Haddo House, Gordon Castle and The Doune.

1847 Exhibits *The Drive* at the Royal Academy. In September paints *Queen Victoria Sketching at Loch Laggan*. Also visits Forest House, Black Mount and The Doune.

1848 Exhibits *A Random Shot* at the Royal Academy. In the autumn visits Taymouth Castle.

1849 In the autumn visits Black Mount and Ardverikie.

1850 In the autumn visits Balmoral Castle (Queen Victoria) for the first time, and The Doune. Begins work on *Royal Sports on Hill and Loch*.

1851 In March visits Osborne House, Isle of Wight (Queen Victoria). Exhibits *The Monarch of the Glen* at the Royal Academy. Visits Balmoral, where he designs the letterhead, and Glenquoich (Edward Ellice).

1852 Death of his father, the engraver John Landseer, in February. Exhibits *The Deer Pass* at the Royal Academy. In the autumn visits The Doune and Mar Lodge, Braemar (Earl of Fife).

1853 Death of the Duchess of Bedford in February. Exhibits *Night* and *Morning* at the Royal Academy. In the autumn visits Mar Lodge, Taymouth Castle and Dunrobin Castle (Duke of Sutherland).

1854 Exhibits *Royal Sports on Hill and Loch* at the Royal Academy for the first time. He is seriously unwell over the summer. In the autumn visits The Doune, Mar Lodge and Glenquoich.

1855 Awarded a gold medal at the Exposition Universelle in Paris; Charles Dickens collects the medal on his behalf. Visits Mar Lodge in August.

1856 In the autumn visits Chillingham Castle and the Highlands.

1857 Begins work on the commission for four bronze lions at the base of Nelson's Column in Trafalgar Square. In July at Brighton, suffering 'debilitating symptoms'. In November 'vegetating' between Redleaf (Billy Wells) and South Park (Lord Hardinge).

1858 Dines at Balmoral in August. Visits Loch Luichart, Dingwall (Louisa Stewart Mackenzie), Dunrobin Castle, Haddo Hall, Chillingham Castle and Howick, Northumberland (Earl Grey).

1859 Exhibits *The Hunted Stag* at the Royal Academy. Suffers distressing mental symptoms throughout the year. In the autumn visits Chillingham Castle, Black Mount and Glenquoich.

1860 Exhibits *Flood in the Highlands* at the Royal Academy. Visits Black Mount in September.

1861 Exhibits *The Fatal Duel* at the Royal Academy.

1862 Visits Black Mount in the autumn.

1864 Queen Victoria visits the artist, 'grown very old', in April. At work on the lions during the summer. Suffers a fall in November, 'in a state of prostration, very nervous & irritable'.

1865 In May Queen Victoria commissions the pair of pastels, *Sunshine* and *Sorrow*. Visits Belvoir (Duke of Rutland) in July. In the autumn visits Blair Atholl, Forest Lodge, Glen Tilt, Glen Affrich, Drummond Castle (Lord Ravensworth) and Chillingham Castle. In November injured in a railway accident *en route* to Wortley Hall, Sheffield (Lord Wharncliffe).

1866 In January declines to run for the presidency of the Royal Academy on the death of Sir Charles Eastlake; his friend Sir Francis Grant is elected. In August visits Vaux, Normandy (the sculptor Baron Marochetti). In the autumn visits Kinrara House and Dunrobin Castle, where the Duke of Sutherland's yacht runs aground.

1867 Bronze lions unveiled in Trafalgar Square in February. In the autumn visits Balmoral Castle, Loch Luichart and Chillingham Castle. In December at Sandringham, Norfolk, with the Prince of Wales.

1868 Exhibits *Rent Day in the Wilderness* at the Royal Academy. Visits the Highlands in the autumn.

1869 Exhibits *The Swannery Invaded by Sea Eagles* and *The Ptarmigan Hill* at the Royal Academy. In the autumn visits Forde Castle, Northumberland (Louisa, Lady Waterford), Chillingham Castle and Black Mount.

1870 *Royal Sports on Hill and Loch*, largely repainted, is exhibited at the Royal Academy for the second time.

1871 Described in a state 'almost bordering on insanity' in April by the artist, Richard Redgrave.

1872 Exhibits *The Baptismal Font* at the Royal Academy. In July certified lunatic at the request of his family and friends; his power of painting described by Thomas Biddulph as 'by no means altogether gone'.

1873 Unfinished equestrian picture of Queen Victoria is exhibited at the Royal Academy. Death of the artist on 1 October. Funeral at St Paul's Cathedral on 11 October.

1874 Six day sale of Landseer's paintings, drawings and prints at Christie's London in May (1408 lots). Winter exhibition of *The Works of the late Sir Edwin Landseer* RA at the Royal Academy (532 loans).

BRIEF BIBLIOGRAPHY

Catalogue of the Remaining Works of that Distinguished Artist, Sir Edwin Landseer RA, Deceased, Christie, Manson & Woods, London, 8–15 May 1874

James Dafforne, *Pictures by Sir Edwin Landseer, Royal Academician. With Descriptions and a Biographical Sketch of the Painter*, London, 1873

T.M. Devine, *The Great Highland Famine*, Edinburgh, 1988

Algernon Graves, *Catalogue of the Works of the Late Sir Edwin Landseer RA*, London, c.1876

Duff Hart-Davis, *Monarchs of the Glen: a History of Deer-Stalking in the Scottish Highlands*, London, 1978

The Landseer Gallery Being a Collection of Forty-Five Steel Engravings after Pictures by the Late Sir Edwin Landseer, London, 1887

Landseer and his World, Mappin Art Gallery, Sheffield, 1972 (exhibition catalogue)

Campbell Lennie, *Landseer: The Victorian Paragon*, London, 1976

Library Edition of the Works of Sir Edwin Landseer RA, 2 vols, London, 1881–93

Caleb Scholefield Mann, interleaved copy of the 1874 Landseer exhibition at the Royal Academy of Arts (see below), with photographs of all recorded Landseer prints and extensive annotations, 4 vols, National Art Library, Victoria & Albert Museum, mss 86BB.19. Another set is in The Royal Library, Windsor Castle

James A. Manson, *Sir Edwin Landseer RA*, London, 1902

Oliver Millar, *The Victorian Pictures in the Collection of Her Majesty The Queen*, 2 vols, Cambridge, 1992

William Cosmo Monkhouse, *The Works of Sir Edwin Landseer RA. Illustrated by Forty-Four Steel Engravings and About Two Hundred Woodcuts from Sketches in the Collection of Her Majesty and Other Sources with a History of his Art-Life*, London, 1879

Richard Ormond, with contributions by Joseph Rishel and Robin Hamlyn, *Sir Edwin Landseer*, Philadelphia Museum of Art and Tate Gallery, London, 1981 (exhibition catalogue)

Paintings and Drawings by Sir Edwin Landseer RA, 1802–1873, Royal Academy of Arts, London, 1961 (exhibition catalogue)

T.R. Pringle, 'The privation of history: Landseer, Victoria and the Highland myth', in D. Cosgrove and S. Daniels, eds, *The Iconography of Landscape*, Cambridge, 1988

Robert Somers, *Letters from the Highlands, or The Famine of 1847*, London, 1848

Frederick Stephens, *The Early Works of Sir Edwin Landseer RA: A Brief Sketch of the Artist Illustrated by Photographs of his Most Popular Works. With a Complete List of his Exhibited Works*, London, 1869; expanded as *The Landseer Gallery*, 1871, *Memoirs of Sir Edwin Landseer*, 1874, and *Sir Edwin Landseer*, 1880 (part of 'The Great Artists' series)

Rachel Trethewey, *Mistress of the Arts: a Passionate Life of Georgina, Duchess of Bedford*, London, 2002

The Works of the Late Sir Edwin Landseer RA, Royal Academy of Arts, London, 1874 (exhibition catalogue)

Adam Watson and Elizabeth Allan, 'Depopulation by clearances and non-enforced emigration in the North East Highlands', *Northern Scotland*, 10 (1990), pp.31–46

NOTES AND REFERENCES

ABBREVIATION

Ormond 1981: Richard Ormond, with contributions by Joseph Rishel and Robin Hamlyn, *Sir Edwin Landseer*, Thames & Hudson, London, in association with the Philadelphia Museum of Art and the Tate Gallery, 1981.

SIR WALTER SCOTT
AND HISTORY

1. In 1818, Sir George Beaumont, the influential connoisseur and collector, had purchased *Fighting Dogs Getting Wind* (private collection); *The Cat Disturbed* of 1819 (untraced) went to Sir John Grey Egerton; *The Seizure of a Boar* of 1821 (untraced) to the third Marquess of Lansdowne; and *Impertinent Puppies Dismissed by a Monkey* of 1822 to another famous collector, Sir John Leicester, later Lord de Tabley (sold Christie's London, 30 November 2001, lot 91).

2. See, for example, *The Examiner*, 28 April 1819, p.269.

3. Landseer's date of birth is recorded in the St Marylebone rate books for 1802. He was baptised on 23 May 1821 at St Marylebone Parish Church, where his birth date is erroneously given as 7 March 1803, the source of much later confusion (County of Middlesex Parish Registers, Baptisms 1821, vol. P89 MRY 1/022, 145, London Metropolitan Archives).

4. Two large collections of Landseer's early drawings are in the Royal Academy of Arts, and the Department of Prints and Drawings, British Museum.

5. F.C. Lewis, sen., took over 88 Queen Anne Street, Marylebone (later 50 Foley Street) from John Landseer in 1803, when the latter moved to 71 Queen Anne Street (later 33 Foley Street). The two families remained neighbours till 1808 when the Lewises moved away. There is little to document Landseer's early friendship with J.F. Lewis, but they moved in the same circles, and shared some of the same patrons, such as the Duke of Bedford. A watercolour by Lewis of an angler with a keeper (exhibited 1830, private collection) was first identified as Landseer in a book by Walter Shaw Sparrow, *Angling in British Art*, London, 1922, p.88, probably correctly. I am grateful to Briony Llewellyn, author of a forthcoming book on J.F. Lewis, and Sally Doust for information about Lewis. Landseer's extensive correspondence with F.C. Lewis, sen., and C.G. Lewis, mostly concerned with engraving, is in the British Library, Add. MS 38608, fos. 1–98.

6. Recorded in C.R. Leslie's *Autobiographical Recollections*, ed. Tom Taylor, 2 vols, London, 1860, I, p.39.

7. See letter from C.R. Leslie to Ann Leslie, 24 August 1824, Castle Leslie archives, Ireland. A misreading of Leslie's *Autobiographical Recollections*, I, pp.83–5, has led Landseer biographers to assume that he accompanied Leslie, and a third artist, G.S. Newton, on a tour of the Highlands. In fact, he left Leslie in Edinburgh for Blair Atholl.

8. John James Murray, seventh Duke of Atholl, *Chronicles of the Atholl and Tullibardine Families*, 5 vols, Edinburgh, 1908, IV, p.359 and note 2.

9. Letter to Ross, 24 September 1825, Humanities Research Center, University of Texas at Austin.

10. C.R. Leslie, *Autobiographical Recollections*, ed. Tom Taylor, 2 vols, London, 1860, II, pp.156–7.

11. *The Letters of Sir Walter Scott*, ed. H.J.C. Grierson, centenary edition, 12 vols, London, 1932–7, 8, p.392.

12. Quoted in Francis Russell, *Portraits of Sir Walter Scott, a Study of Romantic Portraiture*, London, 1987, p.2.

13. J.G. Lockhart, *Memoirs of Sir Walter Scott*, 5 vols, London and New York, 1900, V, p.459, no.XXI.

14. *The Examiner*, no.1321, 26 May 1833, p.326.

15. *Athenaeum*, no.291, 25 May 1833, p.329.

16. C.R. Leslie, *Autobiographical Recollections*, ed. Tom Taylor, 2 vols, London, 1860, I, p.152.

17. *The Keepsake for MDCCCXXIX*, London, 1829, pp.259, 260.

18. *The Keepsake for MDCCCXXIX*, p.261.

19. Letter of 11 June 1827 from the Duke of Bedford to William Adam, Adam Papers, Blair Adam, Scotland.

20. See Charles Gough, *The Unfortunate Tourist of Helvellyn and his Faithful Dog*, The Wordsworth Trust, Grasmere, 2003.

21. *The Journal of Sir Walter Scott from his Original Manuscript at Abbotsford*, 2 vols, Edinburgh, 1891, I, p.119.

22. *The Journal of Sir Walter Scott*, II, p.74.

23. See *The Letters of Sir Walter Scott*, ed. H.J.C. Grierson, centenary edition, 12 vols, London, 1932–7, 10, p.484, note 1. Robert Cadell, Scott's publisher, wrote to him on 29 July 1828: 'I have again missed E. Landseer, but a friend who has seen him during my truant-playing tells me he is to do all and everything you ask him to do.' Landseer had been asked to produce a portrait of Scott for the Waverley novels, writing to Cadell on 5 October (or February) 1828 (Cadell Papers, National Library of Scotland, Edinburgh, MS 21002): 'I have the sketch of him you saw in St John's Wood with me, and will if you please send it to you immediately. I sincerely hope you will be able to induce him to submit once more to the penance of a hour's sitting. If so I am quite sure I *could* execute something better calculated for the Work than that already in hand.' In the event, no portrait of Scott by Landseer appeared in the edition.

24. The original painting of Catherine Seyton belonged to Robert Vernon, and was in his sale, Christie's London, 5 July 1849. It was sold again at Christie's in 1899 and 1915, and more recently, 15 November 1991, lot 41. It was with Agnew's, London, 1995.

25. Duke of Bedford to Landseer, 21 July 1825, National Art Library, V&A Museum, English MSS, 86RR, I, no.25.

26. *The Examiner*, no.955, 21 May 1826, p.323.

27. See Ormond 1981, pp.68–70.

28. In a letter to the Duke of Devonshire of 20 June 1853 (Chatsworth Archives, Derbyshire), Landseer wrote: 'the first time you gave me leave to visit you here [Chatsworth] – I brought Sketches or schemes for Pictures, Bolton Abbey was selected – You made me the fashion! – I feel like a horrid impostor – amidst the *real* treasures of Art you have here – Years – many years have vanished, what have I achieved since the success of 'Bolton Abbey?' Landseer was writing at the time when he had been commissioned to paint a portrait of the Duke with Lady Constance Grosvenor by a group of Derbyshire gentlemen. The commission was never carried through; two related unfinished paintings of the Duke and Lady Constance are known (Corcoran Gallery of Art, Washington DC, and Sotheby's London, 22 November 1988, lot 10, both from the artist's sale in 1874). An earlier portrait of the Duke of 1832 is at Chatsworth, where Landseer also painted the Emperor Fountain (private collection).

29. The picture was bequeathed to the Sunderland Museum and Art Gallery in 1908, together with other works, by John Dickinson, chairman of a firm of marine engine builders. It is described as 'Bolton Court in the Olden Time' in the *Catalogue of the Permanent Collection in the Art Gallery*, Sunderland, 1908, p.10c, no.89a. Its earlier history is unknown. The smaller related oil sketch was in the artist's sale at Christie's London, 8–14 May 1874, lot 111, as 'Courtyard of a Castle in the Olden Time, with figures, Dead Stags, Hawks, and Hounds'. It is listed by Algernon Graves, *Catalogue of the Works of the Late Sir Edwin Landseer RA*, London, c.1876, p.17, no.197, under 1834. Both the oil sketch and a companion sketch for *Bolton Abbey in the Olden Time* have remained as a pair in the same private collection; for the latter, see Ormond 1981, p.121, no.75, illustrated.

30. See Catherine Gordon, 'The Illustration of Sir Walter Scott: Nineteenth-century Enthusiasm and Adaptation', *Journal of the Warburg and Courtauld Institutes*, 34, 1971, pp.297–317.

31. For a recent entry on the picture, see Julius Bryant, *Kenwood: Paintings in the Iveagh Bequest*, New Haven and London, 2003, pp.270–5, no.67.

32. Two versions of the painting are known, one sold at Christie's London, 18 December 1964, lot 56, as 'Birds of Prey Fighting'.

33. *The Examiner*, no.1271, 10 June 1832, p.373.

34. See *The Times*, 24 May 1832, p.3f; *Gentleman's Magazine*, 102, 1832, part I, p.440; and *Athenaeum*, no.242, 16 June 1832, p.387.

35. For the Eglinton Tourament, see Ian Anstruther, *The Knight and the Umbrella*, London, 1963, and *Van Dyck in Check Trousers*, Scottish National Portrait Gallery, Edinburgh, 1978, pp.103–14 (exhibition catalogue).

36. National Art Library, V&A Museum, MSS, 86RR, II, no.106.

37. Quoted in *Paintings and Drawings by Sir Edwin Landseer RA, 1802–1873*, Royal Academy of Arts, London, 1961, pp.29–30, no.152 (exhibition catalogue).

38. Maria Edgeworth, *Helen*, 2 vols, London, 1834, II, pp.3–4, quoted in Julius Bryant, *Kenwood: Paintings in the Iveagh Bequest*, New Haven and London, 2003, p.272.

39. Letter of 15 December 1855, National Art Library, V&A Museum, MSS, 86RR, V, no.346.

40. Letter of 15 January 1860, British Library, Add. MS 46127, fo.48.

41. Letter of 17 July 1867, National Art Library, V&A Museum, MSS, 86RR, V, no.347.

42. *Saturday Review*, 25, 23 May 1868, p.685.

SPORTING PICTURES

1. The Duke and Duchess of Bedford's letters to Landseer are in the National Art Library, V&A Museum, MSS, 86RR, I, nos. 22–47. For a recent account of Landseer's relationship with the Duchess, see Rachel Trethewey, *Mistress of the Arts*, London, 2002, pp.193–216.

2. *The Diary of Benjamin Robert Haydon*, ed. W.B. Pope, 5 vols, Cambridge, Massachusetts, 1960–3, 3, pp.386, 404.

3. Quoted in Georgina Blakiston, *Lord William Russell and his Wife, 1815–1846*, London, 1972, p.372.

4. *The Journal of Sir Walter Scott*, 2 vols, Edinburgh, 1891, II, p.74.

5. The six etching are as follows: 'A Keeper and his Dogs'; 'The Forest Lodge – Glen Tilt'; 'Lady Louisa Russell with Lady Rachel'; 'Dog's Head'; 'Duchess of Bedford on a Pony'; 'Large Stag's Head' (shot by the Duke of Gordon, 5 October 1826); see Algernon Graves, *Catalogue of the Works of the Late Sir Edwin Landseer RA*, London, c.1876, p.11, nos.112–18.

6. The picture passed into the family of the Duke of Gordon's wife, the Brodies of Brodie, and was twice sold at Christie's London, 6 May 1871, lot 115, and 3 May 1879, lot 48, bought on both occasions by Thomas Agnew & Sons. An oil sketch for the picture is in Wolverhampton Art Gallery.

7. Elizabeth Grant, *Memoirs of a Highland Lady: the Autobiography of Elizabth Grant of Rothiemurcus afterwards Mrs. Smith of Baltiboys*, ed. Lady Strachey, London, 1898, p.229. There are several revealing references to Huntly and his wife in these memoirs.

8. See William Scrope, *The Art of Deer Stalking*, London, 1839, pp.xi–xii and note.

9. The label on the reverse of the picture *The Keeper John Crerar* [plate 40] reads as follows: 'Four sketches by Landseer painted at Blair Atholl in 1824/Keeper John Crerar with pony'. In a recently discovered note from Landseer of 15 March 1833 (Blair Atholl archives), he draws attention to an unpaid account of two hundred guineas (half his agreed fee). In the same note he says he began the picture at Blair in 1827. I am grateful to Jane Anderson, archivist at Blair Castle, for this reference.

10. *Morning Post*, 1 June 1830, p.301.

11. *Athenaeum*, no.136, 5 June 1830, p.312; *Morning Chronicle*, 17 May 1830, p.2e.

12. For a description of the event, see Earl of Tankerville, *The Chillingham Wild Cattle. Reminiscence of Life in the Highlands*, privately printed, 1891, pp.31–2. The picture was sold from Chillingham Castle in the 1960s.

13. A MS note in an annotated copy at Bowood of the *Catalogue of the Collection of Pictures Belonging to the Marquess of Lansdowne at Lansdowne House, London and Bowood, Wiltshire*, 1897, p.51, no.205, states that the picture, there called 'The Return of the Deer Stalkers', was 'intended to occupy one of the spaces over the bookshelves in the corridor but proved too large owing to a mistake in the measurements.'

14. Landseer to the Duke of Northumberland, 17 July 1827, quoted in the typescript copy of 'The Northumberland Collection', c.1930, p.207.

15. *The Examiner*, no.994, 18 February 1827, p.99.

16. Letter pasted on the reverse of the picture, together with a cheque drawn on Messrs Gosling and Sharpe.

17. *The Examiner*, no.1048, 2 March 1828, p.149.

18. William Scrope, *The Art of Deer Stalking*, London, 1839, pp.63–4. Landseer supplied illustrations for the frontispiece and title-page of this edition.

19. *Athenaeum*, no.291, 25 May 1833, p.329.

20. All nine were in the sale of pictures belonging to William (Billy) Wells, nephew and heir of William Wells of Redleaf, Christie's London, 10 May 1890. They had previously been exhibited at the Landseer memorial exhibition at the Royal Academy, winter 1874:

Dead Pheasant (lot 27). Formerly Derek Hill, Donegal.

Death of the Woodcock (lot 28). Untraced.

Roe's Head and Ptarmigan (lot 30) [plate 53].

Grouse (lot 33) [plate 52].

Ptarmigan (lot 34) [plate 51].

Black Cock and Grey Hen (lot 36). Christie's London, 16 July 1965 (lot 77).

Teal and Woodcock (in fact 'Teal and Snipe') (lot 37). Formerly Read Gallery, Palm Beach, Florida.

Partridges (lot 38). Private Collection, Scotland.

Dead Wild Duck (lot 39). Christie's London, 20 April 1990, lot 127.

21. The five exhibited picture were *Roe's Head and Ptarmigan* (1830); *Ptarmigan; Dead Pheasant; Grouse;* and *Black Cock and Grey Hen* (the last four all 1833).

22. *The Examiner*, no.1307, 24 February 1833, p.117.

HIGHLANDERS

1. An invoice from the theatrical agent, John Thresher, dated 4 January 1830 (Bedford Office, London, 'Vouchers', no.85) lists various masks and costumes ordered by Landseer on behalf of the Duke of Bedford.

2. See Martin Meisel, *Realizations: Narrative, Pictorial, and Theatrical Arts in Nineteenth-Century England*, Princeton, New Jersey, 1983, pp.142–65.

3. John Ruskin, *Modern Painters*, 2 vols, London, 1844, I, p.11.

4. See Lindsay Errington, *Tribute to Wilkie*, National Galleries of Scotland, Edinburgh, 1985, and Nicholas Tromans and others, *David Wilkie: Painter of everyday life*, Dulwich Picture Gallery, London, 2002 (both exhibition catalogues).

5. See Kathryn Moore Heleniak, *William Mulready*, New Haven and London, 1980, and Marcia Pointon, *Mulready*, V&A Museum, London, 1986 (exhibition catalogue).

6. Four letters from Landseer to Wilkie, 1836–9, and one from Wilkie to the publisher Boys thanking him for a print of Landseer's *Bolton Abbey in the Olden Time*, National Library of Scotland, Edinburgh, MS 9836, fos. 124, 134, 136, 160, 163. In a letter of 18 May 1839, Landseer tells Wilkie that the picture is nearly done, and acknowledges a cheque for £100 in a second letter of 24 May 1839. The picture has not been identified, but it may, in fact, have been ordered by a third party; in a letter of 27 March 1837 (or 1839), Landseer thanked Wilkie for helping him to secure a commission from a 'Mr Hatfield'.

7. Robert Vernon, 'Account of Pictures', quoted in Robin Hamlyn, *Robert Vernon's Gift: British Art for the Nation 1847*, Tate Gallery, London, 1993, p.51, no.40 (exhibition catalogue). The picture was exhibited at the British Institution in February 1830, and must, therefore, have been painted prior to 1830.

8. *The Examiner*, no.943, 5 March 1826, p.148.

9. Letter of 4 April 1829, one of five concerning the commission, Stratfield Saye Archives, Berkshire.

10. In an unidentified review, National Art Library, V&A Museum, Press Cuttings, 6 vols, PP.17.G, VI, p.1560, the Highlander on the left is identified as the distiller, while in other contemporary reviews he is assumed to be the client; for later interpretations, see Johann David Passavant, *Tour of a German Artist in England*, 2 vols, London, 1836, I, p.172; Gustav Waagen, *Treasures of Art in Great Britain*, 2 vols, London, 1857 edition, II, p.274; Evelyn Wellington, *A Descriptive & Historical Catalogue of the Collection of Pictures & Sculpture at Apsley House*, 2 vols, London, 1901, II, pp.243–5, no.104; C.M. Kauffman, *Catalogue of Paintings in the Wellington Museum*, London, 1982, pp.80–1, no.84.

11. *Quarterly Review*, XCII, 1852–3, p.459.

12. *The Examiner*, no.1111, 17 May 1829, p.309.

13. Unidentified review, National Art Library, V&A Museum, Press Cuttings, 6 vols, PP.17.G, VI, p.1560.

14. *The Examiner*, no.1149, 7 February 1830, p.83.

15. John Ruskin, *Modern Painters*, 2 vols, London, 1844, I, p.10–11.

16. *Athenaeum*, no.434, 20 February 1836, p.147.

17. *The Two Drovers* was published in *The Chronicles of the Canongate*, part 1, 1827. Scott's novel, *Rob Roy*, also features drovers. For the story of droving, see A.R.B. Haldane, *The Drove Roads of Scotland*, London, 1952, and John Keay, *Highland Drove*, London, 1984.

18. Letter from Packe to Landseer, National Art Library, V&A Museum, MSS, 86RR, IV, no.244. Three letters from Landseer to Packe and one to his wife are in the collection of the Packe family. In one letter, dated Friday 8th 1839, Landseer writes of the progress he is making with the picture, and of his intention to exhibit it at the Royal Academy that year, which he did: 'I don't believe I shall require your Fourfooted friends again.' In a second letter of 24 July 1839, he acknowledges a cheque for £200. In a later letter of 24 July 1850 he promises to 'refurbish the old Pony'. The painting was sold at Sotheby's London, 6 November 1995, lot 101.

19. Queen Victoria's Journal, Royal Archives, entry for 3 April 1849,

20. Royal Archives, Add c/4 (161).

HIGHLAND LANDSCAPES

1. See Malcolm Andrews, *The Search for the Picturesque: Landscape Aesthetics and Tourism in Britain, 1760–1800*, Aldershot, 1989, pp.196–240.

2. Christie, Manson & Woods, *Catalogue of the Remaining Works of that Distinguished Artist, Sir Edwin Landseer RA, Deceased*, London, 8–15 May 1874.

3. Written between 1845 and 1854 for her family, edited by her niece, Lady Strachey, and published in 1898. Several of Landseer's Highland friends feature in the memoirs.

4. *The Life of Charles James Mathews Chiefly Autobiographical with Selections from his Correspondence and Speeches*, ed. Charles Dickens, 2 vols, London, II, p.57.

5. *Life of Charles James Mathews*, II, pp.45–56.

6. Queen Victoria, *Leaves from the Journal of Our Life in the Highlands from 1848 to 1861*, London, 1868, p.191.

7. *Life of Charles James Mathews*, II, p.53.

8. *Life of Charles James Mathews*, II, p.56.

9. The Earl of Tankerville, *The Chillingham Wild Cattle. Reminiscence of Life in the Highlands*, privately printed, 1891, p.24.

10. Tankerville 1891, pp.30–1.

11. 'Glenfeshie Game Book', Ellice Papers, National Library of Scotland, Edinburgh, MS 15152; references to Landseer shooting will be found on fos. 17, 19, 35, 37 and 46.

12. 'Glenfeshie Game Book', fos. 36–7; 'Lanny' was the artist's nickname.

13. For Callcott and Landseer's *Harvest in the Highlands*, see plate 71. A river landscape by Callcott, with cows by Landseer, said to have been exhibited at the Royal Academy in 1842 (perhaps no.10, 'An English Landscape Composition'), is in a Swiss private collection. A third picture, *The Meuse* by Callcott, with horses by Landseer, was formerly in the collection of Sir John Coote. Six collaborative landscapes by Landseer and F.R. Lee are known, including two in the Tate Gallery: *Cover Side* (1839, no.418), and *A Landscape with Figures* (1830, no.1788).

14. *John Constable's Correspondence*, ed. R.B. Beckett, 6 vols, London, 1962–8, III, p.52.

15. *John Constable's Correspondence*, III, p.128.

16. Tankerville 1891, pp.25–30.

17. Four boxes in a private collection, containing nearly two hundred drawings by Landseer, including several sketches made at Glenfeshie. Another batch of Glenfeshie

drawings, from a sketchbook belongng to Edward Ellice, was sold at Sotheby's, 24 June 1971.

18. Tankerville 1891, p.28.

19. Tankerville 1891, p.29.

20. Tankerville 1891, p.30.

21. For an essay on Pre-Raphaelite documentation of the natural world, see Christopher Newall, 'Understanding the Landscape', in *Pre-Raphaelite Vision: Truth to Nature*, Tate Britain, London, 2004 (exhibition catalogue), pp.133–43.

22. Landseer exchanged the landscape with his close friend and fellow artist Sir Francis Grant for a picture attributed to Velázquez, presumably *The Betrothal of the Infanta*, included in the artist's sale, Christie's London, 8–15 May 1874, lot 150.

PATRONS AND PRINTS

1. See Robin Hamlyn, *Robert Vernon's Gift: British Art for the Nation 1847*, Tate Gallery, London, 1993 (exhibition catalogue).

2. J.C. Horsley, *Recollections of a Royal Academician*, ed. Mrs E. Helps, London, 1903, p.60.

3. The last two pictures were in Vernon's sale, Christie's London, 5 May 1849, lots 64 and 57. *Head of a Young Buck* was last recorded at Tulcan Lodge, Scotland, in 1980. It is not certain which of the presently recorded versions of *The Hawking Party* is Vernon's picture.

4. Vernon was incensed when a print from the still unfinished painting he had commissioned, of his favourite spaniels with Miss Ellen Power, was published without his permission. He accepted the substitute picture, *Cavalier's Pets* (Tate, London), while the original, *Lady with Spaniels*, was bought by King Leopold of the Belgians; see *Vernon Heath's Recollections*, London, 1892, pp.8–14, and Ormond 1981, pp.196–7.

5. 'Landseer letters, mainly to William (Billy) Wells', MSS.86.yy.90. This includes three letters to the elder Wells, 1841–6; letters from the elder Wells to Landseer are also in the National Art Library, V&A Museum, London, MSS, 86RR, V, fos.321–5.

6. Letter in the collection of the Sheepshanks family. The author is grateful to Martin Royalton-Kisch of the British Museum for access to this correspondence. For his paper, 'An Archive of Letters to John Sheepshanks', see *The Walpole Society*, 66, 2004, pp.231–54. The pictures of *Little Red Riding Hood* and *Jack in Office*, are, respectively, in a private collection, and V&A Museum, London.

7. Letter of 17 April 1836, National Art Library, V&A Museum, London, MSS, 86RR, V, no.298. The picture of *Twa Dogs* belonging to Wells was probably *Deerhound and Mastiff*, exhibited British Institution, 1838 (372), sold at Sotheby's Parke Bernet, New York, 14 May 1976, lot 61; *Ratcatchers*, sold Christie's London, 15 April 1836, lot 83, is in a private collection (see Ormond 1981, p.53, no.16); *Highland Family* is *The Drovers' Departure* [plate 75]; *The Ram of Derby* is possibly identical with the picture of *Tethered Rams* [plate 76].

8. Letter of 12 July 1837, Sheepshanks family. The picture mentioned in the letter is *Return from Hawking* [plate 21].

9. Letter of 20 April 1838, Sheepshanks family. The engraving by Wat mentioned in the letter is almost certainly *The Drovers' Departure* [plate 75], published in 1841.

10. For information on the history of Victorian engravings, see Hilary Beck, *Victorian Engravings*, Victoria & Albert Museum, London, 1973 (exhibition catalogue); Rodney E. Engen, *Dictionary of Victorian Engravers, Print Publishers and their Works*, Cambridge, 1979; and Anthony Dyson, *Pictures to Print*, London, 1984.

11. Bell Papers, Royal Institution, London.

12. The ledgers relating to Landseer's bank accounts, 1832–73, are held at Barclay's Bank, Fleet Street Branch, London; this was formerly Gosling's Bank.

13. Bell Papers, Royal Institution; the first page and verso of the account relate to Landseer; the following two pages detail payments for the work or copyright of other artists. The identity of the items listed in the account is as follows:

'Waterloo': *Dialogue at Waterloo* (c.1850, Tate), engraved by T.L. Atkinson, 1855.

'Russell Plates': the prints by C.G. Lewis, after the equestrian portraits of *Lord Cosmo Russell* [plate 30] and *Lord Alexander Russell* (c.1829, Guildhall Art Gallery, London).

'Titania': *Scene from 'A Midsummer Night's Dream': Titania and Bottom* (1848–51, National Gallery of Victoria, Melbourne), engraved by Samuel Cousins, 1857.

'Sir R. Peel's Picture': probably *Lady Emily Peel with her favourite dogs*, commissioned by Peel in the 1840s and finally exhibited in 1872 (Sotheby's London, 12 April 1995, lot 76).

'Heathcote's sketch': not identified.

'The Queen's Picture': *Royal Sports on Hill and Loch* [see plate 137].

'The Flood': *Flood in the Highlands* [plate 81], engraved by T.L. Atkinson, 1870.

'Stag swimming': *The Hunted Stag* [plate 131], engraved by Thomas Landseer, 1862.

'Princess Mary': *On Trust* (Princess of Mary of Cambridge with her favourite Newfoundland dog, Nelson, c.1839, Royal Collection), engraved by W.H. Simmons, 1875.

'The Marquis of Worcester': *The Marquis of Worcester and his sisters* (c.1839, unfinished, sold Christie's London, 19 November 1976, lot 28).

'The Telescope deerstalking Work': not identified.

'Lord Sefton's horses': probably the equestrian portrait of the *Earl of Sefton and Family* (c.1846, unfinished, National Gallery of Victoria, Melbourne).

'Mr Sheridan (the invalid)': *Charles Sheridan with Mrs Sheridan and Child* (c.1847, unfinished, National Gallery of Ireland, Dublin).

14. See *An Alphabetical List of Engravings Declared at the Office of the Printsellers' Association, London ... Since its Establishment in 1847 to the End of 1891. Compiled by the Secretary, G.W. Friend, under the Supervision of the Committee*, London, 1892.

15. See, for example, 'Laying Down the Law', *Punch*, II, June 1842, p.251; 'The Great Dog Question', VII, July 1844, p.38; 'The Tethered Minister', X, 1846, p.36; 'Peace (?) A Recollection of Landseer's Celebrated Picture', XIV, January 1848, p.39; 'The Cat's Paw; or Poor Pus(s)ey', XIX, 1850, p.246; 'The Persian "Cat's-Paw"', LXXVIII, 21 February 1880, p.79; 'Punch's Essence of Parliament' (Gladstone as *Monarch of the Glen*), LXXIX, 31 July 1880, p.46; 'The Grand Old "Man Proposes", and –', XC, 10 April 1886, p.171. I am grateful to Professor Leonée Ormond for these references.

16. Letters from Landseer, Tom Landseer and Ernest Gambart to Jacob Bell, November 1849, Bell Papers, Royal Institution, London. For a biography of Gambart, see Jeremy Maas, *Gambart Prince of the Victorian Art World*, London, 1975.

17. Letters from Charles Lewis and Ernest Gambart to Jacob Bell, 1848, Bell Papers, Royal Institution, London.

18. Landseer to Charles Lewis, Lewis Papers, British Library, London, Add MS 38608, fo.38.

19. Extensive sequence of letters from Landseer to Charles Lewis, Landseer and Lewis to Jacob Bell, together with Jessie Landseer's evidence in the case of Henry Graves & Henry Menck v. Charles Lewis in the Queen's Bench, London: Lewis Papers, British Library, London, Add MS 38608, and Bell Papers, Royal Institution, London.

20. Landseer's only recorded letter to Henry Graves is in the New York Public Library, Manuscripts and Archives Division, 'Miscellaneous Papers'; three letters from Graves to Landseer are in the National Art Library, V&A Museum, London, MSS, 86RR, 2, nos. 159–61; a fourth letter to an unnamed correspondent is among the Jacob Bell Papers in the Royal Institution, London.

21. The picture Landseer painted for Brunel was *Scene from 'A Midsummer Night's Dream': Titania and Bottom* (1848–51, National Gallery of Victoria, Melbourne).

22. Fowler's collection of works by Landseer was sold at Christie's London, 6 May 1899, lots 21, 58–69.

23. These were in the Cheylesmore sale at Christie's London, 7 May 1892, lots 31–61.

24. Private Collection.

THE MONARCH OF THE GLEN

1. Landseer to Count d'Orsay, Houghton Library, Harvard University, Cambridge, Massachusetts, MS Eng 1272, no.4.

2. Landseer's travel diary belongs to descendants of Landseer's sister, Emma Mackenzie. Many chalk drawings survive from Landseer's travels in 1840.

3. Letters to Jacob Bell are in the Royal Institution, London.

4. The five cartoons, 'Challenge', 'Forester's Family', 'Stag at Bay', 'Group of Deer' and 'Dead Stag', were destroyed by fire on 15 October 1873. Reproductions of the cartoons were published by J.G. Millais, *The British Deer and their Horns*, London, 1896, facing p.46, by permission of Sir George Macpherson, Bart, 'owner of the plates'.

5. See Jeremy Maas, 'Rosa Bonheur and Sir Edwin Landseer: a study in mutual admiration', *Art at Auction, the Year at Sotheby's Parke Bernet*, 1975–6, pp.63–73.

6. Both pictures were exhibited at the British Institution in 1838, and were included in the Wells Sale at Christie's, 28 May 1852, lots 51–2. *Red Deer* was sold again at auction in 1937 and 1975. *Fallow Deer* was acquired by the railway contractor, Sir Morton Peto, for Somerleyton Hall, and remained in the house when it was sold to W.H. Crossley, following the crash of Peto's firm.

7. Both *Roe Deer* and *None but the Brave Deserve the Fair* were in the Wells Sale at Christie's, 10 May 1890, lots 46 and 48; the former was exhibited at the British Institution in 1838, and the latter at the Royal Academy of 1838. Both pictures were owned by the American collector of sporting art, Geraldine Rockefeller Dodge, and were included in sales of her collection in 1975 and 1976.

8. Some of the islands on Loch Maree have the ruins of chapels and hermitages, which are associated with the story of early Christianity in Britain.

9. The picture was painted for the fourth Duke of Northumberland, who already owned *Highlanders Returning from Deerstalking* [plate 44]. It was exhibited at the Royal Academy in 1844.

10. Painted for the second Marquess of Breadalbane and exhibited at the Royal Academy in 1846; it was acquired from Thomas Agnew & Son by the first Earl Iveagh in 1889.

11. National Art Library, V&A Museum, MSS, 86M, 3, no.27.

12. Lord Albert Denison Denison (1805–60), second son of the first Marquess of Conyngham, liberal MP and first president of the British Archaeological Association. He changed his name to Denison on inheriting huge estates from his Denison uncle in Yorkshire. Created Baron Londesborough in 1850.

13. *Saturday Review*, III, 1857, p.498.

14. *William Powell Frith, My Autobiography and Reminiscences*, 3 vols, London, 1887–8, III, p.247.

15. For contemporary reviews, see *Art Journal*, 1857, p.166; *Athenaeum*, no.1541, 9 May 1857, p.601; *Morning Post*, 2 May 1857, p.6d; *The Times*, 2 May 1857, p.9a.

16. Aberdeen to Landseer, 27 November 1838, National Art Library, V&A Museum, MSS, 86RR, I, no.7.

17. Aberdeen to Landseer, 14 October 1841, National Art Library, V&A Museum, MSS, 86RR, I, no.10.

18. *Athenaeum*, no.863, 11 May 1844, p.433.

19. Landseer told Sir Francis Grant that he had begun work on the picture ten or twelve years earlier in a letter of 26 April 1869, National Art Library, V&A Museum, MSS, 86RR, 38. The letter is part of an extensive correspondence between Landseer and Grant.

20. J.G. Millais, 'Shooting', *Magazine of Art*, 1896, pp.286–7.

21. *The Times*, 10 May 1869, p.12b.

22. Marianne Skerrett to Landseer, 10 November 1847, Royal Archives, Add c/4/19.

23. Landseer to Count d'Orsay, 29 December 1847, Houghton Library, Harvard University, Cambridge, Massachusetts, MS Eng 1272, no.32.

24. Queen Victoria's Journal, Royal Archives, entry for 19 September 1850.

25. Houghton Library, Harvard University, Cambridge, Massachusetts, MS Eng 176, no.46.

26. Queen Victoria's Journal, Royal Archives, entry for 6 May 1865.

27. Landseer to Dr Tweedie, 19 November 1857, Humanities Research Center, University of Texas at Austin.

28. Landseer had fallen in love with the beautiful Louisa (Loo) Stewart Mackenzie, twenty-five years his junior, and may have proposed to her in 1857. She is said 'to have thrown him over' in order to marry the reclusive and even older Lord Ashburton. Landseer's letters to her and her husband are among the Ashburton Papers, National Library of Scotland, Edinburgh, Acc. 11388, nos. 25, 56, 83. For an account of the affair see Ormond, 1981, pp.18–19, and Virginia Surtees, *The Ludovisi Goddess: the Life of Louisa Lady Ashburton*, Salisbury, 1984.

29. F.M. Redgrave, *Richard Redgrave CB RA A Memoir Compiled from his Diary*, London, 1891, p.316.

30. See Robin Hamlyn in Ormond 1981, pp.204–6.

31. G.D. Leslie, *Riverside Letters*, London, 1896, pp.191–202.

32. The picture, also known as 'Chevy', was exhibited at the Royal Academy in 1868. Its first owner was Richard Heming.

33. *Browsing* was drawn while Landseer was staying with William (Billy) Wells for the benefit of his health, and was given to his host. It was in the Wells Sale at Christie's, 10 May 1890, lot 56.

34. Queen Victoria's Journal, Royal Archives, entry for 1 October 1873.

35. Vol.63, 11 October 1873, p.350.

INDEX OF PEOPLE AND PLACES